This work is indispens... ademy, who
wishes to understand t... porary view
that research and art ... endt's argu-
ment potentially generative for artists is that it is centered in the author's belief
that research and writing can be powerful ways of strengthening and deepen-
ing artistic production. The reader will find a broad range of clear and usefully
provocative insights that frame research not a substitute for art making, but as
a tool for better art making.

– Nick Jaffe, musician, teaching artist,
Chief Editor of the *Teaching Artist Journal*

"In *Artist Scholar*, Daichendt makes a genuine break through in the discourse of
art and artists in education and is by the far the most useful book yet in helping
to articulate and map this previously under researched area of art education"

– Diarmuid McAuliffe
Artist Teacher, Master of Education Programme Leader
University of the West of Scotland, UK

As an artist, scholar and educator, Daichendt draws upon his research and per-
sonal experiences to present the importance of reflective writing in graduate
visual art studio programs. His insights about how the MFA candidate can use
visual and verbal scholarship methods to enhance their own and others un-
derstanding of the art-making process make a significant contribution to the
literature about university art education.

– Judith W. Simpson, Ph.D.
Director of the MA in Art Education on-line program
Boston University

Artist Scholar provides fuel to the artist who functions in an academic setting
to support their work in the studio as a type of research and scholarship. It is
refreshing to read Daichendt's affirmation of the deep and intrinsic connections
the artist can make in their studios and how MFA students may harness this
knowledge though observing, thinking and writing.

– William Catling, MFA
Director, MFA in Visual Art
Azusa Pacific University

"This book will be of value to anyone int... vel
art study in U. S. universities, especially ... n-
ship between art, writing, and scholars...

...ri
... arts
University of Southern California

Artist Scholar

Artist Scholar:
Reflections on Writing and Research

by G. James Daichendt

intellect Bristol, UK / Chicago, USA

Library of Congress Cataloging-in-Publication Data
Daichendt, G. James.
 Artist scholar: reflections on writing and research / G. James Daichendt.
 p. cm.
 ISBN 978-1-84150-487-2 (pbk.)
 1. Art in universities and colleges. 2. Art--Study and teaching (Graduate) 3. Art-
Research--Methodology. 4. Art students. I. Title.
 N345.D24 2011
 707.2--dc22
 2011011407

First published in the UK in 2012 by Intellect,
The Mill, Parnall Road, Fishponds, Bristol, BS16 3JG, UK

First published in the USA in 2012 by Intellect, The University of Chicago Press,
1427 E. 60th Street, Chicago, IL 60637, USA

A catalogue record for this book is available from the British Library.

Copy editor: Macmillan
Cover photo: Kent Anderson Butler
Cover design: Holly Rose
Typesetting: John Teehan

ISBN 978-1-84150-487-2

Printed and bound by Hobbs, Tatton, Hampshire, UK

*For Rachel, Samantha,
Trey, and Logan*

Contents

Preface: Scholarship and Art's Ambiguous Objects xi
 by John Baldacchino

Introduction 1

Chapter 1: Artists and Scholarship 5
 Basic language on research and the arts 11
 Universities and arts research 16
 Playing the cello in a marching band 18
 Artistic scholarship 21
 References 23

Chapter 2: The Professionalization of the Visual Arts 25
 A history of art education 25
 The foundation of university art departments and the art major 25
 Growth in university education 29
 Origins of the American art department 31
 Intellectualism of art making 35
 Teaching to research 37
 The M.F.A. degree 39
 Art history lends a hand 41
 References 44

Chapter 3: The Status of Artistic Scholarship 47
 Research through practice 47
 Going forward with M.F.A. scholarship 50
 Practice-led research 54
 References 57

Chapter 4: Artists and Writing 61

Writing and art making 61
Common graduate writing strategies 61
Why write? 63
Writing critically 66
Writing and higher education 66
References 67

Chapter 5: Reflections on Knowledge and Understanding 69

Art making and understanding 69
Art practice and new knowledge 70
Subject-based knowledge 73
Knowledge and research or understanding and writing 77
References 82

Chapter 6: Practicing Reflective Scholarship 85

An introduction to scholarship 85
What is a thesis/dissertation writing project? 87
Purpose 88
Artistic paradigms and reflective inquiry 89
Where to begin? 90
Developing a question 91
Creative methodologies 94
Data sources and methods 95
Analyzing data 100
Some larger philosophical issues to consider about artistic
 scholarship 101
Resarch paradigms 102
Critical theory 104
Paradigms and research 104
Reflecting on artistic scholarship 105
Completing a research proposal 105
References 106

Chapter 7: Revisiting Writing and Research 109

Doctoral programs in the visual arts 110
Writing and research with art-making option 110
Combined writing and research with final art project 111
Where are we going with arts research? 112
Writing and research 114
References 126

Appendix A – Putting Writing into Practice 129

Title of project 129
Research question 129
Aim and scope of study 129
Rationale for inquiry 131
Objectives to be covered 131
Context 131
Methodology and procedure for inquiry 132
Potential outcomes 133
Bibliography 133
References 133

Appendix B – Banksy Hearts NY 137

Preface to study 137
Title 137
Introduction 138
Research question 140
Limits 140
Methodology and procedure for inquiry 141
Brief biography 142
Timeline 143
Literature review 145
Cultural atmosphere 147
Professional influences 149
Artistic media 150
Imagery 152
Location 152
Irony 156
Conclusion 157
References 159

PREFACE: SCHOLARSHIP AND ART'S AMBIGUOUS OBJECTS

John Baldacchino

It is one of those fables, which, out of an unknown antiquity, convey an unlooked-for wisdom, that the gods, in the beginning, divided Man into men, that he might be more helpful to himself; just as the hand was divided into fingers, the better to answer its end. (…)

In this distribution of functions, the scholar is the delegated intellect. In the right state, he is, *Man Thinking*. In the degenerate state, when the victim of society, he tends to become a mere thinker, or, still worse, the parrot of other men's thinking. (…)

In this view of him, as Man Thinking, the theory of his office is contained. Him nature solicits with all her placid, all her monitory pictures; him the past instructs; him the future invites.

Is not, indeed, every man a student, and do not all things exist for the student's behoof? And, finally, is not the true scholar the only true master? But the old oracle said, "All things have two handles: beware of the wrong one." In life, too often, the scholar errs with mankind and forfeits his privilege. Let us see him in his school, and consider him in reference to the main influences he receives.

– Ralph Waldo Emerson, *The American Scholar*
(1990b, pp. 37-38)

In its original meaning a Preface seems to imply an ordering where a "first word" is said before anything else. However these prefatory comments are meant as a set of words that sit amongst others. So I hope that this is read in dialogue with what Jim Daichendt is offering his readers in this necessary and insightful book. It goes without saying that any *ordering* in this dialogue remains contingent to the fact that Prefaces

normally go first, when in effect we all know that they are written *after*, even though never meant to have a "last word".

While the fable of the ordering of words perpetuates itself—be it in prefaces, explanatory footnotes, or in subsequent reviews that emerge around a text or argument—one expects that a wider and more pervasive fabular community of scholarship abounds at the same time that the recipients of these fables—the narratees, as Lyotard (1989) calls them—remain aware of their responsibility towards what they see themselves doing. In the case of artists the expectancy is never restricted to further fables and woven narratives, but is opened to the objects that art makes and what, as a consequence, becomes *another kind* of object: the necessarily elusive "work of art".

Objects

As I say this, I choose to cite Emerson's *The American Scholar* by way of providing a prefatory caution to what is subsequently said in dialogue with the *object* of this book. I italicize the word *object* to qualify its ambiguity. Far from sinister or misleading, the ambiguity of art's object is contingent on a pluralism of meanings. The object of this dialogue (mine, Daichendt's, the artist's, the scholar's, the teacher's, the learner's... the reader's) is not simply focused on this book as an object of discussion. More appropriately and concretely, the real object of Daichendt's writing is what prompts this book in the first place: art's object.

Yet I would hasten to add that to say so is to mislead the reader into thinking that there is an essentialist end to all of this, and that this "end" must, by some mysterious necessity, be found in the work of art. Apart from reducing art works into fetishes, and consequently position art on the same plane of a fanciful brand of urbanised shamanism (which I would strongly contest), to say that the object of art is an artefact is to dismiss what Georg Lukács (1971) calls art's "speciality". Unlike any other human activity, art is immanent not because it claims to distance itself from everything else, but by confirming that all it does is engage with a world defined by its contingency. This implies that art's speciality is seen as a plural event; which is where I would distance myself from a strictly Lukácsian preoccupation with art's relationship with what he identifies as men and women's "teleological projects" (Lukács, 1974). Art's plurality is not to be sought in the projects that men and women have for themselves, where art may or may not feature as an objective (and here I suppose, Lukács would insert his justification of a teleological project), but in the speciality of art itself, by which it enables men and women to present their respective worlds as plural events.

This opens the idea of art to various paths of discussion, each leading to their own unique ways of definition and understanding, and where they would invariably cross and present us with a limitless engagement with art's *object*. When we talk about "art's

object", the conversations that characterize our plural narratives of art will produce at least three meanings of the word *object*. These are (a) the immediate question concerning what constitutes the *thing* made by artists, (b) the aim that drives the artist to make such a thing, and (c) the open-ended act of being/becoming art. To preserve the pluralist stance of art's speciality I would be more inclined to approach art's act as a *doing* rather than as a *making*. Though "making" is a perfectly viable term, especially when it is linked to poetics by dint of the etymological origin of the word *poiesis* (whose Greek root pertains to *poieîn*, to *make*) the overuse of "making" in art and art education verges on abuse, in that it becomes a ritual, where the artwork seems to be more akin to a fetish.

As if this was not complex enough, it is within the art educator's right to open further paths to another horizon of meanings for art's object. This is the path of education, where what one learns *by* (or *from* and *through*) art is an object that remains no less ambiguous. Like art's object, the object of art's learning moves between a myriad meanings. To mention just three, art's educational object could signify (a) a received body of knowledge; that suggests (b) a state of affairs that has to do with being (an artist and a learner); and (c) a way of understanding where *knowing* and *being* should belong or could be found. The last point suggests a community of learners that are not simply constitutive of a polity (as a *polis* or community) but that signifies a space inhabited by the participants of an *agôn*—i.e. as individuals within a community that is signified by a plurality of relationships, giving rise to endless situations invariably shared between argument and friendship, rivalries and alliances, agreement and discord, as well as contests that presume winners but also losers… *etc.*

While one hopes that art's *agôn* of learning is humanely compelled to an ethical amelioration of sorts, this is no excuse for dogmatically assuming that art's pedagogy is necessarily benign or "progressive". Art's pedagogical agôn also signifies a state-of-affairs that could be as antagonistic as much as agonistic, certain as well as uncertain, reforming but also retrograde and somehow deforming. And it is because of this that such an agôn becomes necessary insofar as this necessity is understood in recognition of art's contingent *situatedness*. In other words, art's educational prospect inhabits a space that could only be anticipated or assumed to a limit, beyond which one has to recognize what Dewey (1966) would term as diverse and open-ended *dispositions*.

Man Thinking and Man Making

One hopes that in an Emersonian context, the word *originary* holds some significance not as a location of an origin (which suggests a causal pattern of teleological processes), but more importantly where the idea of an originary meaning of art and learning reaffirms a plurality of departures that could begin anywhere and at anytime. Thus

art and learning take their place contingently as they claim for women and men the right to remain sceptical about any dogma of certainty or predictability. I say this with a specific art educational context in mind. The sophist cycle of *process* and *product* that has plagued art and consequently art education for decades remains particularly present in the form of a productivist aesthetic that distorts the legacy of the Bauhaus's pedagogical programme. Such fossilized affirmations are immediately recognizable in those well-known constructivist pedagogies that still characterize many an arts institution. The idea of art as a construct of human progress comes straight from the fable of *Man thinking*, which is in turn reinforced under the equally romantic view of *Man making*.

Constructivist readings of art and art education tend to forget that Emerson's celebration of the scholar—and more specifically the *American* scholar—goes contrary to any benign assumption of certainty or predictability. Beyond any Whiggish impression that it may give, Emerson's celebration of the scholar is neither obsessively solipsistic nor blindly communitarian. "He and he only knows the world," Emerson tells us of the scholar. But this does not suggest that the solitary scholar is the custodian of some revealed truth. Nor does it invite the scholar to take some visible social role. Rather, Emerson casts the scholar in a unique yet peculiar position, where he or she has no choice but to confirm the contingent state of the world: "The world of any moment is the merest appearance." (1990b, p. 46) Unlike the old Whig, always hopeful of a world that would ultimately grasp freedom, or the Saint-Simonist egalitarian, whose view of redemptive history is propelled by a freedom based on sorority and fraternity, the scholar can offer no guarantee.

Emerson's remarks have a different tone: "Some great decorum, some fetish of a government, some ephemeral trade, or war, or man, is cried up by half mankind and cried down by the other half, as if all depended on this particular up or down." Ultimately "[t]he odds are that the whole question is not worth the poorest thought which the scholar has lost in listening to the controversy." (Emerson, ibid.)

A cynical reading of this statement is only forgiven if it were qualified by the realization that in Emerson's intended rhetoric there is an equal measure of lamentation and celebration between the assumption of *Man thinking* and the ambiguities suggested by the fable of an originary human who cannot avoid the fate of specialization by which "he" submits to differentiation and the ensuing randomness by which "we" could only celebrate humanity as an inordinate assemblage of women and men in their variegated states of situatedness.

Thus while we have no choice but to take ownership—and indeed liberty—with *Man thinking* as a concept that could easily lend itself to that of *Man making* (as indeed many have done in divvying scholarship between those who think and those who make, between theory and practice, contemplation and implementation), we must bear in mind that unless it is kept within the Emersonian spirit of contingency,

the split between *man thinking* and *man making* remains deeply problematic. The Emersonian proviso also requires that the condition of difference, which makes truth a plural event, could only appear as *coherent* if we remain mindful of those unknown narratives which, Emerson acknowledges in the circular condition of our being: "Every man supposes himself not to be fully understood," he states, "and if there is any truth in him, if he rests at last on the divine soul, I see not how it can be otherwise. The last chamber, the last closet, he must feel, was never opened; there is always a residuum unknown, unanalyzable. That is, every man believes that he has a greater possibility." (Emerson 1990a, p. 168)

Situated practices

More than a case of acquisition—of knowledge or of completion in drawing our objects to a near end—the *situatedness* by which Maxine Greene, after Merleau-Ponty (1989), marks the idea of learning, has to be qualified by a constant sense of possibility and freedom (Greene, 1988, p. 8) which would not be far removed from Emerson's notion of "greater possibility". This is where the dilemma of contingency, of which so many educators often run scared, gains its utmost value.

Just like art's speciality, arts research must always be assumed as a plural practice that rejects teleological certainty. Unlike the social scientific methodological obsession with a palliative search for data, arts research must do the opposite. As Picasso famously said, "I do not seek, I find." To find is to do what Duchamp does in generating art's data by opening further paths to the meanings of art's objects. These objects are not even made by the artist. They are simply found. Here, art's *doing* becomes saliently different from those romantic assumptions of a productivist aesthetic that lies at the root of the customary pedagogical arguments of modernism, and which has been the locus of a series of pedagogical transformations which in and of themselves have shifted us away from the Academy, but where the adeptness to social scientific models have become all too easy to adopt. The ease by which art education has slipped into the canons of social scientific methods had an adverse effect on both art and more so on those who see art as central to education. In art education this represents a major obstacle, especially when social scientific models have been all too quickly borrowed by many arts-researchers and teachers in their hasty response to the demands that academic managers have put on arts institutions.

The need to satisfy a preordained and externally driven research agenda has gradually stultified arts research and more so arts educational research. This is evident in how the arts see themselves surviving the quandaries that characterize tenure politics and academic legitimacy in American universities. Likewise, the arts are continuously being forced to reinvent themselves in order to retain their stake within a centralized

funding structure that follows a business model of standardized criteria that in turn determines what is or should be "arts research" in British, Canadian and Australasian tertiary education. In jest or simple desperation, academics often hypothesise whether a Wittgenstein, let alone a Duchamp or a Beuys (and might one add Emerson!), would survive contemporary academia.

Yet beyond the lament over academic funding and legitimation, the worry is far more radically embedded in what the production of artists and designers in the 21st century has come to represent in terms of the practice and existence of art and design as a "way of life"; i.e. as a human act which, by its intrinsic pluralism has no choice but to purport a paradoxical engagement with the world.

This is where Daichendt critically lends a hand. He boldly states that in his experience "many scholars with degrees outside visual arts are much more comfortable with arts-based research than artists. Artists whose primary study is the visual arts (MFA students) become frustrated by the history and application of social science research methods applied to their discipline. The methods often feel too far removed from their experience as working artists" (p. 53, this volume).

Like Daichendt, I have argued elsewhere that arts-research presents us with a huge quandary because it all too easily concedes that practice must be objectified so that art could fit a method. The fetish of a "valid" methodology is very much bound by academic legitimacy—more specifically by a results-led mania that now drives almost every model of academic funding. So it is hardly surprising to explain why the arts seem to have found in social scientific methods the nearest possible model to satisfy this agenda. While one cannot blame arts institutions for trying to get hold of funds and for gaining academic legitimacy within a system that remains at best alien and at worst diametrically opposed to what the arts stand for, the original proviso for this initial compromise seems to have been totally forgotten.

My problem with the gradual integration of arts research into social scientific models is both artistically moved as well as politically articulated. While indeed there is nothing inappropriate with developing methods and articulating art-based methodologies per se, to force art and design practices within a social scientific matrix that remains fundamentally alien and ultimately adverse to arts-practice, carries great risks. The first risk is that of alienation through essentialism, where as Daichendt amply shows in this book, practices are reduced to methodological categories that may be identifiable to the social-scientific *nomenclatura* of the academic funding bodies but which are radically distanced and ineluctably impervious to what takes place within the studio. This also exposes the arts to the even more serious risk of standardization and to the loss of the autonomy and immanence that characterize the arts in the first place (see Baldacchino, 2009a, pp. 6ff).

The onslaught of *knowledge* economies

The essentialist model that emerges from the social scientification of arts-based research is tied to a productivist model that tends to legitimise art and design institutions by dint of what they produce in terms of transferable knowledge, as embodied in the education (and more so *training*) of professionals within the now-called knowledge and creative industries. This approach finds strong foundations within the liberal and social democratic ethos that the modern art school continues to portend, especially in its claim to be the rightful heir of the Bauhaus. Ironically this could only reinforce the same conservative assumptions of art and design education that the Bauhaus set out to reject.

One possible justification—which must be contested in terms of art's formal, aesthetic and political autonomy—is that such a schooled environment gives art and design the ability to articulate any innovative approach that students may bring into the fray of the discipline. However, what this perceived ability really does is reinforce the same hegemonic condition by which a schooled environment successfully absorbs any pedagogical engagement that initially appears to be either critical or radical. This conforms to the notion of art's pedagogical engagement within that classic modernist assumption of constructivism that finds the ultimate analogy in Walter Gropius's idea of art as a totality, a *Gesamtkunstwerk* (see Baldacchino 2009b).

Without having to repeat the critique of educational constructivism and how this ultimately seals the fate of art by submitting it to the preordained universe of psychologistic dogma and the political accommodation of the *status quo*, one must also remember that contemporary art practice itself begs to supersede and radically critique such an imposition. Many art schools fail to see this as a sticking point. Instead a notable majority persists in rehashing old pedagogical recipes while gently dismissing the newer demands and ambitions that students bring to them. This strongly contrasts with the reality of contemporary art practice, which continues to be shaped by an array of practices and narratives that staunchly resist any notion of totality. To return to an idea of art as *Gesamtkunstwerk* is to yield to the pressures of the assumption that art must be absorbed into a wider scheme of events, which, benign though this may appear, would leave women and men with no way of transcending, resisting, or indeed critiquing the here and now.

In art institutions such forms of radical critique are obfuscated by split loyalties, where on the one hand the artist feels free enough to operate within an academic setting (often because such settings tend to pose as being "chaotic" and appear to be unstructured), but where in effect, this staged "freedom" is wholly schooled by a pedagogical narrative that, like its research-based counterpart, ignores the case for art's specialty and the plurality of art's autonomous place in the world.

The political fallout from this state of affairs should be clear enough for many to become deeply uncomfortable. It reinforces the articulation of an epistemological

foundationalism that proudly pronounces art as a "form of knowledge", and therefore as an *epistemé* that portends knowledge as a quantifiable and identifiable state of affairs. This is reinforced by the inauguration of a "new" way of knowing where the arts are subscribed to the so-called "knowledge economy" which, we are told, now represents the nadir of creativity and innovation. This seems far too rational to disclaim, especially when arts-research itself has become so keen to have a slice of the academic pie by reducing its *raison d'être* to sound-bites of "creativity" and "innovation" where in actual fact there is neither room for paradox, let alone for the practice of difference and aporia.

This epistemological casting of art within the apparent solutions of the creative, cultural and knowledge industries, remains alien to an idea of knowledge in art where knowing is a predisposition of action, and action as that of being. The newfound foundationalism by which the arts are cast as "useful" and therefore purchasable on the market, constitutes a further distancing of the arts from the oft forgotten notion of knowledge as *gnosis*—a term that gave us "gnoseology", where knowledge is understood from Giambattista Vico's radical repositioning of knowledge as a doing, and where doing is an act of being. An accessible way into Vico's notion of knowledge is to say that what we do (or make) is what we know. And just as we cannot know God because we have not made him or her, God knows us because he or she *made* us (Vico 1984). Here making is not a fetish of process (as used in art-education speak). As a term, "making" should be read within the context of "intelligence" as an act that comes in between the acts of *legere*, which denotes the idea of gathering, choosing and picking; in other words, a bringing together of *facts*. As the word "fact" itself has become a shibboleth of social scientific methods, we must not forget that fact (as *factum*) denotes a perpetual act of doing. All this belongs to the understanding, or indeed gathering, of the facts of being, as a consequence of what we do and make, and therefore know.

Contrary to Vico's gnoseological conception, the epistemological narratives that are now favoured by academic accountability belong to a processing of an act of knowing that represents one's apprehension of a reified body of facts and acts that must be seen to be measured, because like any other body of knowledge, the arts must be ultimately distributed and consumed.

Reclaiming a horizon

As Daichendt unpicks the various aspects of art research, practice, pedagogy, and all that comes with the plurality of art's objects, one realizes that here we are dealing with an extremely complex set of questions. To reject the situation outright would lead to nothing. To compromise with a situation blindly and accept the received wisdom of the politics of academic legitimacy will equally consolidate the gradual distortion

and standardization of art into a "scholarship" that bears no resemblance to art's plural reality.

Instinctively one could suggest that questions revolve around familiar situations. Yet as Daichendt rightly puts it, "good questions imply that you do not know the answer" (p. 90) and this is where the task of writing about and engaging with art's ever-expanding questions requires that we reject the customarily expected assumptions of a fixed and well-articulated *ground* on which we base a series of presumed answers.

An academic setup that is founded on the functionalist qualities of a "service" industry that commodifies knowledge and creativity, and which expects the arts academy to provide such a service, could never accept or understand why is it that the pedagogical contexts of art refuse to offer a quantifiable answer. A service-oriented educational setup may efficiently put together a high degree of sophistication in terms of new procedural preparations and the development of top-notch pedagogical facilities. However such facilities cannot be expected to yield a specific answer to art's questions.

This is because any semblance of an answer in art must per force emerge on a horizon that holds no promise of certainty. Any "answer" that one could conjure from a line of questioning that interrogates art's ambiguous objects comes in the form of further questions. We might know *some* answers, but these only confirm that we live with the idea of an answer that never arrives at a specific destination and never seeks a last word or definition. The reason for this is simple: there could never be one answer to art's questions because to talk of art's questions is to assume that no one question could ever be the same. Art's questions never presume an answer. Art's question stands as *tale quale, tel quel… as is*.

While artists cannot vouch for other subjects or actions—and I would argue that rather than a subject to be *learnt* art is an action to be had—they would rightly insist that in any assumption about art (especially those coming from socialized, standardized or developmental views of education) the big obstacle would remain that of a foundational grounding. In the educational sciences this grounding has been characterized by preordained notions, such as that of *Bildung* in certain philosophical traditions, or *cognition* in the developmental habits of educational psychologism, or *agency* and *function* in the social sciences. Art educators have incessantly insisted on applying these "formative" claims to art. This reduced art education to a limited set of definitions of learning that claim to secure a platform of empirical and experiential explanations over which the questions of art are supposedly "answered". In other words, art educationalists often forget that art's questions never presume an answer.

To assume such a ground of application and explanation is hugely problematic because it proscribes art's open-endedness and paradox. In this respect the hermeneutic usage of the term "horizon" allows us to somehow imagine a way of doing art away from art education's answers; and instead to operate within an agôn that begins to

accommodate and reject, deconstruct and reassemble art's questions as an infinite horizon of diverse acts of autonomy. Yet as we do so we must also heed to Daichendt's warning that in art there is a limit to what one can do with words. As he explains clearly and convincingly, words remain insufficient to the artist scholar. I would say in Daichendt's favour that his warning must also apply to the word "horizon" and the linguistic implications that often overwhelm any hermeneutic argument.

Perhaps this is where one reaches a compromise, where one would suggest that the artist scholar takes the role of the jealous custodian of a freedom that calls for its own liberation from the defined boundaries of freedom itself. As Emerson puts it: "Free should the scholar be, — free and brave. Free even to the definition of freedom, 'without any hindrance that does not arise out of his own constitution'" (Emerson, 1990b, p. 47).

References

Baldacchino, J. (2009a). Opening the picture: On the political responsibility of arts-based research: A review essay. *International Journal of Education & the Arts*. 10 (Review 3). Retrieved September 7, 2011 from http://www.ijea.org/v10r3/.

Baldacchino, J. (2009b). What lies beyond the Bauhaus? The political 'logics' of college art pedagogy. *Australia Art Education*, 32(1).

Dewey, J. (1966). *Democracy and Education: An introduction to the philosophy of education*. New York: The Free Press.

Emerson, R.W. (1990a). Circles. In *Ralph Waldo Emerson. A critical edition of the major works*. R. Poirer (ed). New York: Oxford University Press.

Emerson, R.W. (1990b). The American Scholar. In *Ralph Waldo Emerson. A critical edition of the major works*. R. Poirer (ed). New York: Oxford University Press.

Greene, M. (1988). *The dialectic of freedom*. New York: Teachers College Press.

Lukács, G. (1971). *Prolegomeni a un'Estetica Marxista, Sulla categoria della particolarità*. Rome: Editori Riuniti.

Lukács, G. (1974). *Conversations with Lukács*. Pinkus, Theo (ed.), D. Fernbach (trans.). London: Merlin Press.

Lyotard, J.F. (1989). Lessons in paganism. In *The Lyotard Reader*. Benjamin, A. (ed.). Oxford: Blackwell.

Merleau-Ponty, M. (1989). *Phenomenology of perception*. Trans. C. Smith. London: Routledge.

Vico, G. (1984). *The new science of Giambattista Vico*. M.H. Fisch and T.G. Bergin (trans.). New York: Cornell University Press.

INTRODUCTION

Artist Scholar is part history, introduction, and discussion for artists and designers entering, graduating, and employed by the contemporary art academy in the United States. Otherwise known as the university—this haven for artistic expression and exploration has become the cultural hub for art education in the U.S. Despite the rousing success of art education in the university, there continues to be expectations brought on by this context that artists and designers are still unsure how to engage. The Ph.D. in visual art has blossomed overseas and the expectations that accompany this endeavor have changed the landscape and language of graduate study of art and the university's employment of artists. The evolution of art education in the university continues as the variables of craft, skill, technique, theory, history, and criticism shift and expand as it welcomes the perspective of arts-based research.

Several questions guided this manuscript including why is art education the responsibility of the university system? And given the increased demands of research and the Ph.D. in visual arts—what can Master of Fine Arts (M.F.A.) students do to improve their understanding of writing and research without sacrificing their commitment to their studio art process? And finally what might research directed at improving the studio process for the artist scholar look like?

As talk of research begins, so does the inevitable expectation of what is gained from such work. An important aspect of graduate research and of faculty members is the contribution of new knowledge through the research process. This language is applied at top universities overseas and has now made its way to graduate students studying everywhere. For better or worse, artists in the United States apply the language of research to their day-to-day activities without a consistent theoretical and methodological underpinning. Artists refer to their work as research because it is part of the cultural landscape but they often struggle to articulate why it is research and how it contributes to the broader knowledge pool.

This is a great area of concern for me as an artist, professor, and historian. Many of my fellow art professors have adopted the language of research when talking about their work in the studio. From a certain perspective, artists as researchers make sense,

1

especially given the context of the university and the critical thinking that happens in the studio. Artists are apt at utilizing language and can articulate much of the research they do to prepare and complete works of art. However, substituting research for studio processes has become a common trend but perhaps not the best application of it.

I feel dreadfully uncomfortable with the use of research (in certain circumstances) in the artist's vocabulary given my background in social science research. The two can be very different and the use of research makes me feel that the term is used without much thought. I cannot help but notice the difference between the writing, reading, and pre-art making procedures that go into completing a work of art and the research involved in conducting a doctoral level study. The expectations and procedures for conducting such a report are much more systematic and clothed in scientific theories. The methods are well thought out and referenced and they are often repeatable, transferable, and applicable to a larger pool of researchers or practitioners. In the studio, the ideas are thought out but they do not require the same level of organizational structure (they can be but they do not in many M.F.A. artist studios) nor are the results in anyway comparable or transferable. This is not a jab at artists. Instead I believe this is a strength of the artist. The studio and artistic process are a unique aspect of thinking that has rich implications for artists, the research community, and the public at large. While art may not fit nicely into a research paradigm – it does not discredit it from being a research tool. In fact, it would be very difficult to perform any artistic practice without conducting research. Perhaps it is our narrow use of the term "research" and what it means to students and faculty that is a larger concern? Applying the language of research to the artistic process is understandable given the historic development in teaching art and the context of the university.

In fact, upon the first draft of this manuscript, I attempted to manipulate the social science paradigms to fit the purpose of writing projects typically assigned in M.F.A. programs. While such methods may be useful and currently employed by arts researchers, it became apparent to me that writing and reflecting were the essential qualities I desired to see facilitated in M.F.A. programs and not the strict application of methods from other disciplines. Can they? Yes. Should they? This is debatable. The M.F.A. degree has a clear purpose to educate the twenty-first-century artist. This text only seeks to strengthen that concept while also creating more appropriate links to traditional writing projects that are expected in higher education. In many instances a well-written essay or history can tell us much more about a complex idea than a formal research study. Thus literature-reviews, histories, essays, and word studies may be just as valuable to the artist scholar as a case study or a traditional research paper. However, the pendulum can swing too far in the other direction. Too often, I have seen arts-based research presentations and wondered where is the art? The methods and findings are very interesting but the artist is often lost beneath the layers of theory or the concept of navel gazing comes to mind.

The process of professionalization in the university is also a major issue discussed. Current developments have wedded research to art departments and a break is required to discuss what exactly artists hope to do in their education. Art can be a research tool and method for collecting data but it is not the only avenue. I utilize a reflective research paradigm, a basic framework for what is generally considered research, along with a host of writing strategies. My hope is that artists may be inspired by this work and be able to capitalize on the unique aspects of their studio process.

Overall the text argues for better writing at the M.F.A. level with the purpose of becoming better artists. Writing is a form of inquiry and one that will be particularly helpful for the artist scholar. My experience shows that artists in graduate school often substitute critical theory for critical thinking. This type of education may sound intelligent but it is a frustrating endeavor to improve your art making and thinking when students recycle ideas that are not their own. Using the artist's own work as raw data and then analyzing this data combined with many experiences of art making proves to be a significant opportunity to learn about artistic growth, knowledge production and how thought is processed in the studio.

There are a host of paradigms available to facilitate this reflection, and this book introduces a few to get the artist started. This language is important and there is still debate over the use of research and the activities artists engage in in the university. Before the book ends, I suggest that the term "scholarship" become a concept for all arts activities in the university. A term that I believe is much more inclusive of the diverse practices of artists in the university and addresses nagging issues that plague measuring and qualifying arts practice as research.

Art as a form of research and the concept of arts-based research are also reviewed and explored in this book and is presented as one type of inquiry that students can use. The process of writing is highlighted throughout because it is the essential and foundational proposition made that is necessary to provide a document but more importantly because of the thinking that happens when you write and the great benefits it has on art making. In addition the bibliographies at the conclusion of each section will help the aspiring researcher locate additional texts and sources.

The visual arts will continue to be an extended arm of social science research because arts practice is extremely malleable and can be manipulated for a variety of causes (as we see in artist Ph.D. programs). Artists certainly perform research but the problem lies in the contextual understanding of what research is and the expectations of research within the university setting.

This is not a text aimed to bring Ph.D. methods into the M.F.A. studio. It is rather a history and guide for artists to think deeply about their work and how they can improve upon it through critical writing. Graduate work in the arts implies an emphasis on language and reflective thought. This text emphasizes both aspects albeit in a much more systematic fashion that can be applied post studio.

By contextualizing art practice in the university and providing a foundation for future artist scholarship, I hope the text serves as an invitation to artist scholars to push their work further and develop the confidence to situate their art in the university context. The aim is not to condemn or propagate research but instead offer an alternative way (perhaps just a shift of perspective) of thinking about the work artists do and how to think deeply about it in the university and beyond.

1

ARTISTS AND SCHOLARSHIP

What does it mean to be a scholar in the visual arts? Artists are creative, important, needed, and critical voices in society—but are they scholars? In the following text I not only present a broad case for scholarship in the arts but also re-examine how we look at the arts in the academic context. Rather than understanding art as a cultural phenomenon and aesthetic product, I invite you to see art production as a type of inquiry, reflection, interpretation, commentary, and thinking process that has transformed the way we understand the world and ourselves. While this text was written for Master of Fine Arts (M.F.A.) students and faculty in the United States, it will also provoke the interest of anyone concerned with what the arts actually do. My overarching goal is to build upon the context of arts research by offering avenues of inquiry for artist scholars and provide examples that are meant to teach, inspire, and provoke thought about the many decisions that contribute toward a single work of art or series. Whether you are an artist, researcher, or art appreciator, I believe you will have a new understanding for how art is meaningful and transformative across a range of disciplines.

The status of visual art education in the United States is at an uneasy place in history. The adoption of art training and education by the nineteenth-century research universities is still a major point of contention (albeit a misunderstood one). Universities were not the original home of art education but these institutions have taken on this responsibility and are now the dominant source of art education opportunities for the aspiring artist. There are several lingering symptoms of this uncomfortable relationship between artists and the university. A major point of contention is the current terminal degree in visual art being a master's degree (M.F.A.) and not a Ph.D. (like other subject areas). In addition to the question of degree is the added expectation of artists to become researchers or to validate their studio work as a form of research. This is a frustrating endeavor that pushes art programs to become more like their neighbors (scientific disciplines) in the university. Artists worked for quite some time without

ever using the term "research" but it has become commonplace in Ph.D. programs and one has to wonder if this is a positive evolution of art education. As the Ph.D. in visual art looms closer and more desirable to administrators and organizational/credentialing institutions, these issues will become more important.

Artistic creation is a process that utilizes a variety of thinking processes, and the results of these practices are typically valued in our society but not consistently documented as a form of research outside small circles. In the twenty-first century, art is being compared to other types of research and is gaining ground as a prominent theory in the visual arts. Studio and practice-based Ph.D. programs promote art products as research, and there are several blended Ph.D. programs that promote writing and art production as research. In an ideal world many art professionals would like their art to stand for research. However, this is not the current reality. Instead a written paper is expected to accompany the work of art to justify, explain, or document aspects of research or thought. This is a paradigm that is not likely to change but how we write and for what purpose is open to debate.

The writing component is a valuable aspect of art education and in many ways the only form of research recognized by contemporary universities. This is evident in conference presentations in the United Kingdom where papers are distributed and honored but the artwork only makes a brief appearance to remind everyone that the presenter is an artist or that the subject is artistic. Even this publication is primarily words, a frustrating endeavor for the artist scholar who desires to improve his or her art and not necessarily their writing skills. However, the argument presented is that reflective writing works as self-critique and that thinking through words, however difficult it may be, will ultimately reward the artistic process and the art product.

The artist studio is a great example that represents the potential for research in the visual arts. There are many opportunities for inquiry and discovery in these spaces but we need the artist to make the connections. The artist is the catalyst that brings together the media and it is through the writing process that the artist scholar is able to connect the dots and reflect upon the artistic process.

The current language used to facilitate arts research is mature and is delivered quite convincingly, but one must wonder how much this research is aiding their goal to become a better artist? There is no need to reinvent the wheel, as there is much progress in this area outside the United States. A similar dilemma faced visual arts education at the beginning of the twentieth century as art educators within universities debated the significance and importance of manual/technical training/crafts-based training in relation to historical and theoretical studies in art history. While adding studio classes to the university curriculum seems passé, adding research expectation upon the artist's agenda is sometimes a big stretch. This may seem like old hat to our UK colleagues but some US institutions are frightened to adopt many of the commonalities in visual art Ph.D. programs overseas.

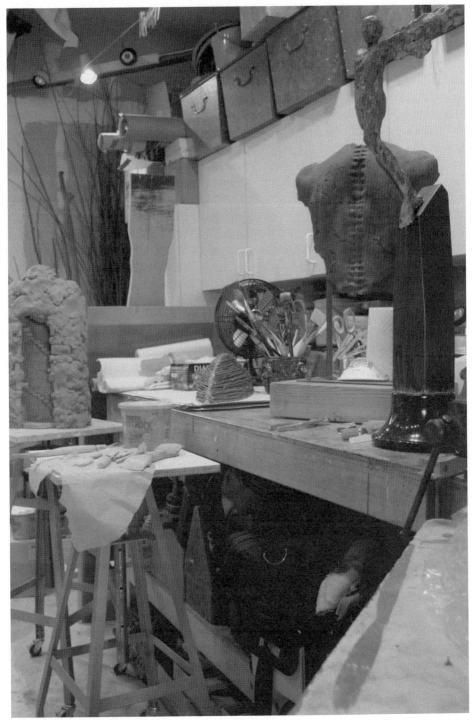

Figure 1. The studio of William Catling, 2011, Courtesy of the artist.

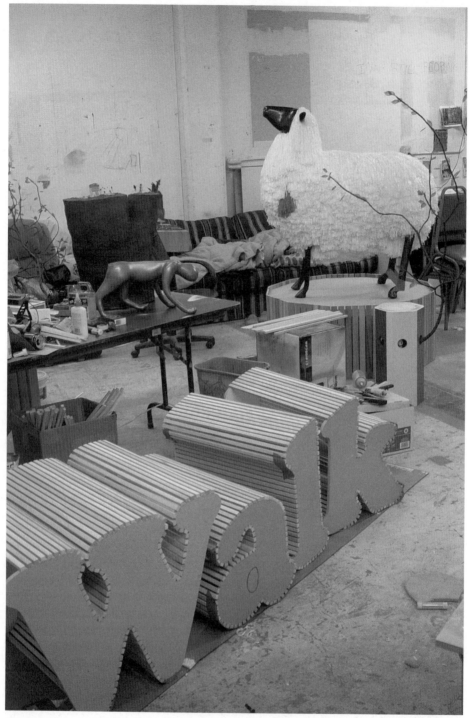

Figure 2. The studio of Macha Suzuki, 2010, Courtesy of the artist.

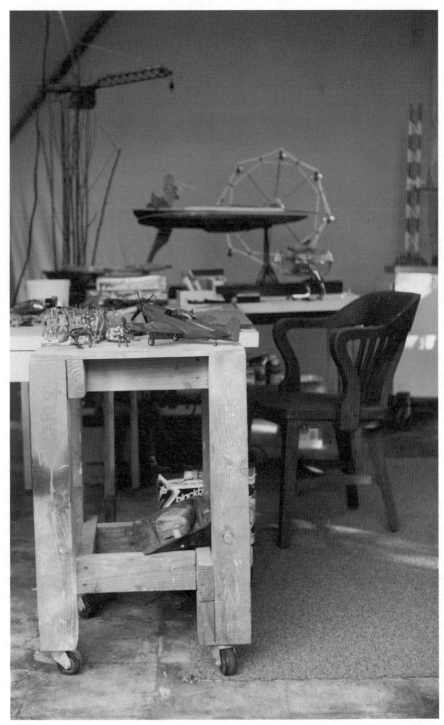

Figure 3. The studio of J. David Carlson, 2011, Photo by Kent Anderson Butler.

Figure 4. The studio of Amy Day, 2011 Photo by G. James Daichendt.

There are many similarities between art making and research to consider. Study, experimentation, and exploration are fundamental both to research and art making. Also, art products are vital to understanding and representing our collective history. Much of our understanding of ancient civilizations comes through art products of past societies because these creations reveal valuable information about technologies, cultures, and societies. In the modern and contemporary eras, artists have altered the way we think about issues that range from pornography to symbolism. In addition, artists also study and document methods in order to further their craft. A great deal of writing was collected and preserved by artists during the Renaissance to build a conceptual foundation and theory of art making. These activities certainly draw similarities to research and display a significant knowledge base in the visual arts. In fact many would call this research or go so far as to say that everything an artist does prior to making the work is research or that the act of making is itself research. This is a very broad application of the term but not necessarily an inaccurate one in describing the artistic process.

Much has changed since the nineteenth century and the arts appear to be quite comfortable in the university as more and more institutions offer art degrees (and specialties). Contemporary artists explore and experiment with an ever-expanding list of materials and technologies to push the limits of what is considered media and appropriate subject mater for art making. But is this research? This is a question every art program and artist in the university should address. The following discussion is an introduction to this issue and can facilitate further dialogue.

Basic language on research and the arts

Research is generally understood as a type of investigation. It is a process involving the collection of information and eventual discovery of new or revised knowledge. Using this definition, research is a search for knowledge. It involves asking questions, discovering, interpreting, and organizing data. A description that sounds a lot like art making.

Any process involving a search for knowledge could be defined as research but we typically think of the scientific method when the term "research" is used. The scientific method is a set of techniques that are used in relation to the collection of observable and measurable evidence. This theory is used to explain the world. It typically involves a problem, a hypothesis, a procedure to test the hypothesis, and the results. This is considered an inductive method. Through observations we formulate theories and laws about nature.

In comparison, the deductive method starts with true statements and leads to a conclusion based upon reasoning. Much like a detective story, a deductive research study would start with a general theory and work toward a specific conclusion. The methods mentioned may be part of artistic inquiry but they do not necessarily slide off the tongue of artists and designers.

In much the same way, the media for artists can be subtitled with data for researchers. Two different types of data that are often used in social science studies are qualitative and quantitative. Quantitative refers to information that can be communicated through numbers and statistics while qualitative explores phenomenon through text and visual imagery. Quantitative research involves systematic investigations that can be counted like how often people perform a particular task. Qualitative is more concerned with human behavior and the reason people do things. The two are very different, yet quantitative studies are typically based upon qualitative judgments and qualitative studies can be represented quantitatively.

Common methods of collecting data in qualitative research involve interviews, observations, and examining documents. This is compared to quantitative research that utilizes the scientific method and consists of collecting empirical data. Histories,

qualitative and quantitative research methods are not foreign to the artist. However, the analysis, documentation, and display are the main barriers that separate the artist from the traditional researcher. It is much more difficult to read a painting or installation compared to a status report or a concluding paragraph. The nonlinear characteristics of art products do not lend it to communicate in a predictable fashion. This is a great frustration for those in other disciplines when they are asked to equate art production to research in fields like history or science. Recognizing the contribution of artists in the academy is one of the biggest barriers artist scholars wrestle with in their professional work. In fact many question whether it is worth it, even when clothed in the proper language. Artists refer to their work as research but when asked about their data, they often provide a list of secondary sources, texts from a number of disciplines, and a host of artists and concepts. It is often a jumble of influences that may vary widely and may not make much sense to the outsider.

Figure 5. *The Road to Damascus*, Tony Caltabiano, 2006, Photo mixed media, Courtesy of the artist.

Figure 6. *Submergence*, Kent Anderson Butler, 2009, Video still, Courtesy of the artist.

There are three types of research that are relevant for the artist. Pure, original, and secondary research: each has a different perspective related to knowledge and process used to achieve understanding. Pure research is where the researcher desires to learn something by studying the subject. A pure research study does not necessarily have a directed plan. In comparison, individuals who are looking for information that no one has discovered perform original research. The third type, secondary research involves discussing and comparing viewpoints and findings from other studies and results in a clearer understanding of the material or possibly new insights. All three are valid types of research and artists could likely fall into any category. Recognizing what you are doing as the artist though is quite valuable for realizing the kind of knowledge you produce.

What kind of research do you perform through your artistic practice?

> Pure research
> Original research
> Secondary research

Much of my argument for arts research is more akin to understanding and inquiry rather than research in the formal sense. Artists understand their subjects of study because they ponder, rethink, and challenge traditional methods of thinking. This challenge is often where the genius is in art making and where new insight or knowledge is gained. This is why the diverse data sources (publications to television) mentioned earlier work so well in the artist studio. The sketches and jumbled thinking can be rough but the artist is working toward an understanding that grows each day (pure research). Even the Sunday painter is rethinking the landscape as the strokes of watercolor reorganize what is actually there on the horizon (secondary research). Understanding is renewed as the composition is reworked with every edit. This knowledge develops in small bits or large leaps as the artistic process continues and potentially never ends. It is an ongoing phenomenon, as the artist grows more insightful and aware as their practice continues. There may never be an endpoint and that is acceptable because we can never fully understand any one thing, but this is why the artist and designer continue to work. I think this concept of a continuous understanding and development of knowledge is comparable to driving across the country. The more roads, towns, and states you explore, the better understanding you will have of the country and its residents. Have you learned something? Yes— does it alter the way you think about space, people, distance, etc.? Yes, of course. A new understanding is developed and a new knowledge of the country can be applied after these experiences, and the driver is apt to contribute to such a knowledge pool. The knowledge or understanding that breaks through the surface in artistic inquiry is often disruptive to knowledge systems and has the potential to change the way something is understood. Much like the new understanding of the country gathered from traveling, artists provide new insights on topics that span all types of knowledge.

As a result of this inquiry or studio process, artists are able to discuss, debate, and perform with a much more critical voice in community as they understand and approach the subject from a new perspective. This is one of the valuable roles artists have in society. They aid our understanding of philosophy and gardening alike because they engage in a wide variety of subjects outside the visual arts. Artists may not always create embodied knowledge in the scientific sense but art and artistic processes are evidence of thinking made visible and there is much an artist can do to identify this production of thought made visible.

Figure 7. *California Landscape I*, G. James Daichendt, 2010, Acrylic on canvas.

Figure 8. *California Landscape II*, G. James Daichendt, 2010, Acrylic on canvas.

Another example of how artists contribute and provoke inquiry and understanding is to look at a particular topic or genre of art. What is considered shocking has been a popular concept since the inception of art. Whether it was Greek humor, Michelangelo's wry personality, or Damien Hirst's various critters encased in formaldehyde, artists have explored methods to shock and surprise their public. Do artists generate new knowledge from creating shocking art? Yes—contributing toward our understanding of a topic certainly is an aspect of knowledge. The artist explores shocking ideas and imagery to stretch what is already known. The successful shock artist understands the context and pushes what is acceptable. This is a visual commentary or inquiry that jolts the audience from a metaphorical slumber to engage an issue.

Universities and arts research

Research as it applies to art making is constantly at the forefront of universities offering advanced degrees in visual arts and among the faculty who work within these institutions. Artists outside the university, from my experience, do not regard their work as research but most would be quick to agree that art products and processes are the result of thoughtful dialogue, deep thinking and that there is value in their products. If artists did not believe this, they would not create. The faculty in many university art departments label their art as research and justify this vocabulary because of their context. This language is equally important amongst students who pick up the terminology from their professors. There is status involved in such language, as status is not only confined to wealth but is, in this instance, an intellectual status that positions the artist in the thick of university politics.

Art making existed as a skill and craft for thousands of years before university art teachers became the elected experts in the field of art. Art was the product of stonemasons and craftsmen in the classical era, the guilds in the medieval era, and finally the art academy from the Renaissance until the nineteenth century. It was not until the nineteenth century that art education and the university aligned forces. In the twenty-first century, the university system is the accepted home of art education, and this relationship infers that art practice is a scholarly discipline. This history of art education within the university is relatively short so it should not come as a surprise that the artist is sometimes misunderstood. The stereotypical artist is rooted in emotion and is heralded as providing a subjective view of the world. Dismissed as inconsequential and unnecessary, artists and designers are often categorized as creators of personal expression and in the worst light reduced to mere provocateurs. Despite these accusations, art education was adopted and continues to be a major aspect of the university.

As degree-granting institutions, universities are concerned that graduates in the arts can compete, engage, and contribute toward the art field in and out of

the university environment. Part of competing inside the university involves the completion of a major research paper in conjunction with an exhibition that is often a capstone for graduate studies in the arts. This process is justified because performing research allows students to gain an appreciation for knowledge and to demonstrate their ability to evaluate and be an intelligent and critical consumer of information. The justifications are logical but the methods for accomplishing this feat vary widely. In my view, art scholarship at its very best should hone independent thinking and creativity because it is the core of what artists do. However, poor attempts to mask writing as scholarship has led to frustration in many artists who are asked to explain their art or process in writing. This is a request that is unfair, frustrating, and virtually impossible—as these are artists, not writers. Interestingly, the artist that practices research is adept at speaking about their work in depth and contextualizing it in the larger academic and art world. One only has to glance through journals that publish arts research like *Art & Research: A Journal of Ideas, Contexts and Methods*; *Point: Art and Research Journal*; *Visual Inquiry: Learning and Teaching Art*; or the *Journal for Artistic Research* to uncover a wealth of artists who walk this line.

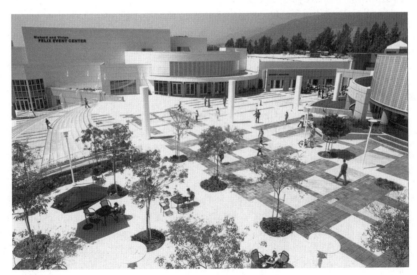

Figure 9. Azusa Pacific University in southern California, Courtesy of Azusa Pacific Unversity.

Playing the cello in a marching band

According to Sullivan (2005), "The critical and creative investigations that occur in studios, galleries, on the Internet, in community spaces, and in other places where artists work, are forms of research grounded in art practice" (p. xi). Sullivan values what artists do and seeks to exploit these features of inquiry for the field of art and art education. Artistic practice, according to Sullivan, contributes new ways of thinking about things and is an important method of research. The act of research is traditionally related to creating new types of knowledge and Sullivan clearly feels art making fits this paradigm. Understanding is a key term for Sullivan and he equates this with new knowledge and feels this comes about through artistic inquiry. This understanding is artistic knowing—a process that helps artists explore the world, themselves, and phenomena.

The most notable objection to using research in relation to art production comes from the historian James Elkins (2009). Elkins bases much of his argument upon the pitfalls of chasing funding sources and the motivation to use research terminology to gain this support. Additionally Elkins feels the term "research" does not adequately identify graduate work in the visual arts and feels research is used as a validation for art production and that there are likely better concepts to use in the work of artist scholars. He posits that much of the thinking in the studio is "outside conceptualization: it is nonverbal, uncognized, tacit, extra-linguistic, nonconceptual" (p. 119). I am sympathetic toward Elkins' position; the funding issues and lack of an adequate vocabulary are great frustrations. To imagine that arts research happens in a vacuum is ridiculous and art programs that take their role in the university seriously must address these issues.

Despite Elkins' objections, the term "research" is beneficial in many ways—this is apparent by the use of the term in arts literature and the field it has inspired (Cahnmann-Taylor & Siegesmund, 2008; Garner, 2008; Gillham & McGilp, 2007; Macleod & Holdridge, 2006; McNiff, 1988; Sullivan, 2005). These texts differ in approach but they demonstrate the interest and continued exploration of arts-based methods in fields like art therapy, art education, and the visual arts. Arts research is a practical concept when validating the purpose of graduate study in the arts, posturing for support from administrators, and applying for funding—the terms "research" and "knowledge" are also likely to garner support because they have an intellectual heritage within the university that administrators understand and respect. It will be difficult to ignore the term "research" but I am inclined to agree with Elkins that a more robust and complicated set of terms is needed to adequately capture the multidimensional characteristics of arts practice imbedded within the research context. The arts are not like other research methods and this is a difference to be embraced.

The artist's role within academia typifies many of the stereotypical ideas we have of artists and how they do not seem to fit within the confines of research and scholarship. Artists are criticized for not being academic enough by their peers and are burdened by a practice that can seem nonsensical (Eisner, 1989). Whether through sincere experimentation or outright irrational motivations, art processes and products have the potential to be frustratingly useless or harmful. However, there is great potential in art making but it can be difficult to recognize.

The odd combination of the artist-researcher reminds me of Woody Allen in his 1969 movie *Take the Money and Run*. Allen plays a young man who takes his love of playing the cello to the local marching band. The confines or characteristics of playing the cello (sitting down in a chair) wreak havoc as Allen attempts to drag his chair in this new context of the marching band. He runs with the chair, sets it down for a few seconds, and attempts to play the cello only to pick up the chair and run a few more paces. Flustered, Allen's character attempts to use an instrument outside the context it is designed to inhabit. Art making in the research context feels a bit like this example as artists fundamentally change their process in order to accommodate the institutional expectations aligned with research. But the arts are more open to change than Allen's character. Writing and research can be used pragmatically to improve art making and they are not quite the contrasting disciplines of marching band and cello.

The process of critiquing art is illustrative of this hard-to-see quality of the artist in the university. The unusual methods used in the critique processes are very different from a standard classroom and can be outright rejected if one does not consider the rewards gained through these experiences. Critiques are opportunities for student-artists to display their work in front of their peers/class and instructor(s). Through a learning process that can last minutes or hours, the group holistically attempts to define, interpret, offer advice, reflect, and experience the work(s) in question. The process is never repeated the same way and to the casual observer it may look like an informal discussion or complete chaos. In fact, many of these objectives do not come about and the artist in question and the participants can fall into arguments, tangents, and total nonsense. Critique is a good representation of the artistic practice and how we understand artists. A former student of mine conducted an informal study of her peers and their understanding of critique in their own education. What she found surprised her. As a student, she thought critique could be quite harmful and frustrating and was expecting a mixed or negative reaction. However, every one of her participants praised the process of critique. It was not perfect and there were plenty of failed critiques, but they all found the process immensely helpful to their identity as artists. Despite the ridiculous nature of critique, students feel it is essential to their education and who they are as artists. In fact, many artists feel this discussion must continue after university so they can reflect on their growth as an artist.

Critique is much like data collection, where the participants produce information that the artist-researcher must collect and analyze to form an interpretation of the art in question. Writing and research about the artistic process can function in many of the same ways critiquing is valuable. Recognizing this process as a way to combat the nonverbal or tacit criticism of artistic knowledge is a good start for students and faculty.

Although critique may be a disordered business, it is informative and educationally rich. The process creates new knowledge for the student-artist to consider. Student-artists as a result, are able to refine ideas or redirect resources to improve their work. This dualism in the critiquing process represents the unusual role artists have in academia, nonsensical and meaningful at the same time; it is no wonder artistic scholarship, like teaching, is misunderstood by university peers. Artists who do not quite recognize the valuable nature of their inquiry can even misunderstand it.

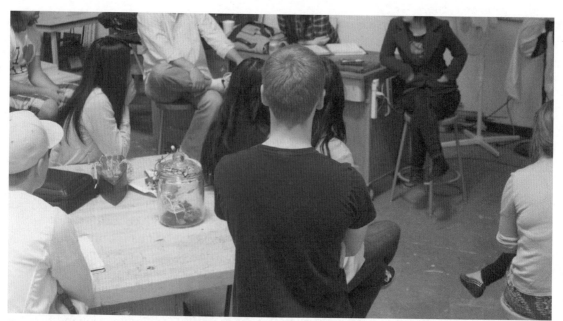

Figure 10. Students participating in a group critique, Photo by G. James Daichendt.

Artistic scholarship

Since the visual arts have become a mainstay in the academic setting, artists have become adept at justifying their place among a sea of academic discourse. This means demonstrating how visual arts practice equates to research performance in other disciplines. However, the contributions of artists are nearly impossible to calculate as compared to a research paper or book project in other disciplines. An art exhibition contributes to culture but it would be irresponsible to say it equals the impact of a published paper. But this is exactly what colleges and universities are attempting to do through performance reviews and tenure expectations. Writing appears to be the common denominator to understand the implications of art practice. I do not necessarily believe that all artists need to write (I recommend it) but the medium of text in this project allows a greater audience to explore the implications of artist scholarship.

The contemporary artist in the university is encountering a range of issues: terminal degree questions, writing requirements, and debatable terminology. The differences are part of the malleability of art to fit in multiple contexts. In this vein, I propose the term "scholarship" to encompass all the aspects of artistic practice in the university. Rather than choose one category over another—for the purpose of this text, scholarship is used throughout to describe the rich variety of artistic practices.

Scholarship is thus a descriptor for the inquiry, reflection, interpretation and thinking processes that artists engage in their disciplines. Scholarship has a history within academia and can represent more than just research (includes study, learning, service, writing, teaching, art making, lecturing, awards, etc.) but can also be inclusive of the term "research". Also, artists are capable of performing research even if it is not through their work but rather about their work or another subject.

Scholarship as a term can address a particular field like the arts but is not exclusive to other fields. It is used within the university as a broad descriptor of work (learning) accomplished, which includes research, presentations, teaching, writing, lab work, sharing expertise, etc. The inclusive characteristics of the term could be a valuable descriptor and concept for artists in the university. Artists working independently can also be thought to contribute intentionally and unintentionally to areas of scholarship. There are plenty of think tanks, governments, museums, private institutions, freelance scholars, medical organizations, and marketing firms that perform acts of scholarship and contribute toward our understanding of a host of issues outside the university atmosphere, and independent artists can be said to work in a similar vein. Their work is held to varying standards but that is consistent across the board and is applicable to artists as well.

The artist outside the university is not necessarily concerned with the previous discussion regarding research. This is sometimes the role of the gallery or museum. The

art gallery produces promotional materials like catalogs, flyers, and press releases that are picked up by newspapers, journals, and magazines that discuss the subject matter or the conceptual agenda of the artist. The larger art field performs the educational process akin to the critique. However, rather than a classroom of students, it is gallery owners, critics, artists, and the general art public who discuss the merits of the work over coffee, on television, in the press, or online. A critical decision is not made but an ongoing conversation is started that hopefully helps us better understand the work on display.

This discussion initiated by museums and galleries validates the work of artists and their relation to bodies of knowledge. We associate certain artists with consumer culture, recycled materials, or a particular region because of these discussions. In situations like these, if the comparison or justification is independent of the artist—how does this relate to art practice as a form of scholarship? Art in this manner is not research. Is it? The artist performed inquiry and ruptured conventions or provoked new thoughts and directions from the audience. The process that follows the exhibition is one that can be deep or shallow depending upon the art and the viewers. Art provokes thought and therefore understanding. It is a form of scholarship inside or outside the university—regardless of who is conducting the analysis.

Independent artists sometimes have much more to overcome because the university offers legitimacy and validation. Artists within the university represent quality and respect because of the institutional affiliation. However, artists in the university also share a much larger burden than independent artists because of the contribution they are expected to make to knowledge or the field. These expectations do not exist outside the university. If scholarship is conducted outside the university, museums or galleries often lead this initiative. This is a much different type of research because a unique aspect of artistic scholarship in the university is that the same person who produced the data also conducts analysis. The insider status of the artist as data producer and the instrument of analysis is also common amongst qualitative researchers.

⟶▶◉ ◉◀⟵

The term "scholarship" embraces a broad understanding of research. It also can represent a variety of methods in arts research and arts production. Scholarship has an intellectual connection to the university and has the flexibility to encompass more than knowledge production. However, research will continue to be used as a specific objective in art education for art practice and to identify the expectations regarding arts scholarship and the indoctrination the arts have undergone in their entry to the university setting. The artist in the university is a fairly recent phenomenon that involves the field of art becoming professionalized by the university system.

Without this change, art education would be the sole responsibility of art schools and academies. The impact of the university cannot be underestimated, because we would not entertain ideas of artist scholarship without the university's presence.

This is not to say that arts scholarship is more or less robust than other areas of study—it is just different, and arts scholarship is a more inclusive set of terms to describe the work of faculty and students conducting this type of work. What can be taken from this progression and debate are a set of tools and theory for reflecting on art in a more productive way that the university will recognize and that will also serve Ph.D. studies if the artist chooses to progress in this manner.

References

Cahnmann-Taylor, M., & Siegesmund, R. (Eds). (2008). *Arts-based research in education: Foundations for practice*. New York: Routledge.

Eisner, E. (1989). The polite place of the arts in American higher education. *Liberal Education, 75*(1), pp. 3–7.

Elkins, J. (Ed.). (2009). *Artists with PhDs: On the new doctoral degree in studio art*. New York: New Academia Press.

Garner, S. (2008). *Writing on drawing: Essays on drawing practice and research*. Bristol: Intellect.

Gillham, B., & McGilp, H. (2007). Recording the creative process: An empirical basis for practice-integrated research in the arts. *International Journal of Art and Design Education, 26*(2), pp. 177–84.

Macleod, K., & Holdridge, L. (Eds). (2006). *Thinking through art: Reflections on art as research*. New York: Routledge.

McNiff, S. (1988). *Arts-based research*. London: Jessica Kingsley Publishers.

Sullivan, G. (2005). *Art practice as research: Inquiry in the visual arts*. Thousand Oaks: Sage.

2

The Professionalization of the Visual Arts

A history of art education

Where we are going requires some reframing from where we have been. This chapter presents a revisionist view of twenty-first-century art education as a professionalized discipline that values the intellectual and philosophical over the craft and technical origins of art education. A theme that is generally recognized but often misrepresented, a patchwork of influences has contributed toward this conceptual and intellectual emphasis in the university and the subsequent expectations for artists who write and research in a professional manner. This is not an objective history as there is no one history of anything (Hamblen, 1984). Thus the perspective presented is a slice of university art education. Four justifications for historical work like this include initiation of persons into the field, creating a sense of belonging, clarifying ideas, and that knowledge of the past feeds our consciousness to formulate new questions about current and future practice (Erickson, 1979). The chapter thus sets a context for the Master of Fine Arts (M.F.A.) students entering the field and clarifies concepts for faculty to facilitate writing and research in M.F.A. programs.

The foundation of university art departments and the art major

The prominent art critic Jerry Saltz calls professionalism the enemy of the arts (Saltz, 2003, p. 68). While the opinionated critic is specifically referring to the gap between where art is made (cramped studios) and where it is exhibited (corporate-like white boxes, mansions, and museums). The tension of being a professional while not being a professional is an odd balance maintained by faculty in university art departments. Saltz continues to blame art colleges for much of the bad art that is produced nowadays. He cites British art critic Matthew Collings' words that British

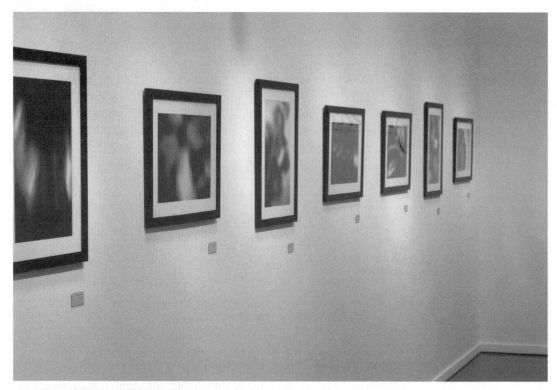

Figure 11. White Box Art Gallery, Photo by G. James Daichendt.

art schools are "Hollow, vacuous, and repetitive places where the same nonsense gets spoken again and again" (Saltz, 2003, p. 69). More recently Saltz (2010) blames much of the bad art created in California over the past few generations on influential artist-teacher John Baldessari. Saltz (2010) writes that he created "A hackneyed academy of smarty-pants work that addresses the same issues in the same ways." While one can write Saltz off as a flamboyant and outspoken critic, his views are telling of university art departments repeating the same lessons time and time again. Perhaps it was a necessary condition that allowed art departments to grow in popularity yet professionalized them at the same time.

Professionalization is a very real dilemma and one that protects and hinders art education. Contextualizing the expectations of the university environment is very useful for going forward and understanding the relationship of the arts in the

academy. The field of art developed from a craft discipline in the Middles Ages to an intellectual discipline during the course of the Renaissance. While this history is common knowledge, it is an important transition that influences the way peers in the university view the fields of art and design. The process is important to reflect upon because the arts were once a labor trade and certainly not part of the professional disciplines suited for study in the university. Craft guilds and family workshops were the appropriate home for teaching and learning art for hundreds of years before the emergence of the art academy during the Renaissance. Art making was a learned discipline during the Classical and Medieval eras and the responsibilities of a sculptor was equated to the role of a stone mason. It was not until the Renaissance that the roles of artists and the intellectual atmosphere of the art profession changed. The art academies in Italy and France facilitated art to become an intellectual discipline where the mind became an invaluable tool for the artist. Courses of study along with a robust set of theories were developed during the sixteenth–nineteenth centuries for artists that transformed their status (Daichendt, 2010).

Separate but related to this history of art education is the division between liberal arts education and professional education experiences (education in the guild or art academy). The visual arts are a consistent offering in liberal arts education curriculums for universities across the United States in the twenty-first century, but that was not always the case. The philosophy held by contemporary liberal arts institutions is a love of learning and knowledge for its own sake regardless of its connection outside the university (Menand, 2009). Real-world goals like technique or craftsmanship can appear utilitarian, vocational, and old fashioned. However, this is precisely what professional schools value. The trade, techniques, and knowledge are transferable and teachable in these contexts for learning. The liberal arts discipline works outside this influence and perspective of real-world goals. Thus twenty-first-century universities and the liberal arts education curriculums work on an island by themselves. This is partially why the values and ethos of art education are not the professional practices and embodied knowledge they once were. Although I state the status of liberal arts education quite plainly, more professionally oriented students and degrees are challenging the nature of this education and there is much debate in contemporary schools over the practicality of a liberal arts education and more cross-disciplinary education.

The history of the university art department is a story of institutionalization. With the foundation of these departments, standards were set and reinforced on where and how art should be taught. Art departments also became the gatekeepers and degree grantors for those wishing to teach within these institutions. In order to teach, you had to pass through the standards set by the art department. This cycle reinforced the institutional mindset. There will always be alternatives to this type of education (private art schools), but these institutions are few and far between. University

art departments are not only accepted in the twenty-first century contemporary landscape, but they are often celebrated and revered places of scholarship and art production. Celebrity artists, blockbuster exhibitions, culture changers and makers, world-renowned museum spaces, and architectural monuments recognized around the world are all located in close proximity to these university art centers. In fact, it is now commonplace for cutting-edge contemporary artists to teach within the university. One only has to view the roster of artist-teachers at colleges around the United States to garner a look at an impressive list of folks familiar to local art museums and galleries. These once-small and homely art departments are now cultural capitals in small towns across the United States as they play host to meaningful art events usually reserved for larger cities. The Wexner Center for the Arts at The Ohio State University is a prime example. Located in Columbus, Ohio, the center hosts world-renowned exhibitions, artist-in-residence programs, performances, films, and events for a relatively small population center. Traveling museum exhibitions, symposia, workshops, and art lectures are just a few of the basic experiences art departments offer to their student body and local community. These events, however, would not be possible without the institutionalization and professionalization of art in the university system. The prestige of the system legitimized the degrees and information these departments produce—so they are trusted sources. Artists thus represent quality and sincerity through their affiliation with the university.

Despite the crafts origins and changes in liberal art education, there was still a divide between art and design schools and university education from the sixteenth to the nineteenth centuries that most artists take for granted. In fact, it was not for a few hundred years after the Renaissance that art making was welcomed into the university. This transition from art school, professional school, or academy to university is particularly important because educating artists was not the primary objective of art education offerings in the nineteenth-century university. The basic art appreciation classes offered by the university were rather part of a well-rounded education and not a serious course of study compared to a professional art school. Pleas for the importance of art education were not uncommon as it played a relatively minor role in university education (Perry, 1923).

The artist/university partnership is a winning combination in many respects. The advent of modernism and the secure position artists' hold within the university allows for experimentation with technique and concepts without dependency on market trends or public taste. These vast changes in art-making philosophies may not have engrossed the general public during the twentieth century but the safety and security of the university allowed artists to practice in comfort and give rise to influential architectural and artistic movements. In fact, many early modern artists are associated with art schools or universities including Walter Gropius, Arthur Wesley Dow, Robert Henri, Kazimir Malevich, Josef Albers, László Moholy Nagy,

Paul Klee, Hans Hofmann, Henri Moore, and Wassily Kandinsky to name a few. More contemporary artist-teachers just located in California would include John Baldessari, Catherine Opie, Paul McCarthy, Lari Pittman, Barbara Kruger, and Charles Ray. Over the past few decades, several art schools developed a reputation for their relevance as contemporary art education centers because of their teaching philosophies. Institutions like Goldsmiths, Yale University, and Cal Arts graduated artists who were poised to engage the field with a knowledge that was current and relevant (or it was relevant for their professors who then repeated it again only to start a new cycle of reinvention).

Growth in university education

The story of the university art department begins in the nineteenth century. American colleges and universities during this time adopted much of the curriculum instituted by the British educational system where students studied law, medicine, or theology. European colleges and American colleges during this time rarely offered art courses and a professional degree in art was certainly out of the question. The first colleges in the United States were founded in the early seventeeth century (Cambridge University, aka Harvard University in 1638) and only offered a conservative and basic course of study. The arts were an extra-curricular subject that added character but the subject was best taught outside the college at private art schools or art academies. There were art academies and ateliers that offered arts instruction in the United States but American students who desired serious study in the arts often sought education from an art academy in Europe. The respected artists of the late nineteenth century were not working within colleges or universities but rather centralized in major European cities and art academies. Traveling abroad, private academies offered an established art education track record and a very high standard of art production. Art academies first appeared in the United States in the late eighteenth and early nineteenth centuries. These early art schools were modeled after the French academies and were mainly established in cities along the East Coast. These schools were organized and maintained by academically trained artists and were not considered universities—they were strictly schools for preparing artists. In fact, many Americans trained overseas and returned to teaching posts at these American art schools.

The history of higher education is helpful to understand this context. Menand (2009) divides this history into two significant periods: the development known as the Golden Age (1945–75) and the subsequent time period that followed this time of growth from 1975–present, which I refer to as the post-Golden Age. The Golden Age was a dramatic time of expansion in the history of higher education. Thelin (2004) writes that three P's supported the age: prosperity, prestige, and

popularity. The success and fortune of administrators and university officials was so high that golden seems to be a proper descriptor of the times. The baby boom, economic growth, and federal monies spent on higher education were all important contributors to the incredible growth in undergraduate and graduate admissions. Undergraduate enrollments increased by 500 percent and graduate enrollment by 900 percent during this time (Menand, 2009). The Golden Age mirrors the growth of art departments and specializations, as advanced and specialty programs were created and added for the growing enrollments. This trend of growth continued up to the highest levels of doctoral programs. Borders were drawn during this time and this is when art history and studio art were often separated and located in different schools or colleges. The experts saw their differences rather than their similarities in the arts. Boston University is a classic example. The Art History and Archeology departments are located within the College of Arts and Sciences while Studio Art, Art Education, and a host of other specialties are located in the College of Fine Arts. This separation and anxiety is felt when a student enrolls in a course offered by another department. Despite their status as an art or art history student, they quickly become an outsider when visiting a separate department that may share the responsibilities of art education in this discipline specific world.

The post-Golden Age witnessed modest growth but the defining characteristic of this period are the questions and changes higher education invoked upon itself. Despite growth, the borders of disciplines became weaker as there was and is more uncertainty in the twentieth and twenty-first century. A philosophical revolution per se is the culprit as the folks within the institution have questioned this objectivity and the tightly defined borders of the various departments (a postmodern theme). Several questions represent this theme. How do we create knowledge? What is relevant? What is the importance of interdisciplinary curriculums? What is diversity? What role should gender differences play in research, teaching and learning? In my own university, where I work in California, many faculty and administrators are attempting to break the discipline-centric system of education by creating a new multidisciplinary liberal studies core curriculum—certainly this a reaction against the traditions set during the Golden Age and represents this internal criticism.

It has taken awhile for the visual arts to settle into the university context since the nineteenth century. While art and design are always the subject of budget cuts at the primary school level and through government funding, they appear to be quite secure in the larger education context despite continual misunderstandings and growing pains. This process (be it negative or positive) of acceptance into the university has institutionalized the visual arts as areas of study alongside fields with longer histories and created a haven for production and professionalism.

Origins of the American art department

Art education was offered as public education in England in the early nineteenth century. This government-sponsored art education program was initially intended to educate designers in response to the industrial revolution. These classes eventually mutated into public school offerings in the United States under a similar guise. Because of the growing popularity of art classes, it was only a matter of time before art education classes became general education offerings at American universities promoting liberal arts education. Art courses thus became breadth classes in core curriculums and sought to provide a well-rounded education for undergraduates. Basic art study expanded from arts instruction to include art history and criticism courses in addition to basic studio courses (or in some cases a hybrid approach). Undergrads could choose in many instances to take art as an elective to meet a general education requirement—a common device still used in liberal arts schools around the world.

A number of individuals are responsible for the various methods of art teaching and how it was adopted and organized in the American university system. The art academy certainly was a factor in addition to the emergence of government-sponsored art education in grade school and high schools in England and America. Emerging alongside the industrial revolution, art training became a desired educational skill in the nineteenth and early twentieth centuries. Walter Smith (1836–86), formerly the headmaster of the School of Art in Leeds, was a British-trained instructor hired by the state of Massachusetts to introduce a system of design education in the nineteenth-century Boston public schools (Chalmers, 2000). This system of art education was developed in England first and imported after much trial and error to the United States—eventually developing to additional states adopting forms of art education at the primary school level. Art education at the primary levels displays a concern and importance for study of art and design that made it easier to adopt at higher levels.

A dramatic shift occurred in nineteenth-century England for universities. In 1868, art professorships were established at Oxford University, Cambridge University, and University College, London. Felix Slade, an English lawyer, collector, and philanthropist established these chairs of art instruction in his will and set in motion a context for teaching art in the liberal arts that continues today in England (although there was a large gap from when these were offered and when art departments became mainstream). The appointments made possible by Slade were the earliest concentrated art education at the university level in England. The professorships in England were critical and influential to other universities, especially in the United States—as professorships in the United States were modeled after the English programs.

As a result of this stimulus provided by Slade, Cambridge University hired architect and art historian Matthew Digby Wyatt; London University hired the painter Edward Poynter; and Oxford University recruited the influential critic, historian,

and artist John Ruskin. These early art professors taught a mix of art history and studio instruction—albeit quite a bit differently from one another. Each professor drew upon their strengths and was just beginning to explore the possibilities of art instruction and learning in the university. Wyatt's role at Cambridge was composed of lectures on art history, theory, and criticism (historical approach). In comparison, Poynter was encouraged to begin a studio-based academy for training artists in the university. The sheer difference in these two approaches (theory/history vs. studio) demonstrates the benefits and a unique freedom the arts had within the university. The move into higher education was a tremendous break from tradition in art education history. The prior systems of art instruction in England were under the control of the academic system or the government-sponsored art and design education system. The new university context allowed autonomy from the dictatorial rule and mandatory curriculums recommended by the administration from the government-sponsored schools in England. This freedom to teach according to individual philosophies is a characteristic shared by many working within the contemporary university atmosphere. This independence was likely a welcoming feeling—especially for Ruskin, as he was a harsh critic of many of the British art educational systems.

John Ruskin advocated for artist education and training in the newly formed Ruskin Drawing School within Oxford University. Ruskin's contributions as a professor of art were much more influential on future university art departments than the other professors because he facilitated an education that was quite different from the traditional skill-based offerings. Ruskin sought to create a whole person through his lectures, studio opportunities, and writings. Art was akin to Natural Philosophy and he felt students should engage in a subject that was much complex than a skill-based discipline. Art was something deep and meaningful to Ruskin, and he pushed his students in the university atmosphere to explore the closely related fields of biology and architecture in order to understand these subjects through art. With a mix of theory and practical training, his approach had a lasting impact on future arts professors in the United States. Despite Ruskin's advancements as a professor of art, the university did not offer a degree in the fine arts. It was not until 1978 that Oxford offered such a degree. In fact, the visual arts major developed much sooner in American universities than in the British system despite Ruskin's accomplishments.

In 1875, Charles Elliot Norton was appointed professor of the history of art at Harvard University. This position was created for him and he held the chair until his eventual retirement in 1898. Norton followed a course of study out of the John Ruskin handbook—advocating the moral aspect of drawing instruction. Norton and Ruskin communicated regularly and it would not be far fetched to state that Ruskin's influence was felt much stronger in America because of Norton. The art instruction at Harvard was multidimensional and Norton insisted that the study of art history should be coupled with practice in the visual arts. Norton at Harvard represented the emergence

of many other programs coming into existence. Additional art history programs and courses were established as early as 1882 at Princeton University followed by additional art programs at Vassar, Smith, Yale, New York, and Columbia universities.

Because of the increase in arts programs, we also see universities beginning to offer introductory courses in the studio arts for the very first time in 1910. One of the few schools to offer such beginning instruction was Brown University, which only offered this course through the Rhode Island School of Design. The introductory courses were intended to encourage and expand knowledge among the student body. While these courses were not required for graduation, it represents an increased presence in the university landscape.

Prior to the elective system, the classical 4-year curriculum was a neatly organized course of study for undergraduates. However, this classical curriculum (which emphasized ancient languages and a bit of rhetoric, philosophy, mathematics, and science) began to crumble in the 1880s when universities introduced electives and faculty became more interested in new areas of study. These interests led to increased departmentalization as old departments did not adequately hold these new courses of study (Best, 1988). The classical system catered to educating clergy and lawyers and soon become difficult to justify. In 1884, the faculty of Yale University was outraged with the classical curriculum and insisted that the President of the University institute an elective system. This combative process was won by the faculty to increase their offerings as the president agreed to their demands (Blackburn and Conrad, 1986). Cornell's first president confirmed this movement of change in 1868 when he emphasized his desire for a school where any type of instruction is offered (Lucas, 1994). The elective system and the culture of choice it offered created a new system of instruction making the study of the arts possible.

Support and enthusiasm for studying art at the university level continually progresses in the twentieth century. A typical call of support for the value of art instruction in 1918 includes

> demanding for it a position among the highest and most essential, as the most liberalizing of the liberal studies, all the more valuable because of its remoteness from the practical, of prime importance for its broadening effect upon the mind and its refining influence on character.
>
> (Robinson & Bailey, 1918, p. 98)

This statement validates a continuation of Ruskin's values and the contemporary justification that art education may not be practical but it is still good for you: a short-sighted and potentially frustrating characteristic that research and scholarship in the arts tries to overcome.

Prior to the Great Depression in the 1930s, it was commonly understood that education in the arts was far superior at an atelier or art academy outside the university and that an education in a European art academy was ideal. However, the increased educational offerings by the university in the twentieth century brought hardship to private institutions. The financial strength, reputations with accreditation agencies, and close relationships with professional associations made the university a logical home for art production in the twentieth century. Since World War II visual arts programs on university campuses have grown exponentially. It was during the post-war period that the majority of schools started to offer introductory courses in art appreciation or art history. Efland (1990) reports that half of the colleges in the United States in 1925 offered art courses but the percentage had grown to two-thirds of all colleges offering art courses by the 1940s.

The college art degree legitimized much of the frustrations parents must have had with their sons or daughters studying the art of painting. A skill not commonly valued in the competitive marketplace, the legitimacy the university brought to the subject of art is immeasurable. The expertise and training offered by artist-teachers became a valued discipline once their instruction was contextualized in a scholarly atmosphere. It is not hard to imagine a concerned parent being much more comfortable with their child earning a college degree in the visual arts compared to a certificate or a nondegree granting course of study that values private instruction. During the course of the twentieth century, professional associations like the College Art Association and the National Association of Schools of Art and Design were established and became significant institutions for maintaining standards in US colleges and universities.

Visiting artist-in-residence programs were originally a great strategy to recruit well-known and respected artists to share their discipline with students. This strategy was used in the 1930s to promote music education and later employed to offer visual arts instruction but permanent visual arts instructors were not a regular position in many US universities until the second half of the twentieth century.

Following World War II, the number of universities offering courses and degrees in the visual arts dramatically increased. In fact the courses were often taken by returning servicemen and women. This new group of students fueled by their military benefits (1944 GI Bill) provided many universities with the income and populations needed to grow programs. Studying art was a popular choice among veterans who sought peaceful civilian lives (McIntosh, 1946). Art departments benefited significantly and were eventually divided into subgroups. This organizational structure was a result of growth and forced the field of art to create and maintain specific disciplines.

Even after artist-professors became commonplace, there was still discussion as to whether the university was the proper home for the artist. This is not an uncommon situation as artists and the field of education has not been complimentary to one-

another. The creative nature of the artist versus the regimented atmosphere of academia can be a poor combination of objectives. The professional goals of the artists compared to that of the teacher are not always in agreement and the university can highlight those differences. The teaching demands and expectations for scholarship appear outside the initial artists' scope of interest and have created tension on more than one occasion (Daichendt, 2010).

Where the visual arts (art, art history, art education) should be located within the university continues today. Art departments are to be found within many different administrative categories in higher education. A study by Prince (1990) found that 23 percent of institutions organized arts programs in Colleges or Schools of Art and Sciences, 16 percent in Colleges/Schools of Art, 12 percent in Humanities/Letters, 3 percent in Schools of Arts and Communications, and 54 percent in single departments or other organizational structures. In my own case, I have studied visual art in a College of Fine Arts, an Education School, and a College of Liberal Arts and Sciences. The varied placement not only confuses but impacts expectations regarding the purpose and scope of scholarship. This diversity underscores the insecurity arts programs face as they are scattered in a variety of locations.

Intellectualism of art making

Art education has changed dramatically over the last century and that has had an impact of how we see ourselves as artist scholars. A major trend according to Goldwater (1943) is the significant decline in drawing courses offered during a time when art departments in the university were growing quite rapidly. Essentially student-artists took to painting without the rigorous education in drawing past generations encountered in their own study. This is an education that values theory more heavily than ever before.

The shift away from a technique-based art education draws many parallels to art education becoming more of an intellectual discipline and less of a crafts-based discipline. The Bauhaus was the first of many influential art and design schools that changed the context of how art could be made and understood. One of the major goals of Walter Gropius, the schools founder was to break down barriers that had existed in the art and design world. The result was art infused with a highly intellectual atmosphere. The teaching served a philosophy and many other educational institutions adapted this type of pedagogy, as art in education became an intellectual exercise. De Duve (1994) hits the nail on the head as he describes the pedagogical shift that occurred when art education left the confines of the academy. Mental and intellectual work was beginning to be, and is now, valued over the manual. It is a deskilling that has taken place and prompted many studio graduates to question the relevancy of their degrees.

The contemporary art degree is a byproduct of art education and not a license or certification for creative success (Singerman, 1999). It does not guarantee success or grant the holder a unique niche in the marketplace. The advantages of this education are a professional knowledge that the artist assumes when entering and graduating from the university: learning to critically reflect on artwork and what it means to be an artist. This knowledge and a progression of knowledge according to Singerman (1999) is quite different from the sciences. Where new knowledge in the sciences trumps old knowledge and leaves it obsolete, the artist's relationship to progress and new knowledge values both the old and new. By recognizing the new it also reinstates and certifies the professional discourse and definitions of the discipline that come from the old.

This progression of the discipline has left many amateurs behind and frustrated as their language and understanding of art has not progressed with the field. This is why there are gaps between the practicing artist scholar and the practitioner who has left the cutting edge of artistic work. The art department in the university provides this knowledge to its students for engaging this art world. Seriousness and dedication are the characteristics of such work and the M.F.A. represents a dedication, practice, and professional knowledge of the art field.

> If painting or drawing are "simply" the repeatable techniques of picture making, then there is only the question of what to represent or make. If art is a set of tools with which to do something else, there is no discipline; there is no demand for further research, no question raised by the medium or by its historical uses and appearances, no "issues" raised by its contemporary practice that plot a future and direction. Each work is separate, complete, and finished instance; it has no stake, because it has no field in which to strike one. It is merely professional.
>
> (Singerman, 1999, p. 208)

The theory-laden and creative discipline of visual art is also comparable with trends in educational history.

> All progressive pedagogues of this century, from Froebel to Montessori to Decroly; all school reformers and philosophers of education, from Rudolf Steiner to John Dewey, have based their projects and programs on creativity, or rather, on the belief in creativity on the conviction that creativity—not tradition, not rules and conventions—is the best starting point for education. Moreover, all great modern theorists of art, from Herbert Read to E. H. Gombrich to Rudolph Arnheim, have entertained

similar convictions and devoted considerable energy to breaking up the "visual language" into its basic components and demonstrating the universality of its perceptive and psychological "laws."

(de Duve, 1994, p. 25)

The artist scholar is thus operating in a visual art world that values creativity, language, and the history of the discipline.

As scholars developed specializations in the arts during the twentieth century, they trained future professors to fill these roles. More faculty studying in the arts results in developing more specific areas of expertise. This method allows faculty to have in-depth experience in a particular aspect of their field. Through specialization, only professionals trained under professionals become equipped to teach future professionals. Thus it becomes rare to have a painting instructor teach outside their area of expertise. This system of growth is also a double-edged sword. The arts slowly became more established in the twentieth century yet professionalized arts education allowed subject specialist to have a monopoly on their area of study. Today, a student has a wealth of topics to explore if they decide to study the arts. No longer is the emphasis on just producing artists—instead there are a variety of offerings related to arts production that one can focus and become an expert.

As any subject becomes more popular, specializations develop; this seems to be at least one cause for the doctorate in the visual arts. This specialization also contributes toward the professionalization of the arts, because faculty members teach their area of expertise and train their students to follow a path that creates a tradition and history of how the field should be practiced. Ph.D. visual artists practice a language and clearly reproduce themselves. The field continues in this way in all disciplines and is continually reinforced with each subsequent generation. Rarely does the art student need to travel outside their area of interest except on rare occasions. Professionalization and specialization have slowly eroded the concept of general and cultural education. The arts are typically thought of as the latter but instead have become the former. Art education is hardly dispassionate and objective in its aim but this may be inevitable without cross-disciplinary study.

Teaching to research

The study of art benefited and expanded because of the university system, but the university brought expectations of scholarly activity. Prior to the nineteenth century, artists, despite their growing status in society, were not part of conversations regarding research, however neither was the university. The American university was also in a state of flux during the nineteenth century and the results of this change are critically

important for today's artists. The contemporary university serves two distinct purposes. As institutions dedicated to learning and teaching, scholars essentially work within the university system to expand human knowledge through their work as researchers, thus bringing the benefits of such knowledge to society through learning and teaching. This current understanding was not always the university's role. Originally universities were primarily teaching institutions, it became a home for the production of new knowledge at roughly the same time the arts were introduced into the university system.

Singerman (1999) writes that the beginning of independent research by faculty in American universities started in the 1870s. Taking notes from German models of higher education, faculties found themselves in more specialized departments. The development of specialist societies and discipline-specific journals helped fuel this research and its dissemination.

> For centuries, the university had functioned primarily for the purpose of transmitting, extending, and propagating received knowledge. Only after the Enlightenment—and particularly after the reform of the Prussian university by Wilhelm von Humboldt—was the university set free from the bonds of religious orthodoxy and transformed into an institution of unfettered inquiry. In America, the British collegiate model of higher education was transcended by graduate study for the doctorate only a little more than a century ago. It is worth noting that the Ph.D., awarded in the United States only after the Civil War, is based on a dissertation that makes an original contribution to knowledge, something that would have been virtual heresy a century ago.
>
> (Muller, 1986, p. 315)

The context of this system is important because the arts were adopted into the established university system that valued new knowledge. Research was becoming and eventually became the standard and defining characteristic of professors rather than teaching. Prior to this, art academies or workshops relished in providing an education that was tabled and rooted in the past. The art academy and the art workshop were controlled educational systems for teaching and learning. In contrast, the research university provided freedom from tradition and the ability for artists to pursue their unique interests. This has afforded great leaps and inquiry on behalf of artists facilitating experimentation. The research university continued to grow and develop in the United States during the late nineteenth and early twentieth centuries as specialization in specific departments heightened (Menand, 2009). This growth resulted in more general education courses (breadth classes in the liberal arts) in

addition to many discipline-specific scholars.

Variations of modernism spread throughout higher education as many artist-teachers brought individual philosophies of creativity to universities across the country in the twentieth century. The critical attitude toward professionals in the arts is noticeable as modern art education moved further away from public expectations for art production. This attitude falls in line with similar attitudes toward professionalism as experts and professionals are much more scrutinized today then they were in the past. The authority held by the degree or education does not hold the amount of weight it did fifty years ago. A similar movement is adrift in the twenty-first century as artists within higher education have deep specializations, place their art in theoretical contexts, and do more work in the intersections of the arts (Merrion, 2009). The intellectual atmosphere and added emphasis on language contributes toward artists developing a solid stance on research and its relationship to the education of artists.

The M.F.A. degree

The highest degree one can earn in studio art in the United States is the M.F.A. Although there are a few new mixed-doctorates geared for artists, the US version of the Ph.D. in visual art does not have the support or the cache that it holds in countries like England. Thus the M.F.A. is the terminal and preferred degree among arts faculty (although I suspect this will change sooner rather than later). The role of research is part of the Ph.D. vs. M.F.A. debate and this section reviews the basics of the M.F.A. degree.

The M.F.A. degree was first offered and awarded in the 1920s and 1930s (Efland, 1990; Singerman, 1999). Institutions like the Universities of Iowa, Washington, and Oregon, along with Yale and Syracuse offered them first before they became much more widespread when the College Art Association recognized the M.F.A. as the terminal degree in 1960. In the following decades, the M.F.A. grew in popularity as more programs and students flooded the universities as tens of thousands of students graduated with this newly formed degree. More than a masters but not quite a doctorate, the M.F.A. is a degree in limbo. It is the terminal degree for those choosing to teach within the university and is a significant achievement as admission to such programs is very competitive. Pink (2004) compares Harvard Business School's application percentages at 10 percent to University of California, Los Angeles's M.F.A. program that only admits around 3 percent of applicants. While application percentages vary according to school and location, the comparison highlights the competitiveness involved in earning an M.F.A. degree. This acceptance rate falls in line with Menand's (2009) observation that the less social authority associated with a field or profession is relevant to how restrictive and rigid admissions and professional standards are within

the university. The M.F.A. is restrictive, but why? This will be part of the problem with any new doctorate in the arts. There is an oxymoron for graduate study in the arts and humanities and the M.F.A. and the doctorate fall into this line of thinking, as law degrees are earned in three years, Medical degrees in four, while many degrees in the humanities are earned in upwards of seven plus years. The M.F.A. although competitive, lasts between two and three years and only qualifies the applicant to teach in a system oversaturated with applicants. A very difficult degree to attain but limited in the influence and stature it holds in the marketplace.

Essentially, the M.F.A degree represents two years of graduate study (60 units), a studio show, and a thesis (although thesis is sometimes a debatable term for these papers). Completion demonstrates a level of excellence in this subject and the potential to teach at the college level. The M.F.A. became the standard degree by replacing the M.A. in art. In comparison, the Master of Arts in Art is a graduate degree without a purpose and has been discontinued by many universities. The M.F.A. has come to represent a higher level of scholarship in the arts and is comparable to a Ph.D. by default in other fields.

However, the Ph.D. in art has emerged and there is much discussion over the advantages and disadvantages of such a degree. The College Art Association states:

> At this time, few institutions in the United States offer a Ph.D. degree in studio art, and it does not appear to be a trend that will continue or grow, or that the Ph.D. will replace the M.F.A. To develop a standard for a degree that has not been adequately vetted or assessed, and is considered atypical for the studio-arts profession, is premature and may lead to confusion, rather than offer guidance, to CAA members, their institutions, and other professional arts organizations.
> (CAA Professional Practices Committee, 2008)

Given that the doctorate is not expected of art faculty in the university, M.F.A. programs have accepted the responsibility of preparing researchers. However, the M.F.A. (and art education in general) emerged and is caught in the middle of a university system that changed the nature of research. Menand (2009) claims that the professionalization of academic work has fundamentally altered research and the doctoral dissertation. When Elkins (2009) bemoans the ability of artists to contribute new knowledge, it is in the context of dissertations ceasing to be a final paper and instead a scholarly monograph that introduced the researcher into the "publish or perish" world. However, if artist scholarship was imagined to be a culminating paper rather than a new scholarly product, the unfair expectations for this contribution could be redirected toward producing quality artist scholars and not artists obsessed with justifying their place in the world of research.

This change is possible because the very folks who run the art departments control the professional expectations for the art degrees. Professionals reproduce professionals, so the changes will not be dramatic and will be decided internally regardless of the outside influences. Menand addresses this issue of disinterestedness of academia from the outside world.

> Two features of professionalism are supposed to make disinterestedness possible. One is the autonomy of the professional organization. Professions are largely self-regulating: they set up the standards for entrance and performance in their specialized areas, and they do so by the light of what is good for the profession… The second feature of professionalism that is supposed to ensure disinterestedness is the very act of specialization itself. Specialization makes work more productive because it narrows the field and therefore allows it to be more deeply and expertly mastered.
>
> (Menand, 2009, pp. 103–4)

The Ph.D. in art will be no different and will continue the professionalization of art education if research and the arts are not addressed at the M.F.A. level first. It is difficult because specialists teach within these institutions and essentially educate students to become just like them. The College Art Association or any professional arts association will support such changes because folks within the art field who set the standards also manage them. This is also the case for journals publishing peer-reviewed articles or juried exhibitions. The evaluative system is maintained from within. Professionals will graduate from art schools with credentials and an area of specialization. The profession of visual art is guarded from within, and those without the credentials (degrees, exhibition record, or publications) cannot practice. These practices can change, and I hope that faculty and students recognize the options before them as the system can be challenged.

Art history lends a hand

Because education in the arts is still relatively recent in the United States, it should come as no surprise that there are misgivings on how artists in the university are any different from artists outside the university. Peers inside the university criticize the subject of art for lacking rigor and intellectual content (Bok, 1986). However, success as an artist is held within the values of the profession and not within the ideals of the university. This causes confusion as artistic peers use their own criteria to evaluate arts scholarship.

From the nineteenth century till today, visual arts education in the university has had both great success and growing pains. The founding of art departments started in the nineteenth century but it was not until the 1930s that it became a popular subject of study. The contemporary confusion over where art education takes place is evidence of how recent this history is to the university. There were many schools that led the charge in visual arts offerings at the graduate level as well. Before the turn of the twentieth century, Harvard, Columbia, Cornell, Princeton, and Yale all begun to provide graduate courses in the visual arts with Harvard awarding an art history Ph.D. as early as 1913 (Singerman, 1999).

The foundation of art history is important to studio because the two developed together. Because art history is closely tied to other academic subjects (history, archeology, and the classics), the methods, procedures, and research expectations were accepted much more readily than the studio arts. In fact, most universities include study of art history as a portion of liberal studies curriculums. German universities offered the study of art history as early as the late eighteenth century and universities in the United States offered courses in the nineteenth century. Essentially the discipline of art history grew from the practice of the archeologist and antiquarian. But the beginnings of the art history department drew much from departments of classics. The popularity of classical art courses and the high regard of art of this era made this it a common focus of study.

Studio courses never kept pace with the popularity of art history offerings in the first half of the twentieth century. Studio courses and faculty were more numerous than art history faculty but the formation of a studio major was much slower to develop than art history (Goldwater, 1943). Interestingly, studio work and art history occasionally crossed paths in the late nineteenth and early twentieth centuries. A good example is the laboratory studio courses offered at Mt. Holyoke College. Laboratory work in studio processes was a means to learn about art history through hands-on activity. Through the use of media, student-art historians gained a better appreciation of individual artists and their work (Hyde, 1918).

The research of art historians involved studying, writing, and investigating art objects of the past, methods in line with archeologists, antiquarians, and historians. Methodologies for conducting research change but the field of art history helped to loosen the gates of academia's acceptance of the visual arts. The newly developed departments of art history proved their scholarly aspirations by initially borrowing archeology methods. Discovering a niche, these scholars focused on an area of study that was overlooked. The doctorate in art history was introduced in the twentieth century and gained popularity as more and more institutions started offering the highest degree in art history until it became the expected credential among art history faculty. The art history degree gained acceptance relatively early on as a professional degree in the university atmosphere and for better or worse developed

an independence from studio art. The new degrees at the undergraduate and graduate level were significant accomplishments in the twentieth century for the study of the arts but since doctoral-level study legitimized the art history, the M.F.A. degree in the United States is still encountering struggles in the twenty-first century in regards to knowledge production, research, and the role of writing in art education.

<center>⋅⊱⋅⊱⋅</center>

The pursuits of all artists can be said to be a type of scholarship—it is the hope that artists in the university system are contributing meaningful ideas to the art field and beyond. Artists inside and outside also practice their work in similar fashions. Artistic products usually are at the core of this dilemma. Recognizing an artistic product as a form of knowledge is the issue and leads to the role of the written word in art scholarship. This includes not only contributing knowledge but also recognizing the knowledge of the past. Practicing in isolation cuts the artist from this information because knowledge of this community is an essential aspect of association with the university.

Elkins (2006) again criticizes the attempts by US art programs to validate art products as some sort of new knowledge. He claims this justification has more to do with economic justifications than scholarship. The industry of theorizing has justified studio art practices as research and the production of new knowledge to help universities that aim to develop and maintain graduate programs in the arts. This writing according to Elkins seems to be an attempt to unify studio practice with the university. However, it does not address the real issue that keeps arts on the margins.

> In my experience deans actually resist a lack of hierarchical instruction: what keeps studio art on the margins is its apparent lack of stepwise, graduated knowledge in college-level courses—knowledge that could be assessed (in UK term) or graded (in the North American term).
>
> <div align="right">(Elkins, 2006, p. 246)</div>

This is precisely what the US art field and the university art department reject when they speak about ideas and concepts. These ideas are prevalent in the contemporary art world and there is a large disconnect between the UK version of arts-based research and what is exhibited in Los Angeles art galleries. There is knowledge that is shared in the university and they are certainly adept at using this language, critical theory, and logic to talk about their work. But my question for graduate writing projects within the university is how to best capture this professional knowledge and reflect on it?

<center>43</center>

References

Best, J. H. (1988). The revolution of markets and management: Toward a history of American higher education. *History of Education Quarterly, 28*(2), pp. 177–89.

Blackburn, R. T., & Conrad, C. F. (1986). The new revisionists and the history of U.S. higher education. *Higher Education, 15*(3), pp. 211–30.

Bok, D. (1986). *Higher learning.* Cambridge, MA: Harvard University Press.

CAA Professional Practices Committee (2008). Statement on PhD Degree in Studio Art. Retrieved on February 26, 2010 from: www.collegeart.org/guidelines/mfa.html.

Chalmers, F. G. (2000). *A 19th-century government drawing master: The Walter Smith reader.* Reston: National Art Education Association.

Daichendt, G. J. (2010). *Artist-teacher: A philosophy for creating and teaching.* Bristol, UK: Intellect.

De Duve, T. (1994). When form has become attitude—and beyond. In N. de Ville & S. Foster (Eds), *The artist and the academy: Issues in fine art education and the wider cultural context* (pp. 23–40). Southhampton, UK: John Hansard Gallery.

Efland, A. D. (1990). *A history of art education.* New York: Teachers College Press.

Elkins, J. (2009). *Artists with PhDs: On the new doctoral degree in studio art.* New York: New Academia Press.

Elkins, J. (2006). Afterword: On beyond research and new knowledge. In K. Macleod and L. Holdridge (Eds), *Thinking through art: Reflections on art as research* (pp. 241–7). New York: Routledge.

Erickson, M. (1979). An historical explanation of the schism between research and practice in art education. *Studies in Art Education, 20*(2), pp. 5–13.

Goldwater, R. J. (1943). The teaching of art in the colleges of the United States. *College Art Journal, 2*(4), pp. 3–31.

Hamblen, K. A. (1984). An art education chronology: A process of selection and interpretation. *Studies in Art Education, 26*(2), pp. 111–20.

Hyde, G. S. (1918). Ways and means of securing proper recognition for art teaching in our colleges and universities. *The Bulletin of the College Art Association of America*, *1*(4), pp. 58–61.

Lucas, C. J. (1994). *American higher education: A history*. New York: St. Martin's Press.

Menand, L. (2009). *The marketplace of ideas*. New York: W. W. Norton & Company.

Merrion, M. (2009). A prophecy for arts in higher education. *Change*, *41*(5), p. 6.

McIntosh, P.R. (1946). Art at the American army universities in Europe. *College Art Journal*, *6*(7), pp. 143–6.

Muller, S. (1986). The role of the major research university. *Johns Hopkins APL Technical Digest*, 7, p. 315.

Perry, D. L. (1923, September). Art for industry's sake. *Nation's Business*, *11*(10), p. 36

Pink, D. H. (2004, February). The MFA is the New MBA. *Harvard Business Review*, p. 13.

Prince, J. N. (1990). *The arts at state colleges and universities*. Washington D.C: American Association of State Colleges and Universities.

Robinson, E., & Bailey, H. T. (1918). Value of the study of art to the students in colleges and universities. *The Bulletin of the College Art Association*, *1*(4), pp. 95–103.

Singerman, H. (1999). *Art subjects: Making artists in the university*. Berkeley: University of California Press.

Saltz, J. (2010, October 24). The Long Arm of John Baldessari: The Conceptual Pioneer, Subject of a Retrospective at the Met, Has a Lot to Answer for. *New York Magazine*. Retrieved on November 22, 2010 from: http://nymag.com/arts/art/reviews/69103/.

Saltz, J. (2003). *Seeing out loud*. Great Barrington, MA: The Figures.

Thelin, J. R. (2004). *A history of American higher education*. Baltimore, MD: John Hopkins University Press.

3

The Status of Artistic Scholarship

Research through practice

Artistic practice is a deep and powerful mode of communication and inquiry. This is evident as researchers and scholars attempt to define and reflect on the arts processes using terms like "studio thinking," "visual thinking," "poetic knowledge," or "tacit knowledge" (Arnheim, 1969; Frappaolo, 2008; Hetland et al., 2007; Taylor, 1998). While the use of each of these concepts slightly changes our conception of knowing and thinking through the visual arts, collectively they point toward the rich and multifaceted process artists enable in the studio. Art-making at the most basic level is thinking made visible. A wonderful sound bite but more is required to help us write about art.

The chore of breaking down what actually happens during studio time is not an easy task. And in order to garner any insight into the studio process, it must either be studied during or after the experience of creating. Many of my own students have commented how difficult it is to write critically about their studio process while they are in the midst of it. It has been referred to as writing about an open-heart surgery while the patient is still on the table. However, comparatively, they have much more confidence writing once the experience has ended. There is so much unknown when the work is incomplete and students still find themselves neck deep in unresolved issues. The field of creativity has much to offer this dilemma. Especially given the theoretical aspects of contemporary art making. The models developed in creativity for studying this type of thinking are applicable to the work of artists. In addition, the field of creativity helps explain why artists do not feel overly confident in the middle of their process.

Lawson (1990) adapted Wallas' (1926) four stages of creative problem solving to develop five steps for understanding the creative process. Below is an explanation of these five steps adapted slightly with the artist in mind.

- Identification – Recognizing a problem exists and choosing to tackle it.
- Preparation – The artist assesses and focuses their mind on the problem and explores the possibilities.
- Incubation – The problem is internalized and nothing appears to be happening on the outside. This can be a period of relaxation and subconscious thought.
- Illumination – This is the discovery or sudden realization of an idea, the "eureka" moment.
- Verification – Verification and application of the idea in the form of an art product. A workable solution or final art product is created.

While the five stages outlined above are helpful and certainly applicable to certain artistic process, there is no "one size fits all" formula for deciphering studio processes. Lawson (1990) and Gruber (1989) believe that reality is quite different from a linear model and more likely the creative process is made up of many small decisions that include extended periods of hard work. The single illumination may not be the best descriptor of this process but it certainly symbolizes part of a process that is internal for the artist when they shift from an unresolved/pre-art making state to decisiveness (which may happen over and over again during the completion of one work of art). The many creativity models available are helpful to symbolize this process but not necessarily as a prescribed formula for studio activity. Artists do not always seek solutions to problems, and their avenues and inspiration for artwork varies along with the purpose of their final product. However, a model like this has great potential to be manipulated by the artist to reflect individual artistic processes.

A generic cycle of artistic production by an artist includes preparation followed by production. Before an artist begins their physical work in the studio, study of the subject in an intimate matter is required. The artist engages and manipulates knowledge in a variety of ways. This may include reading, visiting art shows, engaging political ideals, along with a wide array of subjects and media. Subsequently after acquiring knowledge, the artist creates something based upon their thought process and what they hope to say about the ideas studied. As stated before, this process requires a deep relationship and intense study of the desired subject in addition to knowledge of technique. The process of making, reflecting, and studying often reveals new insights that are then reworked—involving multiple eureka moments. Summed up, the adaption of a creative model generally includes this prep work followed by imagination, development, and eventual action.

Dewey (1957/1997) captures the essence of human activity through three concepts that are applicable to the creative processes of artists. These concepts are impulse, desire, and purpose. And when these ideas are explored in relation to the studio process, they are illuminating (Eisner, 1960). Essentially the formula states when

impulse is frustrated, desire is consciously selected from a library of impulses, and when a certain desire is selected with a method and direction, a purpose is then generated.

> A genuine purpose always starts with an impulse. Obstruction of the immediate execution of an impulse converts it into a desire. Nevertheless neither impulse nor desire is itself a purpose. A purpose is an end-view. That is, it involves foresight of the consequences which result from acting upon impulse… The formation of purpose is, then, a rather complex intellectual operation. It involves (1) observation of surrounding conditions; (2) knowledge of what has happened in similar situations in the past, a knowledge obtained partly by recollection and partly from the information, advice, and warning of those who have had wider experience; and (3) judgment which puts together what is observed and what is recalled to see what they signify. A purpose differs from an original impulse and desire through its translation into a planed method of action based upon foresight of the consequences of acting under given observed conditions in a certain way.
>
> (Dewey, 1957/1997, pp. 67–8)

Purpose is the key stage in Dewey's theory as it relates to the final production of an artwork. Purpose can be discovered and refined on the canvas and this is likely more symbolic of the decisions artists sometimes make when working and refining ideas and media in the studio. As the materials react to one another, the artist sees different perspectives and then again reacts to it. The possibilities constantly change, according to Eisner (1960), as the media is manipulated. Picasso's creation of Guernica for the Spanish Republic's Pavilion at the Paris World's fair illustrates this concept as he constantly reworked this canvas through several stages despite having an initial draft.

Picasso's creation of the infamous mural-sized painting *Guernica* was a reaction to the bombing of the town by the same name by German and Italian planes on April 26, 1937. The initial drawing was begun the day of the bombing based upon his understanding of the fear and anguish of this catastrophic terror. However, as the days passed and as his time in the studio lengthened, his approach changed. The geometric forms originally conceived in a draft became more and more pronounced and the composition more dense. The painting progressed through seven stages photographed by Dora Mar and was eventually completed without color (Cantelupe, 1971). The symbolic language of Picasso combined with his increasingly complex imagery ultimately concluded with a painting Ernest Hemingway called "A new kind of War." The depths of unhappiness related to pain, suffering, and fear Picasso explored are still gut wrenching to this day. While Picasso certainly had an initial purpose and

direction after his first composition, he reworked it and found new purpose as his emotions, ideas, and imagery were contemplated and reflected upon.

The decisions (sometimes reworked many times over) by Picasso to use familiar figures, textures, a limited color palette, and scraps of wallpaper all combined toward the powerful image that was eventually exhibited at the Spanish Pavilion. When the larger and holistic decisions in the studio are reflected upon and broken down, it is easy to see the relation Picasso's thinking and research has to other disciplines. The scientific process and the approaches used by qualitative researchers as they attempt to better understand phenomenon in question are similar to the trial-and-error process Picasso enacted as he attempted to think through an important phenomenon and symbolically capture the terror of given moment in time. Interestingly Picasso one said: "I never made a painting as a work of art, it's all research." This is a comment that heightens our understanding of the artist's engagement with the subject.

Questions and debates over the arts and research like this have been the subject of much discussion in the UK for the past two decades as the Ph.D. in visual arts has grown in popularity. Frayling (2008) recalls these debates as several of the typical questions that arose in the 1990s are now being discussed in the United States. These issues include Isn't art education at the masters levels about mastery of materials?, Doctorates are written contributions that are much different than visual art contributions (fine for other disciplines but not the arts), Degrees for the practical professions are nonsensical, Research is about communicable knowledge and the arts are multivalent, The phrase practice-based is different from research, Why do research in the arts at all and is the decision to pursue research a parody of other disciplines?, Is this a professional issue, or an intellectual issue? While the questions Frayling reviews are not all applicable to Master of Fine Arts (M.F.A.) students, they demonstrate the wide range of debate about the roles of research, writing, and the arts. The slow acceptance and timid reaction to writing and research at the graduate level in the United States is certainly understandable since artists in the American university system rarely write and there is not much of a support system in literature for facilitating such writing and research. The professionalization of M.F.A. faculty has trained them to repeat the same education they received and it is difficult to break this cycle.

Going forward with M.F.A. scholarship

This text assumes the importance of writing and research for artists but that perspective is kept in check as the artwork is the primary product and writing should serve as a foundation and tool to improve the artistic process of the artist. However, in order to go forward, we must take a look around us and take account of the multiple perspectives authors have explored regarding studio thinking and research. These

are certainly important implications for students and faculty operating within the university as it impacts their work and the way it is seen by others in the academic community. Therefore I will review several of these concepts and conclude with some recommendations for current faculty and students working in visual arts programs to consider when writing or teaching. Essentially it is about reflecting on your own art and improving it through the writing process.

It is not surprising that a host of art theorists, historians, and artists have addressed the concept of arts research in texts to guide, inspire, or critique art and practice as a form of research (Barrett and Bolt, 2010; Cahnmann-Taylor and Siegesmund, 2007; Elkins, 2009; Gray and Malins, 2004; Hickman, 2008; Irwin and De Cosson, 2004; Leavy, 2009; Macleod and Holdridge, 2006; McNiff, 1998; Sullivan, 2005). These authors and artists have recognized (to varying degrees) the connection artists have with their subject matter and seek to understand the rich dialogue artists have when creating artwork.

Research by itself, however, does not seem to be enough for scholars to describe art practice. The terms art practice as research (Sullivan, 2005), arts-based research (Barone & Eisner, 1997), arts-informed research (Cole, Neilson, Knowles & Luciani, 2004), A/r/t/ography (Irwin & de Cosson, 2004), and practice-led research (Candlin, 2000) are all used to describe different practices of artistic research.

The term "arts-based research" is the most important and is an overarching term many use in the field of arts research. Arts-based research is a qualitative method and is useful for understanding human behavior and the decisions or reasons for such behavior. The majority of arts research texts and theories fall into this category and they stress the importance and similarity arts research has to other types of accepted qualitative methods. This qualitative connection provides an important tradition and history that grounds the experimental aspects of using the arts in the social science research arena. Arts-based research is also the umbrella term used by many to encapsulate the work by folks concerned with arts research (Leavy, 2009). Leavy (2009) describes art-based research practices as "a set of methodological tools used by qualitative researchers across the disciplines during all phases of social research, including data collection, analysis, interpretation, and representation" (pp. 2–3). The data points are important to consider, as they are ripe materials for interpretation and learning about artistic practices. McNiff's (1998) understanding of arts-based research is similar although it applies to art therapy.

> Art-based research can be defined as the systematic use of the artistic process, the actual making of artistic expressions in all of the different forms of the arts, as a primary way of understanding and examining experience by both researchers and the people that they involve in their studies.
>
> (p. 29)

The tools available for art-based research allow artists and nonartists to borrow from the qualitative tradition. It is a wonderful connection that takes advantage of the artistic process and has birthed very interesting studies by artist researchers concerned with the humanities. These studies emphasize new knowledge and are purposely designed to contribute toward a particular area of study. Further refining the concept:

> Arts-based research incorporates the processes, forms (or structures), and approaches of creative practices in academic scholarship. Therefore, arts-based research draws from the creative arts to inform and shape social science research in interdisciplinary ways, thus redefining methodological vehicles in the field of education.
>
> (Skinner et al., 2006, p. 122)

The majority of arts-based research publications focus on research in the field of art education, art therapy, or art and design doctoral programs. However, arts-based research has also extended into fields like medicine, science, and engineering (Lazarus & Rosslyn, 2003; Gibb, 2004; Penny, 2000). Despite this growth, there is still debate over its legitimacy and rigor. Artists need to recognize that the methods of data collection used are valuable bits of information and should not be overlooked. The drawings, mind maps, sketchbooks, photographs, old napkins, notes, inspirational quotes, pictures, books, conversations, critiques, and anything used to brainstorm or think about subject matter are important. These bits of information represent aspects of our thinking and can be analyzed with qualitative tools. The fact that other disciplines use arts-based research demonstrates that these types of data definitely have something to tell us.

Arts-based research requires that an agenda be decided at the outset by selecting a question to investigate. The sources of data can then be determined only when the researcher has a good idea what they are studying. The wonderful aspect of arts-based research is manifest through collecting data through artistic processes and portraying the results of such an inquiry. Arts-based researchers can provide both visual and written documentation that takes advantage of the multiple types of data available in the arts. The openness and creativity of art-based research allows the researcher to portray their understanding visually, textually, or performatively (Skinner et al., 2006). "The argument of arts-based researchers is that the arts provide a special way of coming to understand something" (Sullivan, 2006, p. 24). The art-based research paradigm is helpful to the social scientist but the artist is quite different and these paradigms do not always acknowledge the personal objectives and goals of the studio artist.

Art practice as research (a term popularized by Sullivan) is a valid and worthwhile art-based perspective for artists and is loaded with theory to support and justify its inclusion as an option for artist scholars. However, many have reservations about its use for M.F.A. students. Art practice as research qualifies the process of art making as a

form of inquiry. In other words practice is research, and the artist must be researching something through this practice. Sullivan (2005) addresses this perspective best when he describes artistic practice as thought and action in an artistic medium.

Art practice as research is presented in the form of creative products and is evident in the studios or workshops of artists. It teaches and inspires new and renewed understanding of a range of subjects. Scholars associated with this perspective understand art practice as an intelligent process that draws similarities to inquiry used to understand phenomenon in the qualitative tradition. The folks who typically utilize art practice as research are located in the fields of art therapy or art education where they apply studio disciplines to study phenomena.

A symbol system more complicated than any language, the visual arts are a complex and multimodal way of investigating anything. Artists studying their own work or themselves offer a wealth of data to draw upon. But what constitutes artistic data when the practice is the research? Gillham and McGilp (2007) write about utilizing some of the records left that are part of the process of creating a work of art. These are items that are commonly discarded that are helpful for understanding the processes of artists. By using these data points, the authors hope that artists and designers can investigate their own processes. Sketchbooks are wonderful data for scholars. It is evidence of thinking processes often expressed in images but sometimes in words as well. Sketchbooks demonstrate the complexity of discovery. Utilizing these documents by placing them in order of completion, comparing them to final works, and revisiting their purpose may bring new ideas to light on how they contributed toward understanding the subject of study.

In my experience, I have found that many scholars with degrees outside visual arts are much more comfortable with arts-based research than artists. Artists whose primary study is the visual arts (M.F.A. students) become frustrated with the history and application of social science research methods applied to their discipline. The methods often feel too far removed from their experience as working artists. Each was developed and is typically utilized to improve understandings of education, learning, teaching, or schools and community. Arts-based research is a particular educational inquiry that allows the rich thinking of the studio process to have an impact on studying educational issues. There is nothing wrong with this perspective but it is generally limited to specific subdisciplines of the arts like art education and art therapy. The visual arts graduate student or faculty member may have such interests in education but the great number will desire other things from their artwork. This problem is certainly represented in arts research texts that are directed at artist scholars with a social science perspective. Arts-based researchers differentiate where they intend to go with their scholarship in comparison with M.F.A. artists who may be unsure where they intend to go with their work.

Practice-led research

Practice-led research is the term often used in higher education contexts where studio art is practiced. This is more typically practiced in programs instituting doctoral study in the arts. It is especially popular in the UK and has received little attention in the United States. The practice-led perspective has a history that reaches back to the 1970s and 80s in the UK (Sullivan, 2006). Arguing for the artist as researcher opened up funding opportunities and new academic career paths for artists in higher education.

Frayling (1993) provides a basic framework for practice-led research that includes three orientations: research into art, research through art, and research for art. Research into art is an investigation that could be historical, aesthetic, and theoretical. It is a process that allows the researchers to stand back from their work as an artist and investigate the artwork. Art is used as a data point in which knowledge is then generated from the analysis of the art. The artist researcher in this instance practices a detachment and uses methodologies from other disciplines like anthropology, history, and psychology. This approach makes artists uncomfortable because it relegates the artistic product of secondary importance.

Research through art attempts to take a subject and translate it through an artistic medium. The artist researcher could choose to study any idea and reflect, contextualize, and engage the subject through their art. According to Frayling this type of research creates knowledge through the interaction of the art and reflection. The knowledge then comes somewhere between the written text and artwork. This perspective is a middle ground and seems to be the most popular as the balance of text and art is manageable with the knowledge floating somewhere between but not tied to one or the other as a primary document. This approach meets the artist in the middle and provides a happy medium between art production and research.

The final category, Research for art or sometimes called research as art is the third option and is much more contested as a form of research among scholars. This perspective considers the artist to be a researcher and performing research during the studio process. The frustrations with research as art stems from the communicability of art products to stand on their own as research products. The issues discussed above—along with a lack of text—creates frustration among other disciplines who cannot use or cite such work in an effective manner.

The images presented demonstrate the frustrations with research for art. The communicability and debate over knowledge and understanding leaves the viewer wanting more. The written or spoken word becomes especially important. The latter perspectives reviewed are a bit friendlier toward the studio artist but they have largely been ignored at the M.F.A. level and reserved for doctoral students. The relegation of the actual art product to serve research is still a frustration and a characteristic that M.F.A. programs should strive to resolve.

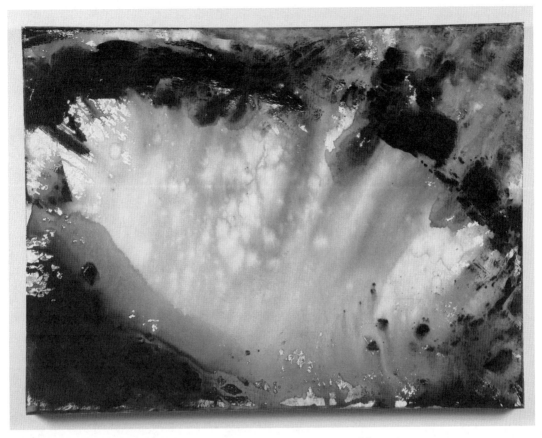

Figure 12. *Luminous Flux*, Amy Fox, 2009, Acrylic on canvas, Courtesy of the artist.

→▶▇ ◀▇◀←

The practice-led perspective is of incredible value and an important set of theories for reflecting on art. Problems with the development often arise from within the discipline. The historian and philosopher have often been burdened with shaping much of how we define and understand the visual arts. However, the artist is in the best position to understand and study the phenomenon of artistic practice since these other disciplines only study the object after its completion. The artist has access to a wealth of information in the studio ripe for development.

But the artist often does not want to talk about their artwork, as writing appears to do a lackluster job of getting to what the image already does. Plus there are many misconceptions of what research is and how it can be performed. Research could be

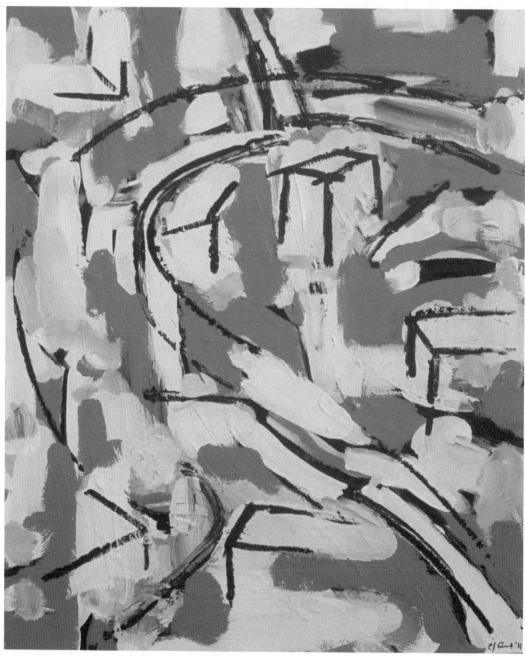

Figure 13. *Los Angeles Landscape*, G. James Daichendt, 2011, Acrylic on board.

understood as studying phenomenon, finding solutions to problems, analyzing general issues, reviewing and synthesizing existing knowledge, and investigating situations (Sarantakos, 2005). But to do this requires reframing of the artistic practice. Artists clearly address phenomena in their work but the contributions to new knowledge vary according to the artist. Plus the role of writing stifles many artists as they feel there is often not a need to talk about their work because words could not possibly substitute for the image and what it communicates.

Art practice can be theorized as research and Sullivan (2006) argues that understanding arises from the inquiry of artists. The problem for the artist researcher lies in creating and maintaining a consistent perspective to document and validate their artistic process as a form of research. Theorizing is fine but actually believing that your work is research is another story among artists who have a hard time admitting such a statement.

Issues surrounding knowledge production, theoretical perspectives, and the role of writing in relation to the visual arts are the major hurdles and tensions that challenge the growth of stronger writing and research standards for the visual arts in M.F.A. programs. The M.F.A thesis can improve significantly if these ideas are considered. I am not advocating adoption of a particular practice-based theory, only critical discussion to the value of writing and research in graduate study. The current supporting documents, essays, or display of knowledge/work accomplished during typical M.F.A. studies are not cutting it. The writing is not respected or disseminated outside small circles despite the cry that artists are researchers. The art is scrutinized however and if some of that energy was applied to writing, M.F.A. graduates could become much more influential beyond their field.

References

Arnheim, R. (1969). *Visual thinking*. Berkeley: University of California Press.

Barone, T., & Eisner, E. (1997). Arts-based educational research. In R. M. Jaeger (Ed.), *Complimentary methods for research in education* (2nd edn) (pp. 73–116). Washington D.C.: American Educational Research Association.

Barrett, E., & Bolt, B. (2010). *Practice as research: Context, method, knowledge*. London: I.B. Tauris & Co.

Cahnmann-Taylor, M., & Siegesmund, R. (Eds). (2007). *Arts-based research in education: Foundations for practice*. New York: Routledge.

Candlin, F. (2000). Practice-based doctorates and questions of academic legitimacy. *Journal of Art and Design Education, 19*(1), pp. 96–101.

Cantelupe, E. B. (1971). Picasso's Guernica. *Art Journal, 31*(1), pp. 18–21.

Cole, A. L., Neilson, L. Knowles, J. G., & Luciani, T. (2004). *Provoked by art: Theorizing arts-informed research.* Halifax, Nova Scotia: Backalong Books.

Dewey, J. (1957/1997). *Experience and education.* New York: Simon & Schuster.

Eisner. E. (1960). The loci of creativity in art. *Studies in Art Education, 2*(11), pp. 22–42.

Elkins, J. (2009). *Artists with PhDs: On the new doctoral degree in studio art.* New York: New Academia Press.

Frappaolo, C. (2008). Implicit knowledge. *Knowledge management research & practice, 6*, pp. 23–5.

Frayling, C. (2008). *Symposia: Creative scholars: Research economies in art and design—Part 1.* London: Tate.

Frayling, C. (1993). Research in art and design. *Royal College of Art Research Papers, 1*(1), pp. 1–5.

Gibb, S. (2004). Arts-based training in management development: The use of improvisational theatre. *The Journal of Management Development, 23*(8), pp. 741–50.

Gillham, B., & McGilp, H. (2007). Recording the creative Process: An empirical basis for practice-integrated research in the arts. *International Journal of Art and Design Education, 26*(2), pp. 177–84.

Gray, C., & Malins, J. (2004). *Visualizing research: A guide to the research process in art and design.* Burlington, VT: Ashgate.

Gruber, H. E. (1989). The evolving systems approach to creative work. In D. B. Wallace & H. E. Gruber (Eds), *Creative people at work.* New York: Oxford University Press.

Hetland, L., Winner, E., Veenema, S., Sheridan, K. M., & Perkins, D. (2007). *Studio thinking: The real benefits of visual arts education*. New York: Teachers College Press.

Hickman, R. (Ed.). (2008). *Research in art and design education: Issues and exemplars*. Bristol, UK: Intellect.

Irwin, R. L., & de Cosson, A. (Eds). (2004). *A/R/Tography: Rendering self through arts-based living*. Vancouver, B.C.: Pacific Educational Press

Lawson, B. (1990). *How designers think: The design process demystified* (2nd edn). Oxford: Butterworth-Heinemann.

Lazarus, P., & Rosslyn, F. (2003). The arts in medicine: Setting up and evaluating a new special study module at Leicester Warwick Medical School. *Medical Education, 37*(6), pp. 553–9.

Leavy, P. (2009). *Method meets art: Arts-based research practice*. New York: The Guilford Press.

Macleod, K., & Holdridge, L. (Eds). (2006). *Thinking through art: Reflections on art as research*. New York: Routledge.

McNiff, S. (1998). *Arts-based Research*. London: Jessica Kingsley Publishers.

Penny, S. (2000). Agents as artworks and agent design as artistic practice. In K. Dautenhahn (Ed.), *Human cognition and social agent technology* (pp. 395–414). Philadelphia: John Benjaminis Publishing.

Sarantakos, S. (2005). *Social research*. New York: Macmillan.

Skinner, A., Leggo, C., Irwin, R., Gouzouasis, P., & Grauer, K. (2006). Arts-based education research dissertations: Reviewing the practice of new scholars. *Canadian Journal of Education, 29*(4), pp. 1223–70.

Sullivan, G. (2006). Research acts in art practice. *Studies in Art education, 48*(1), pp 19–35.

Sullivan, G. (2005). *Art practice as research: Inquiry in the visual arts*. Thousand Oaks: Sage.

Taylor, J. S. (1998). *Poetic knowledge: The recovery of education.* Albany, NY: State University of New York Press.

Wallas, G. (1926). *Art of thought.* New York: Harcourt Brace.

4

ARTISTS AND WRITING

Writing and art making

The process of writing a master's thesis or final paper has become an accepted practice in the Master of Fine Arts (M.F.A.) programs in the United States. However, there is no standard for such projects, and most consider writing to be an auxiliary and unnecessary activity related to art production. Writing may be a part of these programs but the quality, type, and amount varies. The most common approach is in the artist statement, essay, or literature review. All 3 are positive approaches but the characteristics seem to bleed into one another. From my experience with speaking to M.F.A. graduates around the country, I am afraid that these theory-heavy papers are rooted in personal opinion and rarely meet any scholarly expectations that administrators and faculty expect from their students.

Writing is obviously a valuable activity but harnessing it for the purpose of making better art is my desire. What follows is a brief set of arguments for writing and the many benefits it offers the artist.

Common graduate writing strategies

As stated, the 3 most common writing assignments for M.F.A. students include the essay, literature review, and artist statement (although they make take different names and vary widely in quality and length). Yet all are good first steps for thinking deeply about artistic practice. Essays are a popular exercise in academia and take many forms. Common approaches to essay writing include arguments, criticism, and observations related to art practice. The essay is often used as a classroom tool for student artists to reflect on their education and practice. Huxley (2001) argued favorable for the essay format and considered it a creative genre: "By tradition, almost by definition, the essay

is a short piece, and it is therefore impossible to give all things full play within the limits of a single essay. But a collection of essays can cover almost as much ground, and cover it almost as thoroughly as can a long novel" (p. 330). Instructors find the essay is a useful tool to evaluate a student's understanding of a particular subject. Written from the author's personal point of view and forming a systematic argument or discussion, the essay is a format that allows the author to say almost anything about any topic.

In contrast, the literature review is a traditional academic document or component of research processes in the social sciences and is basically a collection of relevant art and research related to the subject of interest. Organizing a literature review is akin to a subjective understanding of a particular set of issues and includes an overview of the subject and analyzes the important aspects, authors, findings, etc. Overall it is comparable to the way a curator organizes an exhibition around a particular theme, concept, or artist.

Artist scholars start the literature review process by collecting resources related to the topic. These materials can be a range of data and include scholarly writings to unpublished poetry. In arts-related literature reviews, artworks, journals, and sketchbooks are referenced because they address a subject of interest. Using these sources appropriately is the key to constructing a meaningful literature review. Authors can summarize the ideas present but often they are organized to provide a structure and a synthesis of ideas or topics that occur in the material collected. This exhibition of ideas presents the scholar's understanding of the particular field and establishes them as a knowledgeable member of the community. It's not an argument or statement to promote the work of an artist. Instead it's a summary of research, as the scholar understands it. Artists are aware of others who are working on similar issues and the literature review is a formal document that demonstrates this understanding in a written form. Artists who complete such a task are placed in a better context for grabbling issues related to their work and the accomplishment of completing a paper demonstrates their expertise. Similar to a handbook, the literature review reports up-to-date info on a specific topic and where another researcher can find it. The literature is a valuable tool for student artists and one I highly recommend artist scholars accomplish in their studies.

However, the artist statement is most practiced among artists in all contexts. Usually a testimony of the interests, background, and goals of the artist, this document explains, justifies, or contextualizes the work of the artist. The artist statement is useful for understanding the artist but it does not typically communicate the richness and complexity of artworks and processes. It certainly is not a scholarly document and the quality and importance of these statements varies. The best artist statements prepare viewers to enter and engage the work of an artist with good standing. They range from a few sentences to a few paragraphs and appear in exhibitions and publication inside and outside the university context.

The essay, literature review, and artist statement are the most common types of graduate writing but are clearly not equal. The artist statement pales in comparison as an academic document and is often the weakest and least useful. An essay or literature review can be much more robust and academic in design and can potentially satisfy the requirement set by an M.F.A. thesis committee.

Why write?

Writing is a positive exercise for artists because it forces the artist to make decisions and aids their own understanding of the choices made in the studio. It stimulates thought and allows the author to evaluate their ideas in a concrete manner. Writing also has a positive impact on understanding artistic products in general (including museum visitors). Cupchik, Shereck, and Spiegel (1994) found that artworks were thought to be more powerful and personally meaningful after the subjects wrote interpretations. The interpretations from the individuals only increased their interest once they wrote their thoughts. This is in contradiction to solving a word problem or mathematical equation that becomes less interesting once solved. Instead the interpretative exercise through writing opens up more avenues for inquiry and thought. This act of reflecting forces thinking and requires the artist and viewer alike to make decisions and interpretations. Writing is a valuable exercise for art appreciation in general and has the potential to be quite revealing when the artist enacts this process.

Writing fosters the ability to traverse complex ideas and there are a host of justifications for going further. Writing has the potential to make thinking directly communicable. Writing also can contextualize artwork in history or in a specific area of expertise. Writing can preserve ideas so they can be reflected upon. It can allow the artist to move among a conglomerate of complicated concepts and allows the reader/viewer to share the experience. It is reproducible, portable, and permanent. And lastly, writing is not as complicated or multifaceted as art making, otherwise we would all be writers and not artists—but writing allows processes and products to have an impact they may never have had in other fields.

Garner (2008) appropriately questions why art making (he specifically refers to drawing) has to be converted, interpreted, or accompanied by a verbal or written explanation. Frustratingly, the hierarchy of the written word is difficult to overcome. The written word is easily transferable, accessible, and portable compared to art products that are problematic at best to reproduce and communicate logically. Artist scholars are certainly quick to recognize the significance of the written word and the important role it should play in artistic research but it does not lighten the frustrating and impossible task of converting artistic products into a written product. I agree with

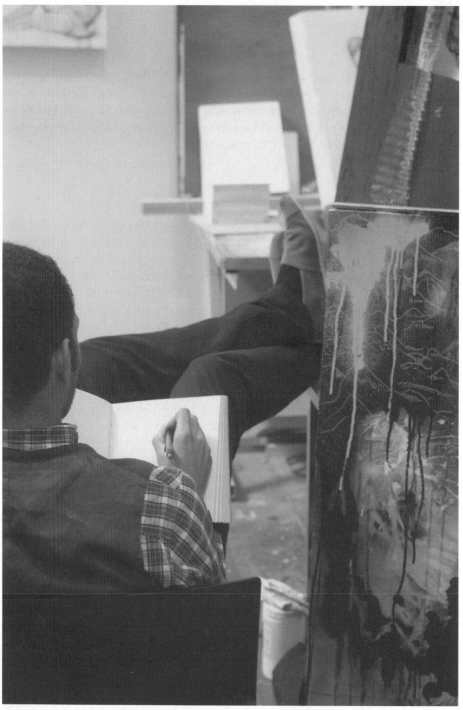

Figure 14. Visual art student and designer Student Staphon Arnold documents experiences in a sketchbook, Photo by G. James Daichendt.

these frustrations, and it is important to consider that the scholar in artist scholar is an addendum to artistic practice, not a central component. I do not doubt that art practice involves research, however scholarship will stand on its own in a much better light if it is combined with artistic processes and products. Artist should not be required to translate their artistic work or process into written form but that does not mean arts scholarship cannot help artists explore their own work or possibly organize their thinking in a more helpful way. The role of writing is not to stand in place of artwork but to act as a supplement and partner in the scholarly process.

The philosopher Immanuel Kant (1790/2000) in the *Critique of Judgment* raises important issues that many artists embrace regarding the unspoken qualities of their art. In his text, Kant explores aesthetic judgment and its relation to artistic genius, where he likens aesthetic ideas to rational ideas and thinks that aesthetic ideas are physical creations that no concept is adequate to explain. Writing or talking about the artistic product is helpful but explaining aesthetic judgment according to Kant negates this aesthetic appeal. This is a reversal of rational ideas that are presented in words but cannot be presented as art. Aesthetic ideas and rational ideas are thus complementary and exclusive to one another because they cannot communicate the same type of knowledge. The artistic genius is the individual who can create aesthetic ideas. However an attempt to explain the art product and why it is sublime or beautiful would prove foolhardy. Under Kant's idea of genius and aesthetics, artists are geniuses and you cannot explain genius—otherwise it is not the sublime or beautiful creation you knew it to be. This is applicable to artist scholars attempting to equate words to their art. Trying to explain an aesthetic object will be unsuccessful because the words will fail to recognize the key aspects or aesthetic judgments.

This line of reasoning is justifiable and a frustration for artists who feel their work cannot be defined by the written word or an attempt to define or explain would only capture a small perspective of the overall picture. However, scholarship in the arts is much larger and can accommodate such a philosophy. The ability to unscramble reasoning behind art objects is a difficult task and the burden falls upon the artist to clarify the object and its contribution—but this is not arts scholarship, instead it is a glorified artist statement. There is a difference between what art communicates and what it contributes to our shared knowledge. Interpretation is not the goal but rather it's about investigating and reflecting upon a process or subject. By shifting perspective, the artist scholar has the opportunity to study what they do.

Mey (2006) understands writing is much different from art practice but a worthwhile endeavor so one can articulate the relationship between "learning as situated understanding, knowledge-in-action and reflective thought" (p. 202). Clear writing is a sign of clear thinking, and writing about art processes and art products give the artist an opportunity to heighten awareness to a host of issues. Mey compares writing to a gesture, a term used in drawing. Thinking of letters and words as gestures or marks

breaks downs some of the animosity artists have toward writing. "The gesture of writing is a gesture of work that realizes thoughts in the form of texts" (Mey, 2006, p. 206).

Writing critically

The writing of art critics is a form of qualitative investigation not unlike scholarly work. Dewey (1934) praised the critic and their ability to lift the veil that obscured the eye from seeing. Just as Eisner (1976) associated a critical eye toward improving educational contexts, the same critical eye is used by the artist on their own art making. Scientific research is concerned with larger laws and rules, yet the reflective writing advocated in this text is about making sensitive and complex observations visually, experientially, and textually. The Appendixes include a brief example of art criticism based upon reflection for understanding. It's not an interpretation but a study of the major influences on a work of art.

The 4 dimensions of criticism according to Eisner (1985) are description, interpretation, evaluation, and thematics. Eisner feels that artist scholars need to go beyond being connoisseurs and become critics. Being a connoisseur involves the original meaning in Latin: *cognoscere* (to know). As connoisseurs the artist scholar can name and identify various aspects and how they relate. This also includes the role of context and our subjective values and dispositions. "Connoisseurs simply need to appreciate what they encounter. Critics, however, must render these qualities vivid by the artful use of critical disclosure" (Eisner, 1985, p. 93).

Descriptions enable the reader and writer to see the artwork that is under investigation. The following 2 stages (interpretation and evaluation) include value judgments. This process enables the reader to see the qualities of something (positive and negative). Critical writing like this is an option and one that the artist scholar can invoke for their own work or the work of others.

Writing and higher education

Art practice as a form of research has gained quite a bit of momentum in recent decades. Here students explore the interaction between research and art making in degree programs that emphasize writing along with art making. Logically this seems to be the next step in artist education since the great majority of disciplines within the university system offer doctoral degrees in the liberal arts. However, the terminal degree required to teach at the university level is the M.F.A. This distinction creates misunderstanding among colleagues who use the doctoral degree as a badge of distinction and feel that because artists do not posses a Ph.D. they cannot produce

scholarship. This is a frustrating circumstance that causes artists to doubt their contributions and lessen expectations. Raising the bar for M.F.A. writing is the logical step toward producing better artistic scholarship. Creating a Ph.D. program in the visual arts without a proper idea of what arts scholarship entails will be a frustrating endeavor for all involved (previously noted by Elkins, 2009).

A plethora of texts address the issue of writing and research. These publications present much of the initiatives necessary to cultivate academic study through the visual arts (Cahnmann-Taylor and Siegesmund, 2008; McNiff, 1998; Sullivan, 2005). A history of this thinking is present in the 1970s when educational researchers adopted art practices as a way to facilitate research (Eisner, 1976; Greene, 1975). Essentially this was a method of using art practice to inform a social science agenda. Because of these foundational texts and methodologies, artists are now writing formal research projects in order to validate or explain their art-making processes or the final artworks they produce.

<p style="text-align:center">⇥⊕ ⊕⇤</p>

The importance of writing should not be overlooked in this instance whether it is for understanding or knowledge production. Writing is the common denominator among research disciplines and it is through this media that the artist's thinking can be transferred and communicated within the university. Art is the main subject of concern and writing about the artistic process will clarify the knowledge bits that are being manipulated by the artist. Not only will writing by artist scholars push the work of artists further, it will also serve the artist and their work and they will have a better understanding of their thinking process.

As an art teacher, I value the myriad choices artists make in their work and the complex set of symbols that are manipulated through media. The movement of a brush across the canvas can create anxiety, calmness, or excitability based upon the pressure or direction of the hand. The colors, forms, and lines the artist chooses each change the way the viewers respond. Simple changes can have a profound impact and twenty-first-century artists have unlimited choices as to medium and concept.

References

Cahnmann-Taylor, M., & Siegesmund, R. (Eds). (2008). *Arts-based research in education: Foundations for practice*. New York: Routledge.

Cupchik, G. C., Shereck, L., & Spiegel, S. (1994). The effects of textual information on artistic communication. *Visual Arts Research*, *20*(1) 39, pp. 62–78.

Dewey, J. (1934). *Art as experience*. New York: Minton, Balchand Co.

Eisner, E. (1985). *The art of educational evaluation: a personal view*. London: Falmer Press.

Eisner, E. (Ed.). (1976). *The arts, human development and education*. Berkeley, CA: McCutchan.

Elkins, J. (2009). *Artists with PhDs: On the new doctoral degree in studio art*. New York: New Academia Press.

Garner, S. (2008). *Writing on drawing: Essays on drawing practice and research*. Bristol, UK: Intellect.

Greene, M. (1975). Curriculum and consciousness. In W. Pinar (Ed.), *Curriculum theorizing: The reconceptualisits* (pp. 295–8). Berkeley, CA: McCutchan.

Huxley, A. (2001). *Complete essays, vol. 4: 1936-1938*. Lanham, MD: Ivan R. Dee.

Kant, I. (1790/2000). *The critique of judgment*. New York, Prometheus Books.

Macleod, K., & Holdridge, L. (Eds). (2006). *Thinking through art: Reflections on art as research*. New York: Routledge.

Mey, K. (2006). The gesture of writing. In K. Macleod & L. Holdridge (Eds), *Thinking through art: reflections on art as research* (pp. 201–212). New York: Routledge.

McNiff, S. (1988). *Arts-based research*, London: Jessica Kingsley Publishers.

Sullivan, G. (2005). *Art practice as research: Inquiry in the visual arts*. Thousand Oaks: Sage.

5

REFLECTIONS ON KNOWLEDGE AND UNDERSTANDING

Art making and understanding

A great number of the Master of Fine Arts (M.F.A.) programs in the United States maintain research expectations for their graduate students and a growing number of studio faculty are taking part in more formal research investigations, yet there is not a text that specifically addresses the concerns of this highly intellectual group. The key difference is that M.F.A. students and artists interested in scholarship will find that their starting points for research will develop out of their own studio practice. This is not the case for nonarts researchers and educationally focused studies that may use art-based data-collection procedures.

The voice of the artist is important to reflect upon because it leads to better understanding for themselves and others. The knowledge brought to the realm of scholarship by art practitioners is credible and trustworthy because of the insider status artists' maintain (Gray and Malins, 2004). Artists are natural data collectors and the knowledge they manipulate cannot be contended. However it is the analysis of this knowledge and the eventual products of artists that are often questioned.

In order to go forward and lift the quality of writing, artist scholars must address the role of knowledge and understanding in their work. This is a theoretical discussion with implications for how they will see their art functioning in the larger world. The following chapter addresses a few issues of writing about knowledge and understanding and how it may impact art making through writing and research.

Art practice and new knowledge

The implications of knowledge and arts production have been a debatable topic for many decades. Hickman (2008) reviews these early debates from the 1970s where art was compared to language and encouraged to be seen as a broad and inclusive discipline. It is established that the arts are quite different from other areas of knowledge and can only be realized when there is interaction with the art object. The arts are characterized as fluid, dynamic, and organic, in which Hickman interjects that "the arts offer a way of understanding the world which goes beyond language" (p. 20).

I continue to have the pleasure of teaching a number of graduate research courses that seek to facilitate research for students earning their M.F.A degrees in visual art and M.A. in art education. The difference between the two fields of visual art and art education is staggering. While the art education students seek to use art making as a method for studying educational issues, the fine arts students have no interest in contributing toward a consistent area outside their own studio life and question the relevance of such study.

The art education students feel they are contributing something to a larger puzzle while the fine arts students do not feel they have the authority to make such a contribution. The fine arts students realize that what they do is valuable but they do not see their practice as contributing something new. Instead they are aware of the field they study and realize how they are interacting with it but these suspicious feelings linger because of their lack of expertise in that field or concept. Even when art students buy into the idea of art research they still have their doubts. The experience or study reveals more about their own work and what it means to them rather than a new insight into the subject of interest. Is this really new knowledge? How can I be sure? They often ask. And this seems fair. After all artists working on their M.F.A. degrees want to be better artists. I believe this is not a reaction that should be ignored. From years of working with artists I have encountered the frustration again and again when regarding their work or process as a form of research.

Certainly, artists perform research in the generic sense. Research is a common activity. One researches the best prices when shopping for a car among a host of other important issues. Artists also engage in this process of generic research in their studies and their artistic process. An artwork requires research about materials, subjects matter, conceptual ideas, and location/context, among other issues. It is not uncommon for an artist to read dozens of books, review lists of paintings, and seek inspiration from dialogue. This research is common but it is loosely organized and not systematically planned like research studies performed in the university context. Within the twenty-first-century university, research has become a term that implies the researcher is contributing some type of new knowledge and students often express doubt whether their art is a form of knowledge.

The materials and subject matter of artists is as diverse as one can imagine. Anything is a possible material or subject for inquiry. Thus the knowledge pool extends to include everything and it is easy to consider use of such diverse materials impressive (which it is). But just because an artist knows a lot about quantum physics does it mean she is contributing new knowledge when this knowledge is organized visually in a painting? Artists do alter our thinking, cause us to rethink what we understand, and highlight issues of importance. If they did not, we would have a difficult time interacting and thinking about artworks.

Authors are constantly attempting to demonstrate that new knowledge is possible and that it is an expected outcome of serious inquiry by artists. This is not made in vain and I believe it is a valuable inquiry because the visual arts constantly need to explore the boundaries of the subject. The history presented in previous chapters demonstrates why the visual arts professor and graduate student sometimes feel uncomfortable in their university role. Art professors may be great teachers and add an aspect to the liberal arts philosophy but the expectations of research create an uncomfortable tension. In addition, graduate students and professors who seek funding and support also require this research language applied to their art to compete with others outside their discipline. Granting agencies are sympathetic toward traditional research conventions, so it should not be a surprise that artists are fighting to get their share of support. The importance of prestige that comes with respected academic disciplines cannot be overlooked, and the research language adds an element of respectability to processes and products that are not typically understood to be equal to books and articles.

Sullivan (2005), an avid artist and researcher, captures much of the frustrations and trials regarding new knowledge and art research. He draws initial comparisons with the health-care industry and their struggle to see themselves as creators of new knowledge. Because their knowledge came from care and not the cure, their identity as knowledge producers did not match with accepted medical language. Instead it was knowledge based in practice that drew from the multiple realities of patients. Thus their knowledge came from their practice with patients. This idea of practice-based knowledge is applicable to the visual arts and certainly has credibility. However, the example directs the understanding of the medical practitioner toward a particular subject (patient study). In this manner, artists can provide new understanding about a subject that could be considered new knowledge. This example is directly applicable to art-based researchers who hope to better understand issues like education or art therapy.

But what we consider knowledge is also a point of contention among artists and researchers. Sullivan describes a notion of knowledge that can be constructed and values multiple realities. He writes:

Conceptions of knowledge are grounded in theories, beliefs, and values, and different epistemological views will have implications for the methods of inquiry we use… that traditional modes of research have a hard time accounting for the breadth and depth of knowing we associate with the full scope of human understanding. For many it is the outcome of other ways of knowing and creating knowledge within the studio contexts of visual arts that offers different yet complimentary pathways in coming to understand things.

(Sullivan, 2005, p. 82)

Sullivan's explanation of knowledge production values an ever-expanding list of experiences as knowledge. The facts and information related to the fields of study by artists do not change because artists take them on or examine them in the studio but they are altered from the process and products produced. By reorganizing bits of knowledge the artists in theory produces new insights and understanding on that subject.

Knowledge is loosely defined in the American language and this leads to its misuse in these matters. Knowledge by definition (through Merriam-Webster) could be considered:

- The fact or condition of knowing something with familiarity gained through experience or association.
- An acquaintance with or understanding of a science, art, or technique.
- The range of one's information or understanding.
- The circumstance or condition of apprehending truth or fact through reasoning.
- The fact or condition of having information or of being learned.

A basic definition, it appears to be along the lines of what artists do in the studio. Artists do gain familiarity with subjects and experiences, artists do understand subjects and techniques, artists do gain information and understanding, artists do apprehend facts and truth, and they do learn about a range of subjects and phenomenon. It is important to also consider that artists judge, ignore, argue, make decisions, question, and provide an outlook on topics with an added disposition of being artists who use imagination, skill, and aesthetics to differing degrees. Researchers study subjects in a detailed and accurate manner and have initial questions that guide their search. Artists in M.F.A programs are not bound by these constraints and it is not uncommon for artists to react to the material, play with media, or experiment without an ordered purpose yet still produce knowledge through their experimentation.

Subject-based knowledge

Hoffert (2010) offers a fascinating comparison between the visual arts and other disciplines that contribute new knowledge to their respective fields. He writes that new knowledge in the field of medicine results in improved health care, new knowledge in microbiology results in better medical treatment, and that new knowledge in engineering contributes to building better structures and machines. According to Hoffert new knowledge is evident in the changes in these particular fields. It is difficult to argue with these statements and I agree with Hoffert's basic ascertainment that particular fields can be improved based upon research and new knowledge. The problem is that these fields recognize new knowledge in a concrete manner. This knowledge can be replicated and verified. The artistic process and the products of artists are more complicated. New knowledge can be gained but it is likely that we are just thinking differently about a topic (which is a form of understanding and knowledge). Art may not change the human condition for the better or worse. Sometimes it is just an idea for discussion, a criticism of an existing idea, or something we did not consider or reflect upon about before. This is a history (in the visual arts) that values the new and old knowledge on equal footing (unlike the sciences where new replaces the old).

To make a connection to new knowledge and the visual arts, Hoffert (2010) selects particular genres of visual art. Hoffert states that new knowledge in environmental art will result in a richer experience of nature. Using the Barbizon painters and the Hudson River artists as examples, he displays a connection to their activist mentalities that had a positive impact on the nineteenth-century-environmental landscape. These artists through their inquiry/practice and serious study were awakened to issues that were problematic and sought to do something about them. They started to understand the landscape and its importance and sought to do this on canvas. They then brought these issues (that were raised through their thinking) to the understanding of their elected leaders and raised a shared awareness and understanding. These painters bettered society and critically examined an important issue through their study of the landscape. They highlighted something and engaged an issue that they understood and provoked additional awareness. The Barbizon and Hudson River artists were just starting to understand the importance of environment and felt they should act upon it (an example of applying a new understanding of the world).

These painters were doing what artists do best in the studio—critically engaging issues of importance to individuals and society. They questioned the imposing industrial revolution and they saw the negative impact it had on nature and fought for its protection. This is a valuable process and perspective to have within the university, as artists question what other folks might consider a given. The artist's voice is needed in the university and the larger society not because of new knowledge contributions

but for questioning our collective knowledge, organizing what we know, and how we use it.

A simplistic explanation of knowledge does not even begin to capture the rich and complex way artists think. The knowledge of the visual arts is more nuanced then simple comparisons to other fields. Holbert (2009) addresses this essence when he writes:

> The multifarious combinations of artists, teachers, students, critics, curators, editors, educators, funders, policymakers, technicians, historians, dealers, auctioneers, caterers, gallery assistants, and so on, embody specific skills and competences, highly unique ways and styles of knowing and operating in the flexibilized, networked sphere of production and consumption. This variety and diversity has to be taken into account in order for these epistemes to be recognized as such and to obtain at least a slim notion of what is at stake when one speaks of knowledge in relation to art—an idea that is, in the best of cases, more nuanced and differentiated than the usual accounts of this relation.
>
> (p. 1)

Holbert is describing the many perspectives that contribute to knowledge in the visual arts. The competencies and roles mentioned all point toward the many perspectives for creating, understanding and learning in the arts. A rich approach that could draw similarities to the way educators have attempted to describe visual learning and its uniqueness compared to other types of learning styles. Gardner (1993) developed a theory of Multiple Intelligences, which refers to the various ways people learn. Kinesthetic is one type of intelligence that applies to the way a person can process information through hand, body movement, control, or expression. This might include activities like drawing, sculpting, dancing, or anything practically hands-on. As one imagines the possibilities, we realize that artists can potentially work with knowledge that can encompass any discipline.

In an attempt to think about the problems of research and the arts, the Research Assessment Exercise (RAE) is undertaken every 5 years on behalf of higher education councils in Great Britain to evaluate the quality of research in higher education institutions. During the year 1996 the RAE sought to define

> original investigation undertaken in order to gain knowledge and understanding. It includes work of direct relevance to the needs of commerce and industry, as well as to the public and voluntary sectors; scholarship; the invention and generation of ideas, images,

Figure 15. Visual art student Jessica Baker uses a variety of materials and concepts,
Photo by G. James Daichendt.

performances and artefacts including design, where these lead to new or substantially improved insights; and the use of existing knowledge in experimental development to produce new or substantially improved materials, devices, products and processes, including design and construction.

(Piccini, 2002, p. 1)

The key aspect of this definition is to gain knowledge that has relevance to industry, commerce, and public sectors. The result must be in an improvement of some sort that can be manufactured. Piccini (2002) continues with the refined definition of research on behalf of the Arts and Humanities Research Council (A British Research Council that provides government funds to support post-graduate research in the arts and humanities), the 2005 successor to the Arts and Humanities Research Board. The new definition of research includes three features:

1. One must define a series of research questions that will be addressed or problems that will be explored in the course of the research. It must also define its objectives in terms of answering those questions or reporting on the results of the research project.

2. One must specify a research context for the questions to be addressed or problems to be explored. You must specify why it is important that these particular questions should be answered or problems explored; what other research is being or has been conducted in this area; and what particular contribution this particular project will make to the advancement of knowledge, understanding and insights in this area.

3. One must specify the research methods for addressing and answering the research questions. You must state how, in the course of the research project, you are going to set about answering the questions that have been set, or exploring the matters to be explored. You should also explain the rationale for your chosen research methods and why you think they provide the most appropriate means by which to answer the research questions.

These protocols are insightful and telling of the direction of arts research in the UK. Although they are up for interpretation and future revision, the state of art research in the UK is based in traditional qualitative research methods. Questions are asked at the outset, a systematic explanation of how these questions will be answered is needed, and the research context must be established, along with an explanation for

the current need for the proposed research, in addition to selecting a research method. Similar to the creativity paradigm mentioned earlier, the artistic process can follow a linear process and function like traditional research paradigms if organized properly. These are not poor suggestions. In fact any good research process should include these elements. The frustration is that the artistic process often does not work this way.

Knowledge and research or understanding and writing

Combined Elkins (2009) and Mey (2006) argue that understanding and writing are more sympathetic to the difficulties in understanding what the arts contribute within the higher education context. These ideas are more akin to the goals of M.F.A students earning their degrees as artists. Rather than framing art production as a knowledge generator, Elkins (2009) posits the term "understanding" possibly replacing the usage of "knowledge" and Mey (2006) suggests using the term "writing" instead of "research" to combat the legitimate issues artists encounter when they do not view their work as a form of traditional research. This does not mean artists do not produce new knowledge or conduct research through their art making or finished art products, but instead it is a suggestion for reframing the way artists can approach artistic scholarship in the university. Artists can potentially create new knowledge, but the larger question is this: is it more reasonable to suggest that artists from a macro perspective are constantly challenging issues and concepts that already exist and force the viewer to think differently about them? Whether this is new knowledge is debatable and is an issue each artist should consider.

Artists and their educational goals of learning or teaching through artwork are akin to the term understanding. There are hosts of artists that have sought to raise awareness or attention to important issues through their artwork. Popular topics include economics, race, war, and politics. Robert Indiana and his series of LOVE sculptures, prints, and paintings is a good example of artwork that increased understanding on the part of the viewer and artist. The piece originated during the Vietnam era and symbolized peace and its importance in society during a time when anger and frustration appeared to blanket the nation. The goal was not a new type of knowledge but increased understanding that hopefully would create action by participants.

Philosophically the concepts of understanding and knowledge cross many paths and some arguments can be made for the change in terminology. Holbert (2008) draws a comparison to Foucault's argument that "the technical, material, formal, and conceptual decisions in painting are traversed by a 'positivity of knowledge' which could be 'named, uttered, and conceptualized' in a 'discursive practice'" (p. 1). This secret knowledge is not entirely clear though and has been the frustration of artists

who know but cannot explain how they know. Foucault (1972) is receptive to knowing things artistically despite the elusive nature of artistic thinking. He used the term discursive practice for organizing different forms of knowledge into statements but how this happens is a bit of a mystery. Foucault believed one could analyze a painting and reconstruct the hidden discourse of the painter. Artists are in the best position to think about this type of understanding. Whether it is through reflection or a host of other writing techniques, the artist is the only one who can tap into this hidden practice that artists refer to as studio time. Writing to better understand this process seems to be an admirable goal and one that could greatly benefit any artist, especially one in the university.

There are shortcomings to using a term like "understanding" instead of "research." The term can be vague, and just about everything we do adds to our understanding of the world (Elkins, 2009). The term could be applied in a number of situations and may be too pliable for describing what artists do in the studio. In fact something as simple as repeating what someone said adds to our understanding. But is that not what many artists do in their own education? Copying from masters adds to an artist's understanding of a subject, technique, or tradition. "Understanding" seems to be too big and too vague of a term but that is exactly the type of term that is needed to capture a process that is too diverse and multifaceted. The point is not to replace research completely with understanding but only to use it when applied to writing about artwork.

In particular circumstances, artists will view their work as a type of research that contributes new knowledge. With all research projects, particular methodologies that suit the objectives of the project need to be developed. The arts as a form of research are no different from other qualitative traditions and such a perspective should be embraced to meet the variety of artistic processes and the potential that artists hold in their art making and thinking.

Anyone who has spent time looking at a piece of art in depth knows that there is much the viewer can learn and understand about life by thinking and looking at art. In fact many developmental theories regarding aesthetic development consider engaging artwork similar to engaging an old friend when viewers are very experienced about the nuances of visual imagery (Housen, 2002). The highest levels of aesthetic development move beyond information recall and storytelling and are more personal and poetic in their interpretations of the experience viewers have with art. Engaging art at the highest levels means understanding it better. One learns more and more each time they encounter the image, learning the subtitles and nuances it holds. Another theorist, Parsons (1978) considers understanding of culture and history an important component of development. Understanding again is the key component used to articulate the high level of engagement. Regardless of the theorist, understanding plays an important role when engaging artwork at the highest level.

New knowledge and research are rarely mentioned and are not something theorist considers when hoping to comprehend what happens when folks engage art. There is much to learn and understand in these engagements; although the knowledge may already exist, the viewer understands the art better through these engagements. Knowledge and understanding are different concepts and while they are sometimes used interchangeably, understanding is much more akin to the artistic process from a bird's eye level than knowledge production.

New Knowledge can be produced through art making but increased understanding deserves our attention. "Understanding" as a concept utilizes knowledge. Both the artistic process and the process of understanding are difficult to define but sound very similar when they are broken down in the abstract. For example, both processes of "understanding" and "art making" can result in abstract or physically real products. Initially the thinker or artist is able to think about the abstract thought or physical object and deal with it by using concepts available to them. The process works from conceptualization to understanding with understanding being a threshold that the artists cross over when they begin to create an actual product.

Artists visualize this limit when they have acted upon the knowledge in some way to demonstrate understanding. During the process of inquiry, artists demonstrate this understanding through the manipulation of materials. This could be a statement or physical response but in the case of an artist, the creation of an art product is the result of such understanding. I envision the threshold that artists cross over in their understanding to be a long and wide area rather than a decidedly simple line that is crossed. Reflecting on this journey is a valuable inquiry for artistic scholarship that allows artist scholars to better understand their own thinking.

Reframing art practice as a mode of understanding opens up many possibilities. Artists use many different types of information/knowledge/data. They practice an awareness of information and manipulate how these ideas are connected and put to use. This is a deep way of knowing that goes beyond a psychological or behavioral definition of understanding and values what we can observe in the studios of artists. Thus understanding can fall short in defining the studio process but it is important to remember that it is only a tool for studying something that is ever changing.

Elkins (2009) writes, "The concept of *understanding* is promising because it has much deeper and broader intellectual history" (p. 117). Understanding implies being able to apply what you know, and artistic practice is ripe for such comparisons. Knowledge already exists whereas understanding in contemporary practice is ongoing. This is akin to the artist studio, where connections are constantly being made. The studio may not be a neat and tidy place but neither is the process of understanding.

I am reminded of a teaching exercise instituted by the famed Bauhaus instructor Johannes Itten who taught his students how to understand the different ways a lemon could be represented. The students increased their understanding of what a lemon is,

how it tastes, and smells. Traditionally when preparing for a still life of lemons, students set up the fruit, organize the details, and compose a picture that contains proper proportions, coloring, and perspective, an academic exercise that any first-year art student would be expected to perform. Normally students would carefully sketch this composition and strive to record it accurately with their paintbrushes, pens, pencils, or a host of other media. The main emphasis is in proper representation of the lemon still life. Emphasis to set a balanced composition and ensure that perspective is accurate would be the typical goal. However, Itten desired to open their understanding of the materials and the symbolic aspects of art making. Instead of following this traditional academic exercise, Itten asked his students to cut the lemons open, taste them, and feel the texture of the lemon between their fingers. After feeling the sting of the sour fruit in their fingers and tasting the bitterness in their mouths, the students were asked to draw the essence of the lemon. As you can imagine, there was much more to their drawings of lemons than proper perspective. Color, line, shape, and form were used to represent these new sensations. Abstract compositions with texture and color exploded off the canvases to symbolize a feeling or taste that overwhelmed the senses. This process of inquiry and knowledge acquisition allowed the students to gather data about lemons and apply it in drawings that demonstrated an understanding of the subject. They did not create anything new about lemons but their art taught the viewer a bit about how the individual artist understood their experience with the lemons. Understanding implies being able to apply what you know and their artistic products are visual representations of this understanding.

Understanding has potential as a conceptual placeholder for artistic inquiry but it should be argued and placed in a context. How does your work provoke understanding or how do you as an artist produce new knowledge? Once this decision is made, what is next? Reflecting, thinking, and writing about the decisions that were made to create the final product are the essential next steps to capturing what exactly happens in the studio (and determining what you have found to be true). This process of studio work is often more than one big decision but happens through a gradual culmination of many small decisions that eventually lead to a final art product and the artist's view on the subject/topic.

So what kind of new knowledge and understanding is being developed? Jones (2006) argues that this new knowledge could be aligned with the study of human consciousness. Jones cites the great modern painters of the past like Monet and Seurat and their success in increasing an understanding of perception. An exploration of consciousness, research, and writing certainly appear closely aligned with subjective experiences and understanding.

Art helps us understand what is good, true, and beautiful in addition to what is bad, false, and ugly. I do not use these terms in the strictest fashion, but instead to emphasize what artist scholarship really does is help us understand issues that are complex and multifaceted. Questions that do not have easy answers are the typical domain of the artist and keep the viewer coming back for more. The answer is not always the point, but an interesting question raised through a sculpture can cause critical contemplation on the part of viewer that aids their understanding of beauty. Beauty is a popular topic to many artists but you cannot measure these contributions in the scientific sense. These contributions are beyond the physical world. Beauty itself does not have a constant presence and cannot be counted or measured. But many artists engage this topic by questioning beauty and what it means in different contexts and cultures. Through these products we gain a better understanding of beauty. Determining how the artist came to this understanding through writing is the domain of the artistic scholarship paradigm discussed here.

Given my support of such ideas, there are many artists who practice nonsensical thinking and are prime examples of artistic thinking gone awry. These artists often make headlines for their exploits and can sometimes sour the complex symbol systems that artists use. An outcry by the press usually follows such stunts. For example, an art student at Yale attempted to artificially inseminate herself and then followed it up by inducing a miscarriage. While the proposed artwork certainly would provoke attention, shock and charade, it begs the question whether the artistic process held some serious inquiry that led to a better understanding of a topic worthy of investigation. Trivial stunts do not add up to much where scholarship is concerned and we can learn much from looking at art like this and asking questions about the thinking that led up to it. The frustration with the anti-intellectualism and illogical thought disguised in art is something most folks have run across at some point in viewing art. This culture of ridiculousness has been lampooned and acknowledged. The musician Brian Eno captures this frustration when he states: "Unfortunately, however, the intellectual climate surrounding the fine arts is so vaporous and self-satisfied that few of these questions are ever actually asked, let alone answered" (Eno, 1996, p. 258). Asking good questions is the key and sound artistic scholarship ensures that it is placed in a context that illustrates its usefulness. Easy solutions are not found in interesting or difficult questions. Good questions have not been asked and require serious study. If you know the answer, why are you investigating it? The art student at Yale knew what she was doing and based upon the cancellation of her performance nothing was gained through the artistic practice (besides controversy). Andy Warhol's often quoted saying "Art is what you can get away with" certainly applies. I do not want to discredit this student entirely. Positioned correctly, her piece could yield an interesting study but either her intentions were not reported accurately by the press or it was a simple stunt that does not represent the richness studio processes have the potential to encompass.

Needless to say, all writing about art will not qualify as sound research or scholarship. The artist scholar must be reflective on their decision-making and the line of inquiry they pursue. "Reflective practice therefore attempts to unite research and practice, thought and action into a framework for inquiry which involves practice, and which acknowledges the particular and special knowledge of the practitioner" (Gray and Malins, 2004, p. 22). Artists have a special knowledge of their subject and or process that authors have difficulty acknowledging and it has been called a number of terms over the years (Arnheim, 1969; Barber, 2009; Cahnmann-Taylor & Siegesmund, 2008; Hetland et al., 2007; Macleod & Holdridge, 2006; McNiff, 1988; Frappaolo, 2008; Taylor, 1998). Artists are not required to write in order to identify what they know or discover, but I do not foresee many artists going through life without talking or writing about their scholarship. It is a process that can only aid artists and their education.

The essential ingredients of a final defense include the artist scholar and a board of experts that determine if the work by the candidate contributes toward the field in question. Study leading to this includes developing a research question/agenda, supervision by a senior researcher, multiple reviews and opportunities for feedback, and the final examination/defense. Essentially the individual then makes an argument responsible for this body of work and if it is persuasive enough, it represents a form of new knowledge. A peer-reviewed process, the M.F.A. students currently do this with their exhibitions but rarely apply it outside the visual (like a written format). This process and these individuals must be convinced that the contribution does what it claims. Be it new knowledge, understanding, research, or writing—it must be convincing. The doctoral programs in place have set an example for valuing this inquiry through a form of application. Knowledge production will never be resolved because of the elusive nature of the subject—especially in our postmodern context (Jones, 2006). The malleability of the arts and its place in society has always been its strength and arguing and positioning how art contributes toward understanding and knowledge provides unique opportunities for its acceptance and use.

References

Arnheim, R. (1969). *Visual thinking*. Berkeley: University of California Press.

Barber, B. (2009). The question (of failure) in art research. In B. Buckley & J. Conomos (Eds), *Rethinking the Contemporary Art School* (pp. 45–63). Halifax, Canada: The Press of the Nova Scotia College of Art and Design.

Cahnmann-Taylor, M., & Siegesmund, R. (Eds). (2008). *Arts-based research in education: Foundations for practice*. New York: Routledge.

Elkins, J. (2009). *Artists with PhDs: On the new doctoral degree in studio art.* New York: New Academia Press.

Eno, B. (1996). *A year with swollen appendices: The diary of Brian Eno.* London: Faber & Faber.

Foucault, M. (1972). *The archeology of knowledge.* New York: Pantheon.

Frappaolo, C. (2008). Implicit knowledge. *Knowledge management research & practice, 6,* 23–5.

Gardner, H. (1993). *Multiple intelligences: The theory in practice, a reader.* New York: Basic Books.

Gray, C., & Malins, J. (2004). *Visualizing research: A guide to the research process in art and design.* Burlington, VT: Ashgate.

Hetland, L., Winner, E., Veenema, S., Sheridan, K. M., & Perkins, D. (2007). *Studio thinking: The real benefits of visual arts education.* New York: Teachers College Press.

Hickman, R. (Ed.). (2008). *Research in art & design: Issues and exemplars.* Bristol: Intellect Books.

Hoffert, B. (2010). Taking Art Seriously: Understanding Studio Research. Retrieved on July 13, 2010 from: http://www.artandeducation.net/papers/view/21.

Holbert, T. (2008). Art in the Knowledge-Based Polis. This essay is a revised and abridged version of a talk given at the conference "Art/Knowledge. Between Epistemology and Production Aesthetics" at the Academy of Fine Arts Vienna, November 11, 2008. Retrieved on July 18, 2010 from: http://www.e-flux.com/journal/view/40#_edn31.

Housen, A., (2002). Aesthetic thought, critical thinking and transfer. *Arts and Learning Journal, 18*(1), pp. 99–132.

Jones, T. E. (2006). A Method of search for reality: Research and research degrees in art and design. In K. Macleod & L. Holdridge (Eds), *Thinking through art: Reflections on art as research* (pp. 226–40). New York: Routledge.

Macleod, K., & Holdridge, L. (Eds.). (2006). *Thinking through art: Reflections on art as research*. New York: Routledge.

Mey, K. (2006). The gesture of writing. In K. Macleod & L. Holdridge (Eds), *Thinking through art: reflections on art as research* (pp. 201–12). New York: Routledge.

McNiff, S. (1988). *Arts-based research*, London: Jessica Kingsley Publishers.

Parsons, M. (1978). Developmental stages in children's aesthetic responses, *Journal of Aesthetic Education*, *12*(1), pp. 83–104.

Piccini, A. (2002). An Historiographic Perspective on Practice as Research. Retrieved on July 18, 2010 from: http://www.bris.ac.uk/parip/t_ap.htm.

Sullivan, G. (2005), *Art practice as research: Inquiry in the visual arts*. Thousand Oaks: Sage.

Taylor, J. S. (1998). *Poetic knowledge: The recovery of education*. Albany, NY: State University of New York Press.

6

Practicing Reflective Scholarship

An introduction to scholarship

Art practice is a form of scholarship and artists are scholars; however there is much that artists in the university setting can do to strengthen the way their work is received by the public and academic community. This is not an argument for better interpretation or explanation of artworks on behalf of artists. Instead it is a push for artist scholars to adopt methods that reflect on their art and highlight the deep and meaningful thinking that takes place. Such methods and activities will only benefit the artist scholar and complement the work they do in the studio and the final exhibition of their work. The important aspect to remember is that the art product comes first and the writing is used as a tool to reflect, reorganize, and inquire into the studio process and the many decisions that led to its creation. Artistic production should always be at the forefront of any artist's mind but the critical reflective methods reviewed in this chapter separate the university artist from his peers outside the academy by acknowledging the conceptual education of the artist and role research has taken in twenty-first-century art education.

In this chapter, the language and conventions of research are presented in a traditional format that can be adapted, and the presentation is meant to serve as a guide and starting place for writing that reflects on artistic practice. This guide is useful for all levels and can be adapted for anything from scholarly essays to formal thesis projects. I would advise artist scholars to read through the entire chapter and come back to the questions presented in order to receive a good perspective on the main components of developing a graduate-level study.

Schön (1983) writes about professional knowledge and the dilemma of professionals articulating what they know. Typically these very competent individuals know more than they are able to communicate in words. To draw out this knowledge they must

reflect on practice in order to identify intuitive or tacit knowledge. Artists and designers through their histories can be considered both professionals and practitioners. As practitioners, their role as researcher is diminished and as professionals, they lose a claim or ability to identify knowledge. However, the field has clearly moved toward a professional standard. As new methods and theories are developed in arts research, the artist scholar must function in a radically different way than in the past (often claiming both roles). New tasks and new ways of understanding knowledge in the twenty-first century are reshaping how the artist is educated and how they practice the process of writing and research aids this understanding of knowledge.

A broad understanding of a scholar is defined as someone who has gained mastery in his or her discipline. Art professors or degree holders in the arts certainly meet these criteria and art students are ideally working toward mastery and their artwork is a an example of this past education, history of art education, and mentorship. The broad use of the term scholar or scholarship is the most important characteristic to consider because it is inclusive of all types of inquiry in the university. To practice scholarship, individuals utilize their expertise to make claims and inquire about the world. Artists do this in their processes and then share it through exhibitions, performances, digitally on the web, or through printed materials. Scholarship is therefore representative of all artistic activities. Certainly this includes the studio product but also exhibiting, writing, lecturing, and even critiques. The Museums then act as the repositories of this collected scholarship and make some of these achievements and contributions in art available for discussion and viewing.

The final exhibit or portfolio is the most traditional means artists use to share scholarship activities in the university. It is an incredibly important step for artists to complete a coherent body of work. However, writing and reflecting on the completion of this body of work or an individual piece extends and transfers aspects of this scholarship to a greater number of people (and valuable to the artist as they intend to grow from their experiences). My hope is that a new generation of Master of Fine Arts (M.F.A) students will graduate armed with the tools and confidence to pursue scholarship that will demonstrate in larger academic and professional contexts how the arts add to our collective understanding of issues from the abstract to the concrete.

As someone who has taught research methods in the art education and studio arts context and mentored dozens of graduate students through the thesis writing process, I have great sympathy for the struggles that artists encounter during this journey. It typically starts with moments of angst and worry: We are artists, not writers who cry! Then a sense of reality sets in as they must begin the process in order to graduate or meet a deadline. This is also true of arts professionals. They are not sure where to start when it comes to writing or performing research about their work. They know that writing could help but feel they have left that aspect of their education in the past with their childhood ambitions of being astronauts and athletes.

I find that this initial reaction is not a dislike or even an unwillingness to write but rather a frustration that they as artists do not posses the tools that enable them to write well. They could not be more wrong. Artists are natural researchers. It only takes a trip to an artist studio or peek inside their sketchbook to appreciate the incredible amount of data artists collect before it is eventually analyzed and presented as a discussion, argument, or problem in their media of choice (the final product). The studio alone has so many starting points for writing—organizing these ideas is the bigger issue because writing requires a much more linear method in order to complete. These are real frustrations for the artist and I hope to clarify a process that appears mysterious so anyone can embrace their talents as artist scholars. In addition, I think nonarts scholars and appreciators will gain a greater respect for the complicated decision making artists undergo in their process when they engage their writing.

Unfortunately the majority of texts that address arts scholarship do so with an heir of intellectualism that makes them impractical and frustrating. Conceptually arguing and posturing art scholarship and its place in humanities are important but it is assumed in this chapter.

What follows is a brief guide to stimulate the thinking of the artist scholar and suggestions to jumpstart the writing process. I present a variety of possibilities that artists can reflect upon in their work in order to push their artistic inquiry further. Many decisions must be made to begin a writing project and a few are suggested in this chapter that will aid organization. These are possibilities for understanding the nuts and bolts of research, advice for asking good questions, and finally perspectives for gathering data that can be analyzed and discussed. In addition, once the artist successfully accomplishes their inquiry, questions regarding how this new insight might be presented are offered. This is complete with examples that demonstrate a few possibilities (in the Appendixes), in the hope to make the goal of writing about art attainable, realistic, and encouraging.

What is a thesis/dissertation writing project?

A thesis or dissertation is a written document that is completed as part of a student's course of study for a graduate degree. The document is generally understood to present the author's research and findings in their area of study. Most M.F.A. programs require such a document in the United States but the standards are anything but consistent (in some cases absent). A culminating exhibition typically stands in its place but by foregoing such an exercise, students are missing a vital aspect of their education.

A generic breakdown of a graduate-level scholarly paper (or thesis/dissertation) generally includes the following chapters:

- Introduction: The initial chapter presents the topic and the question that will guide the research.
- Literature Review: This contextual review presents what has been accomplished in this field of study and how your study fits within it.
- Methodology: The description of the methods and theory used to analyze the data.
- Results: The presentation of what your data collection looks like. This is typically displayed in charts, graphs, timelines, and visuals.
- Discussion: The discussion compares, contrasts, and identifies trends, patterns, and knowledge identified as a result of the analysis.
- Conclusion: An opportunity to review major points and bring the study to close.
- References: These are the list of sources you cited in your study.
- Appendix: The last section can be used to display documents that are important toward your study: Photographs, questionnaires, notes, raw data, and other sources that the reader may find useful for understanding your scholarship.

It is not necessary to follow these strict guidelines but the rationale for each chapter is often present in any well-written article or study.

Purpose

The confusion when artists write resides in the purpose. Typical responses include Why am I writing? Why do I need to explain my work? It feels unnatural and most artists are skeptical if the writing will really help. "Only making art will help my art—not writing" are the defiant cries often heard and acknowledged in M.F.A. programs and professional artists around the country. Why? Partly because it is hard work and writing does not come easy to anyone. Yet the larger professionalization issue is that the professors mentoring M.F.A. students often feel the same way and the two sides comfort one another why the process is not important or secondary to their studies. Unfortunately this is some of the worst advice one could give a potential scholar hoping to grow and expand their understanding of art, process, and subject given the rise of arts-based research.

There is a great similarity between art making and writing that artists can embrace. They are two distinct types of thinking but the symbols system is not as far removed from one-another as imagined. Mey (2006) characterizes writing as a form of mark making not too far removed from drawing. Gestures are symbolic and the marks made in writing share concepts with others used in drawing. Mey's perspective is illuminating, because the task of writing becomes a symbol system that can also be

mastered and utilized to great effect. This is a language the artist understands because mark making is a foundational process for drawing as writing is to communication. Anyone who has learned a new language certainly would agree that words and letters are a symbol system that one must master in order to communicate effectively. Many artists through history have taken advantage of using this symbol system in their artwork and beyond. As with any new tool, practice only strengthens the ability to use it. Writing is a mark-making activity and the sooner the artist begins writing the more powerful their writing will become.

Writing with a purpose is the first goal the artist scholar should consider. Having a clear direction will alleviate many headaches. The artistic process is the subject of our inquiry as artist scholars and it is this essential aspect that we hope to better understand through our writing. This is to be celebrated and not masked behind the studio or the writing serving another purpose (artist statements). This is what being an artist is all about, and your scholarship will only heighten your understanding of it. Art products are rich and densely packed pedagogues for understanding a host of issues, themes, and philosophies. Writing will only help your thinking and give you something to reflect upon. In fact, because art is much more complicated and communicates in such a multifaceted manner compared to traditional writing projects, the scholarship you embark upon has so many possibilities that limiting your scope will be a very important component.

Artistic paradigms and reflective inquiry

In order to begin any writing project it is helpful to situate yourself as a writer so that you have a clear view of what you are writing about and for what purpose. If one does not a have clear question or purpose, frustration will follow. Two possible alternatives are presented that will help artists identify and maintain a consistent focus in their writing or research. Given that your art practice is a form of scholarship what exactly are you writing about? The artist can take on one of the following suggested perspectives to get started:

- Writing/research that reflects an art product or a series or art products
- Writing/research that reflects on artistic practice (with parameters)

Writing that reflects on art practice or products is a post-art-making activity. It is a process that should be practiced by an artist on their own artwork. However, an outsider studying the art or process of a particular artist can also accomplish it. This is strength as it is a traditional type of qualitative and historical process reimagined for the artist. It is desirable because it involves studying the many aspects of artistic

experiences that contribute to making a work of art or the many small and large decisions that happen over the course of making an art product. Reflecting on the process or the product is directly related to the artist and is a self-serving activity. In the end, it helps the artist better understand the decisions and influences that happen yet are not always articulated, noticed, and/or examined.

Schön (1983) focuses on how professionals solve problems and acknowledges that the unwillingness or inability to articulate this elusive problem-solving experience is a major aspect that divides academic and professional practice. Schön calls this practitioner-research which is an insider's perspective on research that allows close proximity and access to the subject of study, the art. This is essentially the goal in writing about the creative practice after it is completed. Decisions are made in the studio and the artist scholar then reflects and thinks critically about how it happened.

Studying processes and/or art product(s) requires decisions to be made. What is to be studied? A single art object? Or perhaps the process involved in the making of a particular sculpture compared with the process of making a painting. Once the subject of the writing is identified, appropriate data can be determined. Writing that reflects on art essentially involves the organization and presentation of influences that contribute to the artistic product or process. When focusing on a particular sculpture, the artist scholar can start to brainstorm and think about the many influences and experiences that went into it. But what exactly can you look at, other than memories and the physical art objects themselves?

In many ways, artists already reflect in this manner during the critique process. The writing and research process will then clarify and heighten this learning and understanding by utilizing methods that can be followed all the way through to the written form.

Where to begin?

Artist scholarship is best understood as a process of investigation that leads to better understanding. In order to start this process, there are number of steps a scholar should consider. These suggestions are adopted from general research practices and are applicable to qualitative research in general. All proposals or writing projects must have a clearly defined question that is addressed through exploration in relation to a context and a methodological process.

Good questions imply that you do not know the answer. This is a major difference from other artistic types of writing. For example, in an artist statement, the artist speaks as an expert who is intent on sharing what the viewer needs to know before engaging the work. In comparison, a good question is something you hope to explore in your work. It is likely that you do not understand everything that happens in the

studio and articulating what you hope to focus on will ease the writing process. The question is aided by several objectives that the scholar intends to follow. Rationalizing why this question is important and how it fits within the subject area or context needs to be clear. And how this exploration makes a contribution to this context is also essential. The methods used to address this question are called your methodology and explaining why this method is a proper theory for conducting your exploration will help readers engage with the data and interpretations you finally present.

Developing a question

Knowing what you are researching is essential to successfully completing any form of arts scholarship. The topic must be an area you enjoy reading, thinking, and writing about because many hours will be spent conducting scholarship in relation to this idea. This topic as an artist scholar is often your own artwork or concepts related to it. Moving from a general topic to a specific statement or question is a key aspect of narrowing your study so that it is manageable. In arts scholarship, art making and art processes are the main perspectives to consider and can shift your perspective quite a bit—so it is important to consider and refine your focus.

Some questions to consider:

- What is your subject of your study?
- Is it your art product? One, two, or a series?
- Is it your artistic process? From when to when?
- Is it a subject or topic? Can you easily identify it? What do you want to know about it?

The above-mentioned questions are critical because they will shape how you mold your manuscript from data collection to interpretation. Choosing to study one art product limits your research to revolve around that specific object. This approach will realistically allow the scholar to complete an in-depth study. A common mistake is to make the question too large. For example, to studying your entire life's work—which would prove to be frustratingly endless. The same logic can be applied to a historical topic or philosophical inquiry.

Given this perspective, what works would you choose to study? Limiting your data proves to be a valuable and a smart choice for those who actually hope to complete their study. Choosing a subject and developing a good question limits and closes off potential distractions from hindering your scholarship. Other options might include comparing works or processes that are definable. The possibilities are endless but your end goal should be in mind as each choice alters what exactly you are studying.

If you choose to a study a particular event/concept, it must have defined borders in order to determine appropriate sources. A case study is a common social-science approach that is concerned with studying an individual, group, or event. The valuable aspect of this method is that it limits variables. By formulating a subject to study within a good question, it establishes boundaries. Boundaries are important to set and are essential aspects of a good case study. An arts-based study could easily be characterized as a case study because it is a study of something with definable borders (compared to a sample of something). A case is often characterized as something the scholar can get their hands around—essentially knowing where the subject ends—which can be an artwork, a length of time, or a particular experience or person.

A good question might examine the decisions, influences, education, and experiences that contributed toward a particular sculpture completed this year. Knowing when the sculpture began physically and conceptually along with notes, drawings, and experiences that contributed toward its ultimate completion will help the artist scholar explore how these enterprises interacted with one another through time. Analyzing and organizing these pieces of data on a timetable of when they occurred, where they occurred, organizing them by subject, type, or any other organizing structure will help the scholar see them anew and provoke new understanding and potential relationships and trends. It is through this analysis that aspects of the studio process that are considered mysterious become communicable and transferable to a great number of scholars.

Is your question too broad?

An important point to consider is whether your topic is too broad or too narrow. Focusing on your practice as an artist is a very broad topic and impossible to adequately cover in a paper. However, studying your practice between two dates or your practice leading up to a new series has limits and allows you, the artist and researcher, to gather data that helps you understand this particular subject. Studying the entire process that led to a series may be too much data to effectively analyze while two to three artworks may be much more manageable and meaningful and could very well be representative of the entire series.

Why is this question important?

Once you decide on a topic and question, it is important to consider what this question will tell you and why it is important to even ask it? In the end, it is your hope to make the knowledge gained to be useful to others beside yourself. So how

will answering this question be relevant beyond this investigation? Sure it may be personally beneficial but the usefulness of such studies becomes more powerful when it is applicable to the larger field. Are there other artist scholars that may find this useful? Could it be beneficial for a particular field that is part of your practice?

How does this question fit within the field of study?

After developing an appropriate question, scholars generally proceed through a process that includes reviewing and evaluating the existing scholarship to provide context. Often called a literature review, the scholar paints a picture of how they understand the field and how this proposed study fits within this context. This involves a lot of reading of available research. It can be organized in a number of ways including a historical perspective or through major issues and concepts. These completed studies will arm the artist scholar with examples and knowledge to better situate themselves. Reading and writing about completed research also helps refine ideas and focus on new studies. It is a process that may likely involve revision of the original question, as gaps in knowledge and under-researched areas will become apparent. This research should help contextualize your question within the larger field of knowledge. If you cannot find a reason for conducting this investigation, perhaps the question is too self-indulgent?

After the context and question are situated, the artist-scholar collects data through a methodology, analyzes, evaluates, or interprets the data, and finally displays the results. However, selecting a methodology is a critically important step that determines how you will collect data.

What type of methodology do you plan to use? And why?

There are many possibilities to embrace in your artistic scholarship and a host of publications that advocate particular methodologies. The methodology for you depends upon the type of question you are asking. There is no one single methodology for any type of research. In order to go down this path and select a particular path requires a good question and direction.

A dictionary definition would identify the methodology as a body of practices, procedures, and rules used by those who work in a discipline or engage in an inquiry; a set of working methods. In other words the methodology helps us understand the process of inquiry and the methodology must be followed in order to garner quality results. It is a system of methods developed by researchers in particular disciplines to aid the scholar with a structured process of inquiry.

This text emphasizes the role of reflection and viewing artistic products as creative products. The following section reviews this construct for creativity and its potential role in artistic scholarship. The arts-based methods reviewed earlier draw many similarities to the methods reviewed below and both are excellent starting point for scholars interested in an arts-based agenda.

Creative methodologies

The field of creativity is a relatively new concept with its origins in the late nineteenth century. An item that is of value in a particular context is considered creative and artworks certainly fall into this distinction. Various researchers characterize creativity in one or more of the following criteria: divergent thinking (the ability to think of many different and original ideas), triarchic thinking (a balance of analytical, creative, and practical thinking), multimodal thinking (the ability to shift between modes or modalities of thinking), personality traits (unique traits common to creative individuals), creative processes (formulas for creative work), motivation (the role of intrinsic motivation in creative people), impact on domain (creative products must be recognized for they are not creative), and the importance of context/location/creative spaces (Csikszentmihalyi, 1999; Gruber, 1989a; Gruber, 1989b; Gruber and Wallace, 1999; Johnson, 2010; Sternberg, 2003; Torrance, 2002; Weisberg, 2006). Using one or more of these theories applied to better understand the production of an artwork has great potential for new insights.

The field of creativity is ripe with methodologies applicable to studying the artistic process and I often use Howard Gruber's (1989a) perspective on creative work to capture the elusiveness of studio work. Gruber argues that creativity is developmental and arises from the unique perspectives of individuals. This applies to the unpredictability of the studio and the way individual artists organize their resources. Each artist is different and the context and variables involved must be considered. Using this research methodology, I am able to reflect on the artwork of someone else as easily as an artist would be able to reflect on their own process or art product. I emphasize the importance of reflection to take advantage of the post-art-making ability to look back at how the various decisions and experiences fit together to create the final product or series of art products.

The reflective action is an important component to consider when selecting a methodology and one emphasized in this text when conducting research on your own process. Reflecting on the complexity of artistic practice allows the scholar to uncover the structure and growth of an idea. Creative products and good ideas come about through a lengthy process and are often not just a result from a "eureka" moment (Johnson, 2010). Mapping and organizing these enterprises allow the artist scholars to make insights that were otherwise unavailable or unexplainable regarding this experience.

Choosing a methodology helps to think through the process and what types of information/data is available to you as the scholar. Will you have enough information and evidence to address your question? The importance of journal keeping and appropriate types of data that can inform your study are discussed below.

Data sources and methods

The reflective process seeks to make the unexplainable available. The thinking that is outside conceptualization, nonverbal, uncognized, tacit, and extralinguistic requires sources to better understand it. Data sources can be primary, secondary, and tertiary. Primary sources are directly related to the subject of study. Secondary sources are works completed by other researchers about the subject (once removed) while tertiary sources are general summaries of these findings (twice removed from the subjects) and can be found in encyclopedias and are generally considered common knowledge.

Gathering data as artist scholars is often quite simple as it is immediately available. However, scholars can conduct interviews, surveys, along with gathering and sorting the many examples provided. Using more than one type of method for gathering data allows the artist scholar to triangulate their work. Having more than one method makes the findings more reliable as information that corroborates with one-another from multiple sources is more reliable (think observations, interviews, and a reflective journal that corroborate the same idea).

Essentially as an artist scholar, there are a host of primary sources that will fuel your analysis. Research is based upon using primary data in all fields and the following categories are examples of appropriate types of sources.

Observations and self-reflections

Once a reflection or observation is made, it can be recorded. When and where these experiences happen can be useful as the progression of ideas can be mapped or outlined in a timeline.

Sketchbooks, notebooks, and letters

Sketchbooks, notebook, and letters are excellent examples of thinking made visible. By reviewing these documents, the scholar can identify trends in thinking, where the focus of attention has been directed, when it happened, or where aspects of problems and solutions may linger. The sketchbooks of artists are utilized by

many types of scholars to garner background and perspectives into what the artist is concerned about. Think of Leonardo da Vinci's sketchbooks or the letters of Vincent van Gogh. Scholars know more about these artists because of the large amount of data available.

Writing, publications, papers, and statements

Examining artist statements over a length of time can demonstrate the changing emphasis of an artist. Publication and papers stress interest and where influences may be when corresponded with artwork created at the same time. It is important to examine these documents, as anything written by the artist is helpful in the analysis.

E-mails

In the digital age, e-mails have replaced much of letter writing of previous eras. Therefore virtual exchanges between colleagues, mentors, or influential persons may be significant enterprises to consider. These documents can also track interests and influences.

Teaching (lectures/speeches)

Many artists also teach and the content of pedagogy is often reflective of what the artist is concerned with in their own artistic practice. Lectures and speeches at conferences and in the classroom may yield useful data. The amount of time this material is studied also may apply to artistic processes and vice versa. Lesson plans and homework assignments may also yield useful data.

Exhibitions, performances, and advertisements

Exhibitions, performances, and evidence of these events in the form of advertisements may be helpful. The culmination of much thinking and inquiry, the timing, location, and works involved hold much information. Often a timeline of events can be constructed and compared with other significant events.

Figure 16. Advertisement for Jackson Pollock Art Exhibition, 2009.

Figure 17. Mind map based upon the
concept *Artist Scholar*, 2012.

Mind maps

Mind maps are diagrams that the artist scholar can create that represent words and concepts that are linked to a central idea. This is an activity that the artist creates and the final product can be used as evidence of their thinking. Mind maps are often used as a brainstorming device that enables the creator to make connections and hierarchical connections between ideas.

Art and objects

Art is the primary subject and type of data used in arts-based research. However, other artworks created before and after, along with objects can be useful data points for comparison. Changes over time in a body of artwork can be discerned through careful study of art.

Documentary photos

Documentary photos of the studio, artist, and stages of a work on progress are examples of photographs that may be helpful to the artist scholar. If the photograph is directly connected to the subject studied, there is much one can learn from the photo.

Feedback and critique from peers

Feedback from peers in the form of critique (oral or written) is very useful since critique plays a significant role in the education and growth of artists. Evidence of this critique could be recorded in notes, tape, or some other form of digital archive. These conversations may be quoted and compared with many other types of data available to artist scholars.

Interviews

Interviews with family, friends, arts professionals, collectors, and associates may help construct impressions and histories related to the subject of study.

Journals, memoirs, and diaries

Journal keeping during the art-making process can produce a significant amount of information/data to be reflected upon after the work is completed. The journal acts as a record of your thinking and provides you, the writer, with actual evidence to quote and analyze. Having a detailed and consistent journal as a resource will aid your writing and validate much of your claims as you will be able to provide examples and evidence for your arguments. The journal is also helpful because we often forget much of our thinking as times passes. Plus your perspective of an experience can also change over time and the journal can document these changes. As an art piece is reworked, changes can be recorded, influences acknowledged, and mistakes corrected. These series of decisions will have dates and their order will be more apparent if they are documented. The journal is considered raw data and it is only after data like this has been analyzed that something may be discovered.

The types of entries may include a breakdown of the studio day, what was worked on, conversations or critiques, books, articles, or art that has been engaged, etc. It may not seem essential to your studio process but keeping track of your experiences will go a great length as the studio may often extend to many other aspects of the artist's life.

The reflective journal

Reflective practice is perhaps more akin to research in education and creativity but it has great implications for artists. The major aspect of capturing the studio is discovering methods for reflecting on this illusive practice. The reflective journal or learning journal is one such tool, that is, a document that the artist would write in to track their progress in the studio. Many artists will only feel comfortable writing after the making is complete, however the journal is a wonderful avenue for capturing some of the important decisions made in the studio that can be used as data later.

A reflective journal provides

- Data the artist scholar can use to base discussion
- Experiences in the studio and reactions to them
- A timeline of events
- An opportunity to remove yourself or shift perspective from the studio process
- A journey of understanding as a concept, artwork, subject grows
- A set of issues considered, possibly in a particular work or series of artworks
- A reflective account on particular experiences

The data produced from reflective journals allows the artist scholar to analyze important aspects of their own thinking. For example, a potential journal would allow study of the areas most reflected on in practice, general nature of reflections, perceptions of the studio process, and to what extent previous experiences played into reflections and art making. The growth of ideas and experiences are just some of the possibilities a reflective journal could serve when used as a research tool.

Analyzing data

The most exciting aspect of conducting research is analyzing the data that was collected. The hard part of conducting a study is the groundwork that must be accomplished before the data is collected. Once a good question, direction, and methodology are selected, the analysis is fairly straightforward.

As data is collected, the data analysis process has already begun. As the artist scholar, the data can be organized and summarized around conceptual issues regarding the research question. There is not one method for conducting analysis but researchers dive deep into their data and immerse themselves in the information. As the data is manipulated and engaged, critical issues will rise to the surface.

Some basic steps to consider when analyzing date include

- Reviewing your data.
- Beginning any analysis starts with reading and reviewing the data available. Re-reading the journal entries, notes, and artwork is the first step. Ask yourself what limitations does the data present and if it is biased in anyway.

Focus on key questions, themes, events, or concepts

What was the purpose of this study? Review your objectives. Identify key concepts to look for as you read the data. As you ask questions, certain data and relationships may appear. Choosing a theme, event, or concept is likely based in your original objective.

Categorize information; identify patterns, connections, or themes

Highlight and use a coding system to track information, categorize, and identify relationships. Organize and summarize different data in larger categories. This may involve reading and rereading material until relationships are noticed. Categories and

subcategories may emerge or categories can be brought to the analysis to organize this thinking. Assessing the importance of one category over another or the relationship they may have with one another is part of the analysis.

Interpret

What does all this information mean? Eventually the artist scholar needs to bring the data back to the original purpose and find meaning. This often involves taking a step back and reflecting on the process. The results of this insight are then presented.

A high level of understanding is the result of the analysis. The artist scholar should consider summarizing the results, identifying any themes, recognizing patterns; perhaps a structure or flow might emerge, or a new meaning or theory might be highlighted.

Once there is no new data and no new insights, the analysis is coming to end and can be presented in the form of a discussion. It is not necessary to include everything you studied nor is it necessary to present every piece of evidence. Part of analyzing is deciding what information is helpful in relation to the question you asked and the story you plan to share. The presentation can be straightforward or it may take on a more creative flair.

Final results and presentation of research

After choosing a question, determining its viability and importance, selecting a methodology and analyzing your data the final study is written and presented. During the writing process, the scholar asks what was learned? What is valuable or significant? An interpretation is given on this process and it often involves rearranging the data to reveal or make it meaningful. As this is written, the scholar often recognizes that the process of thinking and reflecting on their work is quite informative and valuable in relation to their art making. New insights are gained about the studio process and this is helpful when they return to the studio.

Some larger philosophical issues to consider about artistic scholarship

Qualitative researchers and specifically arts-based researchers must consider some larger issues concerning knowledge and what is knowable as they go forward in their writing. This will help alleviate frustrations with some of the prescribed formulas

mentioned prior. Deciding on what is knowable and what knowledge is or if it is even possible to know something in the visual arts is something the artist scholar needs to decide before beginning a writing or research task. Having a clear sense of what is knowable will determine what is researchable. Declaring this perspective will also allow other scholars to understand the epistemological assumptions of the author. But let us start with a few basics. Acknowledging a worldview aids the scholar's perspective when conducting a study. What is knowable is directly related to what can actually be researched. Not believing that anything can be known for certain changes the way you view your study, and acknowledging this is valuable for the individual scholar and the wider community reading their writing.

Essentially, a worldview is how you understand the world around you, a framework of ideas about yourself, the environment, and your relationship with the world. What you can know and how you view reality is directly related to what you can study. If you believe truth is out there and you can discover it, then your methods and direction will be quite different from the scholar who feels multiple truths exist and hopes to understand one particular perspective.

Hatch (2002) organizes five research paradigms (positivism, post-positivism, constructivism, critical theory, and poststructuralism) in relation to the ontological (What is the nature of reality?), epistemological (What can be known and what is the relationship of the knower to the known?), and methodological questions (How is knowledge gained?). These paradigms are important to think about as artist scholars. Articulating what is real, what can be known, and how you can learn this are not just relegated to scholarship and research but applicable to life as well.

Research paradigms

Positivism

- Ontological – reality exists out there to be studied
- Epistemological – noninteractive
- Methodological – experiments, surveys, empirical tests, and correlation studies

Positivists believe that knowledge can be ascertained through the senses and is testable. Positivism is best described through the scientific method and can be verified through empirical means. The goals of knowledge in positivism is to describe what the researcher observed and experienced. If you cannot observe or measure it—it cannot be understood through the positivism paradigm. Artists often will have difficult time

using such a paradigm because so much of their data is internal. Observing thoughts and feelings are a difficult task because they do not always have behavior characteristics that can be observed.

Post-positivism

- Ontological – reality exists but can only be approximated
- Epistemological – researcher is instrument for approximating reality
- Methodological – qualitative methods

Post-positivism is a rejection of positivism and realizes that the observations of the researcher are not as objective as they think. In fact, the post-positivists believe that their observations of the world contain errors and that all theory generated from such observations should be open to reinterpretation. Post-positivists do not believe that they can truly understand the phenomena being studied because of this error in thinking but instead use multiple methods for measuring so they can triangulate their observations to have a better understanding of what is happening. The post-positivist paradigm is a good place to start for artists because it allows the artist scholar some freedom when exploring a process or product that can only be approximated.

Constructivism

- Ontological – multiple realities and mental constructions
- Epistemological – knowledge is a subjective/human construction
- Methodological – qualitative methods

Constructivists create their own reality (thus multiple realities exist) and understanding of the world through their experiences. Knowledge, truth, or understanding is thus created in part by the researcher and not necessarily discovered. These views are entirely subjective to the perspective of the scholar, and the scholar realizes that there are many possible interpretations. A bit of an ideal position that values the input of all sides, a constructivist will be aware that as a scholar investigating their own work, the reality constructed will be one possibility. The constructivist scholar will seek the input of others to help construct a collaborative understanding of the subject of study. This could include interviewing others about the products or processes being studied. Most artists appear to operate within this frame of mind—as their views are socially constructed.

Critical theory

- Ontological – approximated reality can be understood through race, gender, and class
- Epistemological – knowledge is subjective and political
- Methodological – transformative methods that eliminate false consciousness

Critical theorists believe that knowledge is free from values and biases. Critical theorists explore their ideas in relation to larger ideology and see their investigations as a political act. The phenomenon (process, subject, or product) studied from the critical theory paradigm is shaped by social, political, cultural, economic, ethic, and gender-based forces. Artist scholars interested in this paradigm will have more success if they not only attempt to describe the phenomenon studied but also attempt to alter or change the phenomenon through their inquiry.

Poststructuralism

- Ontological – order is created in the self to ascribe meaning in a meaningless world
- Epistemological – there is no truth
- Methodological – deconstruction

The poststructuralist paradigm rejects truth or facts about the world. At the outset, this makes the paradigm difficult to consider for artist scholars, as each person is responsible for creating a new meaning in a meaningless world. Poststructuralist studies are likely to be deeply philosophical investigations.

Paradigms and research

The following paradigms were presented in order to jumpstart thinking about knowledge and what is knowable. It does not require a decision at the outset but is instead meant to ground your thinking as you go forward as an artist delving into the world of research. Exploring the ramifications of these questions will help the artist scholar better understand their worldview and how they expect to learn based upon this disposition. Researching a question using methods that you do not believe in will not create a well-thought out or coherent study. Considering your position within the paradigm coupled with your topic of study determines what types of data

and methods the artist should expect to use.

Try to describe your research topic and how you might go about collecting data to understand it. As an artist scholar, you likely will desire to study your own work. How does this change your thoughts on what you can know about your own work?

As a scholar, researchable problems or subjects must be chosen. The artist scholar has a wealth of worldviews to consider and they can be narrowed down when considered and hypothesized in real-world situations. As artists tend to study themselves, artists act as self-observers. The artist produces the data and also analyzes it. Reflecting on your own actions, discussions, and documents and what can really be known from such actions should be clear at the outset.

Reflecting on artist scholarship

The previous paragraphs highlight a sliver of what is possible in artistic scholarship. Writing and researching art can take on many forms and the brief suggestions will hopefully inspire the potential artist scholar to begin an investigation from one of the perspectives. Once a direction is identified, there is more reading to be done as the authors cited in each section will be helpful resources in learning more about that particular field.

There are risks in writing about your own art. The process must be organized and directed. While the examples provided are not the only direction, they represent a standard and basis of providing some sort of knowledge: new or reorganized knowledge that then encourages additional quests for knowledge by the artist scholar and the reader. Much like a work of art encourages reflection, so should the writing and research by the artist.

Completing a research proposal

There is not a correct form or structure for creating a research proposal but considering the material covered in this chapter, the artist scholar should be able to address the following criteria before beginning a project.

- Title of project
- Research question
- Aim and scope of study
- Rationale for inquiry
- Objectives to be covered
- Context

- Methodology and procedure for inquiry
- Potential outcomes

The purpose of the proposal is to educate and persuade your readers that the plan is practical and appropriate. It needs to convince them about what you propose to study, how you will do it, and when. Any questions or objections should be addressed. The list should be convincing, detailed, and well cited. An additional bibliography or list of references of potential sources is helpful and evidence that the subject has been well researched.

<p style="text-align:center">⇒⇛ ⇚⇐</p>

This chapter functions as a pragmatic series of suggestions for M.F.A. students to think deeply about their writing. From initial thoughts about the role of scholarship to suggestions on strategies to approach a scholarly paper. It is not an exhaustive checklist but a primer for organization. The language is familiar to those inside the academy and once learned can be manipulated.

Through the reflection process the artist scholar is attempting to better understand aspects of their art or process. Identifying exactly what is being studied is critical. A common mistake involves attempting to understand the artistic process in general. This is nearly impossible as it is likely changed or will change in the future. Thus the artist falls into making generalization about their work and the writing will read more like an artist statement rather than a reflection on their process. Clearly articulating that the study intends to focus on the completion of one particular art object (or an identifiable number) allows the artist scholar to collect data related to that process used for that art product and investigate it in a detailed manner. Will it be the process of completing an entire show, the process of completing one product, or a particular part of the process like inspirations for artworks, sketchbooks, or how the artistic process has changed between two dates?

References

Csikszentmihalyi, M. (1999). Implications of a systems perspective for the study of creativity. In R. J. Sternber (Ed.), *Handbook of creativity* (pp. 313–35). Cambridge: Cambridge University Press.

Gruber, H. E. (1989a). The evolving systems approach to creative work. In D. B. Wallace & H. E. Gruber (Eds), *Creative people at work*. Oxford: Oxford University Press.

Gruber, H. E. (1989b). Creativity and human survival. In D. B. Wallace & H. E. Gruber (Eds), *Creative people at work*. Oxford: Oxford University Press.

Gruber, H. E., & Wallace, D. B. (1999). The case study method and evolving systems approach for understanding unique creative people at work. In R. J. Sternber (Ed.), *Handbook of creativity* (pp. 93–115). Cambridge: Cambridge University Press.

Hatch, J. A. (2002). *Doing qualitative research in education settings*. Albany, NY: State University of New York Press.

Johnson, S. (2010). *Where good ideas come from: The natural history of innovation*. New York: Riverhead

Mey, K. (2006). The gesture of writing. In K. Macleod and L. Holdridge (Eds), *Thinking through art: Reflections on art as research* (pp. 201–12). New York: Routledge

Schön, D. (1983). *The reflective practitioner: How professionals think in action*. New York: Basic Books.

Sternberg, R. (2003). The development of creativity as a decision-making process. In *Creativity and development* (pp. 91–138). Oxford: Oxford University Press.

Torrance, E. P. (2002). *Torrance tests of creative thinking*. Bensenville, Ill: Scholastic Testing Services Inc.

Weisberg, R. W. (2006). *Creativity: Understanding innovation in problem solving, science, invention and the arts*. Hobken, NJ: John Wiley & Sons.

7

REVISITING WRITING AND RESEARCH

Art education within the university has witnessed rapid change internationally during the past 40 years. Most countries in the English-speaking world have developed Ph.D. programs in the visual arts during this time and are making great strides in research and writing in the visual arts. The United States has lagged behind in this higher education degree progress until recently. There has been considerable movement on these fronts as a few programs were established and more debate continues at national conferences. No area epitomizes qualitative investigations quite like the artistic process and it is surprising that it has taken the United States university so long to recognize the impact the arts can have on new knowledge and knowledge production, especially with early proponents of visual arts research were Americans like Elliot Eisner, whose work dates back to the 1970s. Despite the slow start, Master of Fine Arts (M.F.A.) students and faculty should be encouraged by the work they currently do and how it can be interrogated through writing, how art making can be considered a type of inquiry and that writing can inspire new work. There is a rich tradition of art making in US universities and more systematic and theory-based writing schemas will transition the M.F.A. graduate to more advanced study or increased understanding of what their art means and what it can do.

As noted, a few new doctoral programs have begun to take shape in the United States (and more will follow), plus there is a healthy amount of doctoral work in disciplines related to the visual arts that artist scholars have used to advance their education (art education, visual studies, visual culture, communication/design). It is progressing quite slowly (which is to be expected unless a the Ph.D. is incorporated as a terminal degree), but a few programs are worth noting for their platform and various strategies to incorporate research and the visual arts. This is not an inclusive list but rather a quick sampling that provides a few options for the artist to pursue

research and writing at the graduate level. All the programs presented are text heavy although the weight of the visual exhibition or portfolio is more present in some than others.

Doctoral Programs in the Visual Arts

The Institute for Doctoral Studies in the Visual Arts is a program located in Portland, Maine (although classes are held in various locations like New York, Paris, and Venice). The focus of the program is on acquiring a theoretical foundation to support visual practice. There are no studio offerings and no formal exhibitions offered through the program. Instead the program is configured to "facilitate artists in acquiring advanced studies across art theory, aesthetics and a range of discourses framing the discursive landscape of contemporary art practice" (Wilson, 2009, p. 1). The program expects to admit practicing artists and arm them with theory and philosophy. It is similar to a traditional program in philosophy but specifically geared toward the artist. A written dissertation is submitted as part of graduation but there is not a required studio component, nor is there any opportunities to exhibit. Texas Tech University also offers a doctoral degree in Art with a similar philosophical bent but is much more inclusive of the studio component as it aims to facilitate art making as part of the course of study. The classes include a heavy emphasis on critical studies and history and the program is open to the historian or artist, as it is concerned with a broad application of theory to artistic practices (although the practice does not need to be the student themselves). Each of these programs (Institute of Doctoral Studies in the Visual Arts and Texas Tech University) is a theory-based doctoral and we can expect their graduates to practice as artist philosophers, theorists, and historians. Although each model is a bit different, the overarching goal is to produce artist scholars who will function in a multidisciplinary fashion. They will likely publish and exhibit their work in a number of fields that will elevate and include the artist in discussions that were not available decades ago. This is a progression of art education that allows the artist to have a voice in theoretical and philosophical knowledge production and understanding.

Writing and Research with Art-Making Option

Teachers College, Columbia University offers a doctorate in education that is geared for the artist who wants to teach art at the college level. This degree could be considered an art education diploma because the department is located within a Graduate School of Education. The difference between the Ed.D.C.T. (Doctorate of

Education in the College Teaching of Art) and the doctorate in art education (Ed.D.), a separate field itself, is the specialization in teaching visual art in a higher-education context (art education focuses on primary, high school, and museum/nonprofit contexts). In the Teachers College program there is an emphasis on educational theory and how art making intersects with pedagogy. Art making is encouraged (and classes are offered) and can be part of the curriculum but a final exhibition is not required (although students do receive credit for completing or organizing an exhibition). An art department within an education school, it is an art education degree where artist are well versed in qualitative research methods like many art-based methodologies. These students often write qualitative studies based upon their own practice and how it relates to education. The educational context is limiting for most artists but it is also refreshing to see an avenue for artist research that progresses beyond formal art education scholarship. This is a degree for artists that are confident in their practice and want to incorporate some aspect of education. It raises the level of art education theory for college art instructors and provides an alternative to a grade or high-school specific course of study. Graduate are able to publish and present in education, theory, and aesthetics-based resources where it is sorely needed. Art-based research is also a very common option for research (because Graeme Sullivan served as a faculty member) and many of the graduates incorporate their art making into their studies. Interestingly, the program finds that most students do not enter the program with much experience in writing and research.

Combined Writing and Research with Final Art Project

The University of California, San Diego offers a Ph.D. concentration in studio art practice. The Ph.D. program is located within an existing art and media program, which offers the concentration on top of an established degree program. Students complete the same course of study as a history student might but their final research component may be combined with an exhibition or final art project. This combination of research and art making is more in line with established art-based programs overseas. It would be rather controversial to only contribute a visual product as a defense (but many would like to see the trend move that way) The UC, San Diego program, however, is still in its infancy but the model is promising as the department has established a context where art making is placed in a position where it may serve as a mode of inquiry or as a product for reflection. Enforcing a final product instead of suggesting emphasizes the importance of the visual art product for the artist and the university. The written component is still present and the United States has yet to see a program that only requires a visual product but this seems unlikely unless the M.F.A. degree is used for a model (Perhaps a Doctorate of Fine Arts degree). The UC,

San Diego program is a context ripe for experimentation where the verbal and visual are each emphasized and encouraged.

While all four programs are theory and text heavy, Jones (2006) found that the less writing or research a program maintained, the more rigorous the thesis defense. This appears to be true in M.F.A. programs as well. A healthy combination appears to be the best remedy as programs that stray too far to one side lose the benefits of writing or studio practice. It is also worth emphasizing the consistent call and desire for better writers entering these programs. Graduates from M.F.A. programs are consistently not provided enough opportunities to write in a critical fashion and this will plague all programs until higher standards are established and maintained.

Where are we going with arts research?

To determine where we are going, we first need to find out where we are. From the history and debates presented it becomes obvious that the M.F.A. is neither completely understood nor consistently applied across the United States. From scientific investigations to 5-page papers/essays, there is a lot of work to be done to strengthen writing at the M.F.A. level. This is not to say that quality comes through quantity, but I do have a hard time recognizing that a short paper could be more than a simplistic review of complex subjects or an overanalyzed artist statement.

Do philosophers own the realm of art theory? According to Danto (1987) this responsibility has been handed over to philosophers and is no longer the domain of artists. But artists can take control in their writing and reclaim this area. The role of writing about theory complements art practice and vice versa (Dronsfield, 2009). Art practice shows an aspect of theory that cannot be seen. Recognizing how this knowledge is produced and utilized will go a long way toward the stability and stature of the artist in the university. Research is equated to inquiry/process in the studio but the reflection is the application and it is this component that is most often missing.

Piper (1989) writes: "Nevertheless the goal is to show one's respect for difficult and complex ideas by thinking as deeply and thoroughly as one can about them, and to show one's respect for one's readership by communicating one's thoughts about them as clearly, carefully, and consistently as possible" (pp. 149–50). This application also demonstrates a respectability that places the arts within a larger cultural context of professionals.

If the M.F.A. degree is about producing quality artists—as I believe it should, the written component should contribute toward this end goal. It does not need to mirror the scientific but rather utilize writing and research as a method of critique (reflective paradigm). The application of the Ph.D. is up in the air at this moment in the United States, as the speed of its adoption and the types of programs that will be most popular are unknown. The few options mentioned vary widely and more are

likely to be debated rather than adopted as is. The opportunity to call an artist "Dr." is a great step forward in honoring artistic study but it should not be the driving force for more advanced degrees..

The university artist has done well over the past century but critiques like this from Elkins (2009) frustrate me: "If you are like ninety-eight percent of artists, you don't need to know any academic field quite that well, and so the degree isn't that necessary… It will inevitably create a scholasticism—a uniformity, an orthodoxy, a conservatism—as every academic discipline does" (p. 279). This is precisely why reflective writing is needed. Without the discipline in print or the voice of the artist, art degrees become an easy target for the knowledge and understanding that may be there but not communicated. Plus, imagining that the M.F.A. is not already professionalized is far fetched.

The issue of professionalism is plaguing the development of better writing and research standards in the United States. Much of the worry is not about knowledge production or research standards (which it should) but instead on the ramifications for the current terminal degree and the status of art teachers. The reflective stance of research can benefit artists and the uniformity that Elkins suggests is already in place. The low expectations of not having to know that much about an academic field is the problem that seems to be a larger concern. Increased writing and research will help alleviate it and increased interdisciplinary research can break much of the professional boundaries that are established.

There is truth to Elkin's statement that must be addressed and it appears to be a caution against higher education progressing without improving what we already have. The doctoral degrees in art reviewed are a positive step but they are only shells for the education experience and there are conceptual ideas that are much more exciting to consider. The history of art education is a history of malleability and justification. I would argue that we already have a uniformity of accepting a lower level of writing at the M.F.A. level and that more needs to be done to raise the standards. Without a move to add rigor and standards to M.F.A. writing expectations, the Ph.D. in visual art has the potential to be neither academic or artistic, which is worse than conservatism. Expecting more from writing will heighten critique and produce better artists. Improved scholarship is a byproduct of this change. The following categories presented below are a sampling of topics and directions that artist scholars have already taken and should be used as inspiration for what is possible when art making is used to reflect and write about in a deep and meaningful fashion.

The artist scholar is alive and well and is capable of studying and reflecting on their own work. After all they are closest to the materials and the data. The place of knowledge is central to this discussion and Schön's (1983) distinction between knowledge in action and knowledge on reflection is important to consider. By reflecting on the art experience, the artist scholar is able to take a look and reflect on

the process of art making. It is not as though one must shut off their thinking in order to create art and then only through reflection can the scholar determine what has been done. In fact there is much thinking happening during the making process—but its not often realized until put into words. The following paragraphs briefly reflect on potential avenues for writing and research and how they have positively impacted the studio process. In presenting these examples, they include examples of how writing can inspire new creative work, how art can be interrogated, and how making art can be considered inquiry.

Writing and research

The artist Man Ray felt his own writing was an inspiration for creating additional work (Svenungsson, 2009). A conceptual artist before, the term existed, his writing was a central aspect for developing his thinking and his artistic process. He is not alone, as contemporary artists like Mike Kelley also use writing as a tool in the creative process. Svenungsson (2009) in studying artist writers established 5 categories to explain the different ways that artists have utilized writing. They include expressive me-focused storytelling in the first person; methodical revelation of (philosophical) truths; systematic revelation of technical and pedagogical truths; literary experimentation, with content in the open and in disguise; and well-referenced academic writing with further ambitions. While academic writing has been emphasized in this text, there is room for storytelling, truths, and experimentation to provoke understanding about art subjects. Several of the examples blur these lines as well.

Writing as experience

Hans Hofmann, the abstract expressionist painter, through both his art making and teaching influenced a generation of artists hoping to learn his theories of modernism and abstraction. Hofmann's writing like his teaching often sought to explain these theories but his poetry is of specific interest. Hofmann's poetry utilizes language as an art form to describe and help the reader/viewer better understand what they could experience physically. It was a clever use of writing functioning as a pedagogical tool and entry point into understanding his art.

Given the experiential aspect of painting and teaching, poetry allows the reader to have an artistic experience the way a description, artist statement, or lecture cannot. Words fail when one attempts to describe something that does not exist physically. Thus his poetry sought to capture something his essays could not articulate.

Figure 18. *Goliath*, 1960, Hans Hofmann, Oil on canvas, University of California, Berkeley Art Museum and Pacific Film Archive, Gift of Hans Hofmann.

Words, therefore, can describe in succession of time; but a description, such as would serve as a guide for a painter, would not bring up an image to the mind at all comparable to the vividness to that which the most ordinary sketch would give. For the mind is compelled laboriously to reconstruct the object after the description is complete by putting together the several parts which have been necessarily separated in the description, while the eyes see the object at once as a whole while we review the parts. Whenever then a poet wishes to paint an object, let him not suppose that a description will accomplish his end.

<div align="right">(Walter, 1888, p. 27)</div>

Art, like poetry, has the ability to awaken and provoke new perspectives. The American poet, T. S. Eliot (1933/1964) writes that poetry "may make us from time to time a little more aware of the deeper, unnamed feelings which form the substratum of our being, to which we rarely penetrate; for our lives are mostly a constant evasion of ourselves, and an evasion of the visible and sensible world" (p. 149). Poetry written by the visual artist thus serves the artist to refine their thinking and benefits the viewer/reader as another medium is available to engage the artist's particular product(s) or process.

Space and the picture

> One cannot see space–
> one can only sense space–
> Since one cannot see space
> One can also not copy space–
> and since one senses space only
> one must invent the pictorial space
> as the finale of a pictorial creation.
> Therefore one must be inventive in using
> the pictorial means:
> the Line, the planes, the points
> these are the architectural means
> with which to build up space as
> experienced–
> experienced by the senses
> and not only perceived by physical vision
> because vision and space experience
> together

create a inner vision
in the junction and by relation of a multiple physical
experience
with a psychic reaction.

(Hofmann, 1955/2008)

Hofmann's poem draws interesting parallels with the concept of poetic knowledge. Poetic knowledge is more than just a knowledge of poems but "a spontaneous act of the external and internal senses with the intellect, integrated and whole, rather than an act associated with the powers of analytic reasoning" (Taylor, 1998, p. 6). This perspective is most like the finished art product. It can be difficult to understand and it may require much more work on the part of the reader but it is an interesting option to explore and can aid the way we think about the elusive nature of art. However, writing or research as an art form is not too far off from accepted research practices in the university. Narrative studies, a method of qualitative research, are used to understand the stories people tell to describe their lives and experiences. Stories shape the way we understand life and our experience as humans. The narrative method can bring about an explanatory process that allows the reader to understand the subject in a new way.

Writing as inquiry

The artist Jason Swift uses writing as one of many tools to investigate and eventually create art. Seeing no separation between his research and art making, the artist explores his experiences and develops narratives as the writing and art develop simultaneously. Rather than explain or highlight an aspect of his work, the writing and art serve as an inquiry. Swift (2011) writes: "Research methodologies and writing go hand in hand with the making of objects and construction of narratives and any written research is not separate from my art practice. It is art and my art is my research and one cannot exist without the other." Stories develop and meaning is made as the artist develops a voice and product. More than technical application, Swift's practice is an investigation.

Writing however is not always discernible in the visual arts, and creative use of writing can sometimes become an obstacle. The critical reactions to the Whitney Biennial in 2008 were quite bizarre. Instead of criticizing the show that everyone loves to hate, much of the negative comments were directed at the wall text that accompanied the art on display (Gibson, 2008). The writing by the curators of the show was not inspirational, understandable, or a form of inquiry but rather a specialized language that was appropriate to a select few. However unfortunate, this is not the type of reflective writing that inspires creativity nor is it helpful or inclusive for

Figure 19. *Source of Practice*, Jason Swift, 2004, Dimensions variable, Plastic, Wood, Steel, Paper, White Vinegar, Rubber and Found Objects, Courtesy of the artist

other artist scholars. Clear writing equates clear thinking, so experimentation should be used carefully.

Writing inspiring or interrogating work

Writing may also be used as a stimulus and inspiration. Writing that informs art making considers the work that aids, stimulates, and informs the artistic process. This could be background research and writing artists complete before they begin a work of art or writing that reflect on the artwork that eventually changes the work in question. The writing could potentially continue throughout the creative practice but the pattern starts with influences like reading, drawing, looking, and thinking which then feeds the artist intellectually and practically. This process often is referred to as research and is the groundwork for making powerful and meaningful artwork.

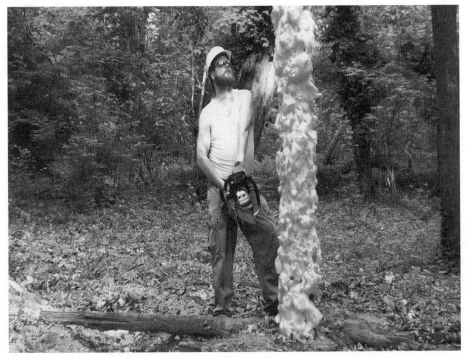

Figure 20. Lumberjake, Jacob Amundson, 2009-10, Video still, Courtesy of the artist.

Jacob Amundson uses writing as an interrogation tool. Reading and writing on a number of major themes, he addressed the subjects of humor, pop culture, and religion for a 2010 thesis. A collection of essays, his writings delved into issues of personal significance and was organized in tandem with completion of his artwork. The writing helped him formulate and organize much of his concerns in addition to contextualizing his work in the contemporary artworld (and broader fields like humor), an important component for graduates who hope to engage the larger art world. The final product functioned as evidence of this journey and was presented as a collection of biographical and theoretical essays that addressed important components involved in the production of these artworks. The organization of Amundson's text is rhizomatic and does not follow a traditional linear format. Much like the writing process, it was dynamic and interactive. Instead, the reader can jump to different topics and make connections in a nonlinear fashion (much like his own work). An interrogation of specific ideas, the study is revealing for understanding the knowledge base that fuels his art. A helpful organizational tool, Amundson leaves a basic footing for the reader as an annotated bibliography that the scholar can use to situate themselves to understand the entire study.

Writing that documents

The artist scholar Craig Goodworth (2010) uses writing and art as a larger form of inquiry into a host of topics. Goodworth considers how the emptying of oneself is necessary for sustainable community and suggests that ascetic and aesthetic experience can assist in this process. Utilizing the artistic and writing process, Goodworth explores emptying himself physically and emotionally to allow room for community and the other. Seeing his life as a larger performance, the writing is a way of documenting this inquiry much like the time-based work he produces. Goodworth's film *Mapping Purgation* (2008) is a performance-based artwork that depicts the domestic butchering of animals. The removal of the animal innards is one physical manifestation of this larger philosophy that is being tested and examined. Goodworth's writing contributes toward an inquiry-based quest that sheds understanding on how purgation assists transformation in nature, in art, and in the self. Writing clarifies the inquiry for Goodworth. It is not representative of the artistic inquiry but is another form that the artist uses to strengthen, display, and continue his inquiry in another medium. The art is a type of inquiry that demonstrates the material and immaterial process of purgation through the sensuous, spiritual, and sublime elements of death and hollowing; it represents a serious amount of understanding of thinking about transformation, and the writing and art could function separately but when presented in the academic context, they display a wealth of understanding about the topics explored.

Figure 21. Craig Goodworth's 2011 antler drawing that conceptualizes his research, writing, and art making. Courtesy of the artist.

Art-based research values the visual over the verbal and Goodworth's drawings, performances, and sculpture are related to psychological issues that explore human conditions like thought and action. Even in organizing such a study, drawings that organize and link the many aspects of the individual artistic process are important to consider. Goodworth's drawing demonstrates how meaning is constructed in his research paradigm and how he understands this information.

Writing as art

Writing can function as a work of art on its own, and many of the examples given could be argued from this perspective. This perspective often utilizes creative writing, narrative, poetry, story, and metaphor to better understand the complexities of the subject studied. The actual writing project functions separately (although complimentary) to the artwork. A narrative can capture the complexities of the artistic process, poetry might elicit symbolism, or a metaphor might capture the elusive subject matter that words have trouble conveying in a particular artwork. Writing as an art form utilizes text to shift, alter, and provoke additional inquiry and thought regarding art practice and art products. It is not mean to be redundant. Rather writing as art should provoke new insight and could encompass an entire study or a single chapter.

The end goal is to create new ways of understanding the subject of interest. The metaphor of a journey or expedition is often used to describe the research process: an exploration undertaken by the artist scholar to discover new lands and experiences. New lands or experiences could be subject matter, research methodologies, or additional research related to the subject. In the end, the traveler gains an appreciation for the process and the new discovery. The metaphor works on many levels and illustrates the powerful nature of such language.

Dunlop (1999) challenged the conventions of art as research by completing a novel as a dissertation. Using narrative to develop a better understanding of education and literary study, the story constructed was informed by personal experiences from secondary-school teachers and university educators. To contextualize the work, Dunlop went to great lengths to write a history of literary forms with an educational agenda.

In Dunlop's (1999) own words:

> Boundry Bay is the story of Evelyn Greene, a newly appointed university professor teaching in Faculties of Education and Arts. Interwoven through the novel are the narratives of marriage, love, separation, divorce, teaching and educational life, motherhood, loss, the role of

recovery and the reconsideration of lives into new shapes and forms. The story begins with explorations of young love and marriage to Jay, followed by the birth of their daughter Mara. The narrative continues as Evelyn decides to leave her marriage and engages in the journey that takes her to Boundary Bay, a place where she feel "she holds the landscape in her arms."

<div align="right">(p. 12)</div>

As Dunlop explored, research and writing as an art form can alter the reader's perspective to see the subject of study in a new light.

Figure 22. *Lakeside Residence*, Anne Marie Veloz, 2011, Mixed media, Courtesy of the artist.

Writing that organizes

Anne Marie Veloz (2010) also uses her art as a form of inquiry and used writing as a way to organize and present this journey. Veloz has continually been interested in the discarded remains of communities left from the progression of society. She visits the dessert areas of this country and is fascinated by the abandoned homes that the weather and earth are slowly consuming. Documenting them and eventually reconstructing them on a miniature scale, the diminutive sculptures represent the essential aspects of these former dwelling places. She acknowledges these structures as representing the ever-pressing dream for the American utopian lifestyle. These topics were not well defined at the beginning of Veloz's studies but by reflecting on her own artistic inquiry and teasing out the main themes, she was able to gain a better understanding of how her mind and body reacted and interacted with the empty spaces. She used three mediums: photography, installation, and sculpture to explore the concept of inhabitance, and each medium raised several issues with many overlapping and becoming the central concepts aspect of her work. Applying Sullivan's (2005) perspective that because things change, you need several different ways to represent something in order to understand it, Veloz recreated 9 sculptures that the artist inhibited. The artist inquired through her imagery why certain houses no longer have an owner and are left abandoned. She found a human desire in herself to reclaim these spaces and inject life back into the structures once inhabited. Through Veloz's (2010) writings she eventually questioned her relationship with the house through her sculptures and placed them within a larger context.

Gray and Malins (2004) stress the experimental nature of art practice and the reflective learning that takes place through the scholarship of artists. Veloz fits this description as her inquiry took her to an unknown place and she used her writing to understand this context. The relationship between practice and research changes as one can inform either. This is a circular framework that can be implemented in any academic discipline and one that great values the process of making art and the reflective artists who recognize the impact that each of these roles has on one another.

This type of writing purports the art object as the significant contribution and the writing serves as a foundation in which it can stand confidently. Asking how this preliminary work supports, guides, and/or inspires artwork is important. A working knowledge of subject matter is demonstrated through such a process and aids the artist as they make decisions in the studio. In addition, narrowing the field of study is important. Following the writing and research and identifying what exactly it supports (practice and products) are important decisions to make.

The American M.F.A. program has the potential to facilitate radical investigations with writing and research that can benefit the student and faculty with great rewards.

By embracing the studio experience and using writing and research as a tool is an exciting opportunity. We are only scratching the surface with the reflective examples provided and I look forward to witnessing artist scholars pushing the guidelines in the future.

—————

The United States has certainly lagged behind in the progress of visual arts education at the higher levels compared to programs overseas, and one must wonder if the foundation set at the grade school and high school levels have set a precedence. There are many factors that could have contributed toward this confusion over the significance of arts education, but false presumptions of discipline-based art education reforms that circumvented art making and valued the philosophy, history, and criticism aspects of US art curriculum must have undoubtedly had a negative effect on the academic calibre and understanding of what art education entails. Diluting the studio component of art education and regulating it to one quarter of the curriculum was preached in universities throughout the United States and continues to be instituted by teachers who were trained in this manner. While it is only one development in art education history, it joins forces with post-modern educational schemas that have devalued writing production for artists.

The dilemmas and frustration go hand in hand with the positives of artist being affiliated with the university. Without this history, artists would likely not be debating the merits of writing, new knowledge, and how it related to their practice as visual artists. However, arts-based research has become an accepted paradigm in the contemporary university abroad and there are many decisions that need to be made by art departments in the United States. Doubts about how research should be applied to graduate art education programs have plagued art instruction in recent years. This knowledge that artists hold or practice is thought to be beyond conceptualization and while skills and techniques may be offered in a university education, the conceptual language that is part of being a professional is now the core of this unspoken knowledge.

Professionalization and institutionalization are concepts we can comfortable apply to the arts since the university has adopted the majority of art education responsibilities for higher education. The traditions and intellectual heritage of the visual arts have been identified and claimed by many to build a case for its importance in the university. Credentials, safety, stability, and validity are just a few of the many benefits for student and artist-teachers that institutions of higher learning offer. Because of this, study in the arts has expanded greatly, as universities created many specialties in art studies. This relationship has pushed arts research to becoming a reality as artists outside the university rarely think in these terms.

Since the education of artists became the responsibility of university, the role of new knowledge and its role in the education and practice of artists in the university has become a hot topic. The progression of these ideas has pushed the field of art education into unchartered territory overseas and the United States could be characterized as playing catch up with our colleagues or potentially positioning itself to address the role of research differently.

As we know, technical training does not make the artist in the twenty-first century. These are characteristics that have passed and are part of the profession of being an artist. In the same manner, an artist that does not hold conceptual tools to engage research will find themselves further from the expected discourse and processes from artists in the university.

The twenty-first century university continues to build a foundation for arts education that facilitates the creation and study of art. Criticism that art education has become professionalized or too conceptual will continue to plague these institutions and part of the successful implementation of arts scholarship will be up to individual art departments to determine what role writing and research should play in a students education and how relevant it should be for faculty and their own scholarship. I believe that becoming more critical in our writing and thinking will help artists from falling into this trap.

Arts-based research as it exists in countries like England, Canada, and Australia is very different from the M.F.A. experience in the United States. The priority of artist education is of great concern to U.S. programs. How will artists in the university save and protect the vitality of the studio as the pitfalls of assessment, credentials, professionalization, and the expectations of research come tumbling down on American M.F.A. programs. The Ph.D. in the visual arts will eventually come and when it does, it has the potential to dramatically alter the way artists operate in the American university. There are many positives that a Ph.D. in visual arts can offer including higher expectations from graduates and faculty, access to additional funding from grants and fellowships, and a robust set of theories for investigating phenomenon. However it is coming from a different set of objectives compared to the current M.F.A. degree in the United States, and artists will likely feel their role in the university shift from art maker to researcher.

But has this not happened in the past? The dramatic shift from a craft-based discipline to an intellectual profession radically transformed the place of artists and art education in Renaissance society. The change in educational focus corresponded with the development of private academies and artist clubs that focused on preserving the progress of creating and teaching the visual arts. However, it was not until the nineteenth century when the university system in England welcomed art teachers into their midst. The visual arts within the university have blossomed to create opportunities for arts appreciation in small communities everywhere and the recognition, stability, and record of quality has given the arts a platform for artistic inquiry outside the marketplace.

The relationship the visual arts have with the university has created an expectation for research in the arts. Artists have qualified their practice as scholarly products but the expectations of artists continue to be raised in the twenty-first century. M.F.A. programs occasionally require thesis papers although the quality varies quite a bit depending on the program. This is a problem that needs to be solved before Ph.D. programs start accepting graduates. A recent push in fine-art research is dramatically changing the expectations of artist scholarship and appropriate methodologies that support the goals of artists are needed.

Artists will continue to prosper in the university but how the doctoral degree impacts this education remains to be seen in the United States. In the mean time, artists can claim their ground and emphasize the importance of artistic practice through their scholarship.

References

Amundson, J. (2010). *Thesis exhibition*. Azusa, CA: Azusa Pacific University.

Danto, A. C. (1987). *The state of the art*. New Jersey: Prentice Hall.

Dronsfield, J. L. (2009, Spring). Theory as art practice: Notes for discipline. *Research: A Journal of Ideas, Contexts and Methods. 2*(2), Retrieved on July 30, 2011 from http://www.artandresearch.org.uk/v2n2/dronsfield.html

Dunlop, R. (1999). *Boundry bay: A novel as educational research*. Unpublished doctoral thesis, University of British Columbia, Vancouver, Canada.

Elkins, J. (Eds). (2009). *Artists with PhDs: On the new doctoral degree in studio art*. Washinton D.C.: New Academic Publishing.

Eliot, T. S.(1933/1964). *The use of poetry and the use of criticism*. London, UK: Faber and Faber Ltd.

Gibson, E. (2008, April 18). Taste—de gustibus: The lost art of writing about art. *Wall Street Journal*, p. W13.

Gray, C., & Malins, J. (2004). *Visualizing research: A guide to the research process in art and design*. Burlington, VT: Ashgate.

Goodworth, C. (2010). *Thesis exhibition*. Azusa, CA: Azusa Pacific University.

Hofmann, H. (1955/2008). *Hans Hofmann: Poems and paintings on paper*. New York: Ameringer Yohe Fine Art.

Jones, T. E. (2006). A method of search for reality: Research and research degrees in art and design. In. K. Macleod & L. Holdridge (Eds), *Thinking through art: Reflections on art as research* (pp. 226–40). New York: Routledge.

Piper, A. (1989). "A paradox of conscience". In A. Piper, *Out of Order, Out of Sight—Volume II—Selected Writings in Art Criticism* (pp. 149–50). Cambridge Mass.: MIT Press, 1996.

Schön, D. (1983). *The reflective practitioner: How professionals think in action*. New York: Basic Books.

Sullivan, G. (2005). *Art practice as research: Inquiry in the visual arts*. Thousand Oaks: Sage.

Svenungsson, J. (2009). The writing artist. *Art & Research: A Journal of Ideas, Contexts and Methods*, 2(2), Retrieved on July 30, 2011 from http://www.artandresearch.org.uk/v2n2/svenungsson.html

Swift, J. (2011). Personal communication.

Taylor, J. S. (1998). *Poetic knowledge: The recovery of education*. Albany, NY: State University of New York Press.

Veloz, A. M. (2010). *Thesis exhibition*. Azusa, CA: Azusa Pacific University.

Walter, E. L. (1888). *Lessing on the boundries of poetry and painting*. Ann Arbor, MI: Andrews Company Publishers.

Wilson, M. (2009, Spring). Panel discussion: Concerning doctoral studies. *Art & Research: A Journal of Ideas, Contexts and Methods*, 2(2), Retrieved on July 30, 2011 from http://www.artandresearch.org.uk/v2n2/panel.html

Appendix A

**Putting Writing to Practice
(A Sample Proposal)**

Title of project

The Journey to Apartment Billboard

Research question

Given that the artistic process is a multifaceted process, I am interested in exploring the many experiences that went into the creation of the sculpture "Apartment Billboard," specifically the role of writing and reading in relationship to my teaching, scholarship, religion, and family life.

Aim and scope of study

Reflecting on one product allows the scholar to dive deep into the small decisions that made the product. Larger samples can be used that allow for multiple comparisons but too large a sample can result in a superficial investigation that lacks depth. "Apartment Billboard" was created over a 3-month cycle and during that time I kept a weekly process journal where I documented aspects of my artistic experiences including hours in the studio, general reflections, and goals/accomplishments during this time. These journals and the analysis of the actual sculpture and the development of ideas will be categorized in order to better understand a process that is thought to be beyond conceptualization.

Figure 23. Suburban Skyscrapers [mixed media sculpture], J. David Carlson, Private Collection, Courtesy of the artist.

Rationale for inquiry

Scholarship that contributes to self-reflection and better understanding of the artistic process is among the most helpful and meaningful feedback an artist can receive. The writing process can function similar to the critique process albeit in a much more detailed and introspective manner.

The role of play and writing in my art also fits within larger historical and contemporary themes in visual art. Through this study, I hope to contextualize these themes and find my place among a community of artists that also address these concepts. Several texts and publications have aided my process to contextualize the field of play and how my work fits into this knowledge (Ackerman, 1991, 2000; Appadurai, 1998; Csikszentmihalyi, 2000; Deutsche, 1998; Gooding, 1991; Hyde, 1998; Jung, 1989; Kuznets, 1994; McClary, 1997; Meares, 1993; Miller & Lupton, 2000; Montessori, 1972; Nachmanovitch, 1990; Stewert, 1993; Suton-Smith, 2001; Winnicott, 1989).

Objectives to be covered

Objectives include writing a brief history to contextualize the important issues (play theory, arts-based research, and writing infusing art production) surrounding my work. In addition, I plan to analyze how and where writing infused my art production of a single sculpture. Since data is readily available in notes, sketchbooks, reflections, and art products—utilizing my methodology to analyze and finally present my findings is of primary concern.

Context

Since the year 2004, my art work has addressed the concept of play as a historical subject in addition to applying play methods in the studio. Sculptures range from golf ball sculptures to invented three-dimensional landscapes featuring materials regularly found in hobby shops.

My studio practice regularly follows the writing or research informing art paradigm. Research is the primary mode of discovery as I study play theory, history of play, play methods, toys and culture, and the psychological aspects of play. In addition I am also interested in the educational theories associated with the Bauhaus, Montessori, Waldorf, and the Black Mountain College. This is a diverse range of enterprises and while each may not manifest in a particular piece, the continued research helps feed ideas in the studio.

My analysis of play theory has a profound impact connecting my studio practice to my personal childhood experiences (playhood). Instinctual play is a theory I explore as I reflect on my early activities with objects (toys). I investigated what toys I gravitated toward and which were imposed on me as a child. Winnicott (1989), a well-known psychoanalyst of play explains that objects help us understand our place in this world. He claims our childhood associations with objects simplify our uniqueness as complex human beings. I apply object recognition directly in my studio practice. Reacquainting myself with my with favorite childhood toys, I build sets, position action figures, and construct themed transportation vehicles. Reengaging with these toys in a playful manner then leads to experimental art works (Carlson, 2010).

As I read and write about play theory, these ideas then inform my studio work. While writing or performing research on play theory satisfies the initial spark for creating artwork, it useful to reflect on this process once the work is complete to analyze exactly how this research actually influenced a work or series.

Methodology and procedure for inquiry

Using Gruber's (1989) network of enterprises, I plan to identify links between personal history, education, faith and scholarship. Ebertz (2006) provides a hermeneutical model linking personal scholarship, field of study, and scripture and shows that there is a natural connection, rather than one that is forced. I hope to build upon this model including the roles of my additional enterprises.

Gillham and McGilp (2007) suggest that artist scholars approach their investigation as either a conventional logical format of an academic paper or in a chronological narrative that describes the journey. The narrative perspective is specifically applicable to reflecting on art because it considers the progress of work in relation to the artist's increased understanding of the subject/topic addressed in the work. Once the analysis is complete, I plan to present the finding in the form of a narrative that recounts the creation of Apartment Billboard.

Planning is essential when thinking about data and what the artist intends to study when reflecting on their art. Much can be done during the process to provide a rich amount of data for reflection and to inspire writing. Capturing the thinking process can be difficult. In many traditional qualitative studies, researchers use interviews and observation to learn about the subject studied. However, as an artist scholar you are observing yourself, so how do you produce data to be analyzed? Journal keeping is the best answer and it can be done after each studio session. This resource allows the artist scholar to think about their studio thinking. In addition it can be reorganized and broken down into a timetable or a host of organizational chunks (subject, influences, productivity, etc.) that will cause the artist to see their data in a new light. The journal

is evidence of thinking at a particular moment and is the data that the artist scholar can use to compare and contrast ideas and influences over time. This is metathinking and it is a reflective and helpful process that demonstrates a serious inquiry about individual processes. Processes like this are very helpful for a scholar like myself who is writing reflectively because once the product is complete I can revisit these journals and identify crucial milestones and influences that went into a particular work of art or series of works.

Potential outcomes

Reflecting on art is a valuable perspective to consider as a writing project. As a formal paper, it provokes a much more critical approach then a literature review or listings of influential causes. If considering utilizing writing as a tool for artistic scholarship, remember that it is predicated on the artwork being finished. If the art is not complete, only the aspects that are complete can be reflected upon. Otherwise you are writing to inform your artwork. Looking forward I foresee several categories emerging including play, education, spirituality, and teaching being important contributors to my artistic process. Writing greatly influences my ideas of play and I suspect that these ideas will also infiltrate other areas of my life like teaching, more than I realize.

Bibliography

A list of sources (in the form of a bibliography) related to the concepts explored in the proposal demonstrates the depth of the proposed topic and its relevance in play theory and contemporary art. The following texts listed in the references address concepts of play in art, education, and philosophy.

References

Ackerman, D. (1991). *A natural history of the senses*. New York: Random House, Incorporated.

Ackerman, D. (2000). *Deep play*. New York: Vintage Books.

Appadurai, A. (1998). *Social life of things*. Cambridge: Cambridge University Press.

Carlson, D. (2010). *The art of David Carlson*. Azusa, CA: Azusa Pacific University.

Csikszentmihalyi, M. (2000). *Beyond boredom and anxiety: Experiencing flow in work and play*. San Francisco: Jossey-Bass.

Deutsche, R. (1998). *Evictions: Art and spatial politics*. Cambridge, MA: MIT Press.

Ebertz, R. (2006). Beyond worldview analysis: Insights from Hans-Georg Gadamer on Christian scholarship. *Christian Scholar's Review*, 36(1), pp. 13–28.

Gillham, B., & McGip, H. (2007). Recording the creative process: An empircal basis for practice-integrated research in the arts. *Internation Journal of Art and Design Education*, 26(2), pp. 177–84.

Gooding, M. (1991). *Surrealist games*. Boston, MA: Shambhala Publications.

Gruber, H. E. (1989). The evolving systems approach to creative work. In D. B. Wallace & H. E. Gruber (Eds), *Creative people at work*. New York: Oxford University Press.

Hyde, L. (1998). *Trickster makes this world: Mischief, myth, and art*. New York: North Point Press.

Jung, C. G. (1989). *Memories, dreams, reflections*. New York: Vintage Books.

Kuznets, L. R. (1994). *When toys come alive: Narratives of animation, metamorphosis, and development*. New Haven, CT: Yale University Press.

McClary, A. (1997). *Toys with nine lives*. North Haven, CT: Shoestring Press.

Meares, R. (1993). *Metaphor of play: Disruption and restoration in the borderline experience*. Lanham, MD: Jarson Aronson.

Miller, J. A., & Lupton, E. (2000). *The ABC's of Bauhaus, the Bauhaus and design theory*. New York: Princeton Architectural Press.

Montessori, M. (1972). Secret of Childhood. New York: Random House.

Nachmanovitch, S. (1990). *Free play*. New York: Penguin Putnam.

Stewert, S. (1993). *On longing: Narratives of the miniature, the gigantic, the souvenir, the collection*. Durham, NC: Duke University Press.

Suton-Smith, B. (2001). *The ambiguity of play*. Cambridge, MA: Harvard University Press.

Winnicott, D. W. (1989). *Playing and reality*. New York: Routledge.

Appendix B

Banksy Hearts NY

Preface to study

The primary purpose of reflecting on an art product is to capture an aspect of the creative process that is often thought to be mysterious. The studio is considered the traditional place where art is created. However the artist's studio in the twenty-first century is not necessarily a physical space and this thinking may occur in a myriad of locations and contexts. Artists who reflect on their own art and process through writing have a wealth of information available to themselves. This chapter is essentially a sample and one possible method for writing about an artwork or subject and how it can aid the artist and their education.

To narrow the study, I chose one image. By using a particular work of art, I reflected on the potential influences and enterprises that contributed toward the creation of this piece. This is only an example and future studies could be organized in a number of ways, each revealing new aspects and insights into the subject studied. Despite the issues presented, if a proper case study and reflection can be conducted on the art and process of Banksy, then it should serve as an encouragement for other artist scholars when writing and reflecting on their own work.

Title

Reflecting on The "I Love NY" Doctor

Introduction

There are not many forms of art making that could be more distant from the university environment than street art. The artist scholar working in the ivory tower functions in another world compared to artists who work under the cloak of darkness. The university artist is often secure and has a history of creating art within the safety of the university walls. Street artists in contrast often must conceal their identity in order to evade the law. But are they that different? The aim of this study is to capture an aspect of the studio that is often thought to be beyond conceptualization. Artists and specifically Banksy make many decisions before a piece is presented to the public; investigating how and why these decisions were made based upon data has rich implications for understanding the professional knowledge practiced by Banksy. The inability to articulate knowledge is a consummate issue for professionals and reflection is one method that can be used for articulation (Schön, 1983).

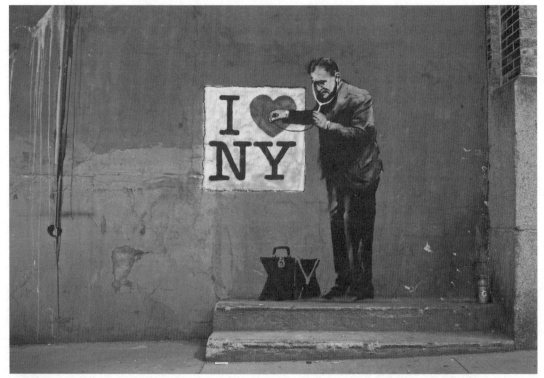

Figure 24. *"I Love NY" Doctor*, 2010, Banksy, Photo Courtesy of Pest Control Office.

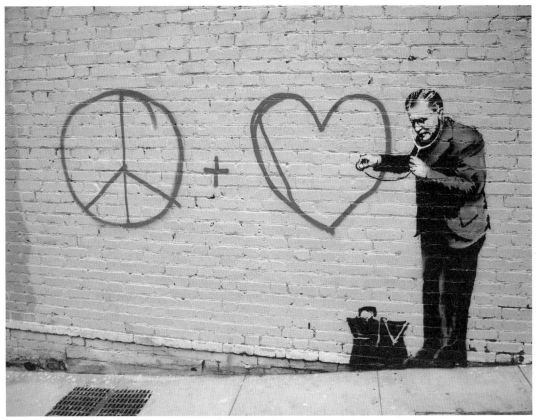

Figure 25. *San Francisco Chinatown Doctor*, Banksy, 2010, Courtesy of Michael Cuffe.

The work in question has been called The "I Love NY" Doctor. It appeared on a wall in Lower Manhattan during the latter part of Spring 2010. Because it is street art, it does not have any of the traditional information that accompanies artworks exhibited in galleries and museums. It is attributed to Banksy because of the style, dark humor, and materials used. In addition there is a viral community online that collects, shares, and discusses recent Banksy artworks and many aficionados have confirmed this particular work (in addition to the artist's own website that continually updates recent street works by Banksy, the most reliable authentication). This identification and proclamation is often the only way one can confirm the legitimacy of the artwork. As part of Banksy's tour and publicity featuring the new movie *Exit Through the Gift Shop*, several alleged Banksy artworks started to pop up in cities in the United States. The image featured here (see Figure 24) was only available to see in New York City for a short time before it was destroyed. A similar doctor image was produced by Banksy in San Francisco during the same year in conjunction with the tour (see Figure 25).

Research question

The purpose and organization of this study are centered on the following assumption and research question: Despite the intimate knowledge artists like Banksy have with the studio process, much of this activity is instinctual and tacit. Given this elusive nature of the studio work, what enterprises went into the construction of the artwork "I Love NY" Doctor and how did they interact to create this artwork? The study will also review concepts that are related to street art and contextualize Banksy historically.

Limits

There are many challenges that limit any individual study and it is important to recognize these obstacles. A limitation is that I am not the artist and access to the artist is restricted. I must practice some caution and skepticism with my sources. Therefore I am looking to draw data from primarily interviews, the artist's writings, and his artwork. Corroborating evidence with the artist, accessing particular data, validity of sources, and my role as an outsider are all significant limitations that require identification to situate my subjective position.

There are also a multitude of avenues for organizing this information including selecting an objective, choosing appropriate data, and deciding how to analyze that data to formulate some interpretations. By selecting to write about an elusive and mysterious artist, I am intentionally demonstrating that anyone has the necessary tools and resources to reflect on their own artwork. This is intended to be an exercise first and foremost. I am not Banksy and this is not my artwork, as someone from outside I am placed at a disadvantage (this could also be an advantage). Taking a post-positivist perspective of knowledge, I realize that this study will not be an objective assessment but rather provide a better understanding of a phenomenon that will be approximated. By choosing particular goals and organizing information according to my objectives, insights are gained which might be different if another set of parameters are chosen.

This is a qualitative case study that utilizes a methodology from the field of creativity in order to take a closer look at the elusive nature of studio practice. It is assumed that writing appearing under the Banksy name belongs to the artist and is taken to be his while also realizing that the artist practices quite a bit of sarcasm and irony in his art and writing. Arts-based research is a growing tradition in art practice and the following study intends to shed light on a particular practice of street art. Studying the actions, statements, and art of one street artist will allow for future comparisons between other street artists and scholars reflecting on their own work.

Methodology and procedure for inquiry

The procedures for the following study includes setting a theoretical framework for collecting and analyzing data related to understanding the creation and thinking process that contributed toward The "I Love NY" Doctor. The focus on a specific work of art allows for an in-depth investigation. Using Gruber's (1989) network of enterprises permits the researcher to organize the many aspects of the artist's life into a structure. Every artist is different and has a different set of experiences and this methodology helps layout these unique perspectives and the many decisions that led up to the artistic product.

The network of enterprises allows the scholar to "focus attention on the way the creative person is organized as a unique system for recognizing, embracing, and doing the new job at hand" (p. 3). This type of research analysis requires attention to the unique creative person and how their work represents a new perspective. As each person is distinctive and operates in a different context, Gruber (1989) uses an evolving system for understanding how creative work happens. Producing art products is a creative act and by studying the decisions that led to a product, it allows the artist scholar to better understand the process or product. Identifying essential streams or areas of influence/thinking and their relationship with one another allows the scholar to gain a better understanding of the thinking process. Using primary resources such as artist writings and artworks to better delve into understanding the particular aspects of their work is an example of how artist scholars and their writing serves as a complementary form of scholarship to their artistic practice.

By writing a brief biography, a progression of thought allows for close investigation and understanding of the artist's life and work. Identifying essential streams of influence/thinking and their relationship with one another allows the researcher to gain a better understanding of Banksy' creative process and its culmination in a particular work.

As a result, the following reflection has several goals to better understand the research question:

- To identify and analyze the network of enterprises used by Banksy and how they contributed to the formation of the "I Love NY" Doctor.
- To place the individual work within the artist's creative works over time.
- Identify subjective networks of enterprise to investigate smaller aspects of the art and/or process.

Through the writing process several enterprises emerged from studying Banksy's "I Love NY" Doctor which include cultural atmosphere, professional influences, media, imagery, location, and irony. Each topic is explored in sections and is compared with primary and secondary sources.

Brief biography

Banksy is the pseudonym for a British street artist whose identity is shrouded in mystery. Labeled Britain's most wanted artist, he has become part of the visual culture of England and an international art star. More appropriately Banksy is an antihero of the artworld as he consistently criticizes the institutions that seem most likely to hold him up or be a supporter of his art. A tag on the front steps of the Tate Britain states "Mind the Crap." A gesture that provokes controversy, creates headlines, and instantly sparks debate.

We only know Banksy through his street art, brief interviews, and a collection of stories that contribute toward the myth of Banksy. Yes, he is a mortal (or a studio of mortals) that installs arresting and thought-provoking imagery. His work has popped up on public walls in cities around the world. His wit and politically inspired messages

Figure 26. *Peeing Dog*, Banksy, 2011, Photo by G. James Daichendt.

have garnered international attention. His images are described as cunning, humorous, politically loaded, and immediately accessible. Popular subjects include rats, monkeys, policemen, pop culture references, soldiers, children, gas masks (images of death, war, etc.), and the elderly. These subjects are often juxtaposed with short quips (think Jenny Holzer meets stenciled spray paint) that provoke and illustrate the ridiculous. Subjects have included a young girl frisking a policeman in riot gear and a "No Loitering" sign on the side of an abandoned home devastated by the Hurricane Katrina in New Orleans. His more notable exploits include a guerilla-like installation at Disneyland in southern California that featured an inflatable doll dressed in a bright orange Guantanamo Bay prisoner uniform that was subsequently installed in the natural decor surrounding the attraction Big Thunder Mountain Railroad. The park was immediately put on high alert and needless to say Disney officials were not happy. In addition he has placed his own uninvited artworks in the Museum of Modern art, the British Museum, and the Metropolitan Museum of Art as unofficial additions to their collections. Funny, frustrating, and intriguing, the secretive Banksy disguises himself and claims it is much easier and quicker to install works himself rather than waiting for the institutions to acquire them. Considered by some to be the ultimate artist, his imagery is approachable and available. Others consider him a public nuisance for defacing property and sneaking work into museums. In his own words "People either love me or they hate me, or they don't really care" (Banksy, 2006, p. 238).

Timeline

In the last decade, Banksy's popularity has skyrocketed. A major museum exhibition at the Bristol City Museum and Art Gallery, an Oscar-nominated movie, a major book deal, and a continuous flow of articles in the leading magazines and newspapers have made him an international art star. Even *Time* magazine ranked Banksy 56 of out of TIME's top 100 most influential people of 2010 (Time's Staff, 2010). Banksy feels these are unprecedented times where there are new ways to be an artist and new audiences, in an artworld that essentially belongs to the people (Miller, 2010). The press seems to agree and Banksy's popularity does not appear to be slowing down.

A selected timeline emphasizes some of major accomplishments by Banksy in his artistic career.

1974	Approximate year of birth, Bristol, UK
1990	Approximate time when Banksy began practicing graffiti
1992	(1994) Banksy is part of the local Bristol graffiti scene
1992	Banksy has an epiphany to use stencils
2000	First solo show, Severnshed Exhibition, Bristol, UK

2000 First show in London, Rivington Street Arches (actually on the street, outside what is now "Cargo" club/bar/gallery)

2001 Banksy's stencils appear in locations around England

2001 Mona Lisa with rocket launcher stenciled in Soho

2002 Existencilism is self-published

2002 Exhibition, *Existencilism* at 33 1/3 Gallery, Los Angeles, CA

2002 Banksy stencil "Mind the Crap" outside the Tate Gallery, London

2003 Exhibition, *Turf War*

2003 Venice Beach stencil "Fat Lane"

2003 Banksy hangs a work in the Tate Museum (lasts 2.5 hours due to poor glue)

2003 Stencils appear in Paris and Barcelona

2003 "Banging Your Head Against a Brick Wall" is self-published

2004 Banksy produces fake British notes with the portrait of Princess Diana

2004 "McDonalds is Stealing our Children" installation in Piccadilly Circus, London

2004 Banksy installs work in Natural History Museum, London (lasts 2 hours)

2004 Banksy hangs a work in the Louvre, Paris (unknown how long it lasted)

2005 *Cut It Out* is self-published

2005 Banksy hangs a work in the British Museum (lasts 8 days)

2005 Banksy hangs works in four NYC museums
(lasts 2 hours in Metropolitan Museum of Art)
(lasts 8 days at Brooklyn Museum)
(unknown length at Museum of Modern Art)
(lasts 12 days at Natural History Museum)

2005 Banksy paints 9 images on Israeli West Bank barrier

2005 Notting Hill exhibit features 200 rats scurrying about guests

2006 Banksy replaces 500 copies of Paris Hilton CDs with his own remixes and cover art

2006 Banksy dresses an inflatable doll in Guantanamo Bay uniform in Disneyland

2006 Exhibition, *Barely Legal* in Los Angeles

2006 Christina Aguilera purchases several Banksy images for £25,000

2006 Banksy painting at Sotheby's sells for £50,400
2006 Banksy stencil at Sotheby's sells for £57,600
2006 *Wall and Piece* is published by Random House
2007 *Bombing Middle England* sells at Sotheby's for
 £102,000
2007 "Space Girl & Bird" sells at Bonhams of London for
 £288,000
2007 Banksy receives award for Art's Greatest living Briton
2008 Exhibition, The Cans Festival
2008 Banksy creates a series of works in New Orleans (3rd
 anniversary of Katrina)
2008 Exhibition, Village Pet Store and Charcoal Grill, New York
 City
2009 Exhibit at the Bristol City Museum and Art Gallery
2010 Banksy's film *Exit Through the Gift Shop* premiers
2010 Banksy named by TIME magazine as one of the most
 influential people of 2010
2010 The "I Love NY" Doctor is produced.

Literature review

Street art is often considered within an art historical context as antimodern or a postmodern movement. The graffiti-based art form has been considered a reaction against the white walls, powerful institutions, and personalities that were products of the modern era (Stahl, 2009). Modernism was the dominant philosophy of art making during the twentieth century and street art began to gain popularity as the story of modernism came to an end in the second half of the twentieth century. As a movement, modernism began roughly during the industrial revolution in the mid-nineteenth century and eventually passed with the advent of post-modernism in the 1970s. While these dates can be argued, modernity is generally characterized for rethinking art, culture, philosophy, and psychology in the twentieth century. An overarching theme in this movement is the desire to create a utopian and perfect society. A goal that appeared possible with the advent of the machine age when it seemed like mankind could make anything possible. However, Gablik (1985) writes that modernism failed and that as a result of this thinking there was no way to measure success, standards, or what a work of art is. This was the ultimate failure of the movement because a consistent value system disappeared.

The city walls and urban environments constructed in the twentieth century represented much of this empty progress of modernism. The International style of

Architecture mainly influenced by the Bauhaus teachers and students dramatically altered the way buildings were made in this era (Daichendt, 2010). New materials and advancements in construction allowed living spaces to be constructed cheaper. The use of glass and the box-like design of modern architects sought to take advantage of space and create a technological utopia. This influence is present in urban environments of the United States. Skyscrapers of metal and glass resemble shoeboxes in contrast to decorative exteriors architect favored in the previous century. A critique by Tom Wolfe (1981) in his witty text *From Bauhaus to Our House* bellows that the folks who work within these structures can barely appreciate them:

> Every child goes to school in a building that looks like a duplicating-machine replacement-parts wholesale distribution warehouse. Not even the school commissioners, who commissioned it and approved the plans, can figure out how it happened. The main thing is to try to avoid having to explain it to the parents.
>
> (p. 1)

Lewisohn (2008) calls graffiti anti-modernism because it reacts against the modern infrastructure in which it takes place. The perfect living space in which these artists have grown up in is not working and graffiti can be seen as a social critique as these artists seek creativity and individualism in a context that makes the individual invisible. The term graffiti however, is a mid-nineteenth-century idea that referred to the inscriptions and scribbles archeologist found on the ancient walls of Pompeii (Stahl, 2009). Street art is a recent brand of this ongoing public conversation that has progressed beyond tagging and the use of spray paint with new media and concepts.

Studies of graffiti have shown its practitioners feel they are enlivening the areas of cities that are derelict (Bowen, 1999). Banksy certainly falls into this category as he often states the importance of graffiti. He has even tagged the side of a plain gray square building in Southbank, London in 2004 with the simple slogan that read: "Boring" in huge read letters. (Banksy, 2006).

Graffiti is a well-studied subject and extends beyond traditional art history and criticism (Gablik, 1992). It is also explored from a sociological, urban planning, or anthropologists point of view because of the territoriality and the social-economic status of street artists (Bowen, 1999). These studies primarily focus on graffiti in order to control it.

Graffiti from an institutional perspective is a crime. It consists of any type of writing or drawing on any surface without the permission of the owner. This is the nature of the antiestablishment manifesto that graffiti artists embrace. Historically, prehistoric cave paintings could be considered some of the earliest forms of graffiti and this mark

making has continued through the classical civilizations, the Middle Ages and up to the present times. Reactions to Banksy's graffiti clearly demonstrate this divide. His supporters and fans applaud his ability to improve their surroundings and question the status quo while others like Peter Gibson (spokesperson for Keep Britain Tidy) fight his work as vandalism.

Street art is a huge business in the twenty-first century. It is no longer the hidden art around the corner from the gallery but instead is often on display in public galleries and museums and written up in newspapers and journals around the world. Street artists have crossed over into design, fashion, and pop culture and some are as recognizable as celebrities. However, in many respects street art is still noticeably different from art education in art schools around the world.

The multiple views regarding street art are present in a 2010 Banksy street work, San Francisco Chinatown Doctor. Graffiti artists jealous or unconvinced with Banksy's message covered his work with yellow paint. In contrast, the Building owners cleaned the yellow graffiti and attempted to preserve the image illegally placed on their building by Banksy.

Cultural atmosphere

While Banksy's history must be approached with skepticism, it is believed he became interested in graffiti in the early 1990s. The dates are mushy since Banky's age is unknown although his approximate year of birth is believed to be 1974, making him a teenager in the 1990s, when he first started using stencils. Early examples are rare and a well-written account is provided by Wright (2007) who focuses on Banksy's years as a street artist in Bristol.

According to Wright (2007) the city of Bristol was home to a rich music and graffiti scene in the 1980s. As a young child, Banksy recalls the intense discussions regarding graffiti with his schoolmates. It was a topic of great interest to him and his friends. The city of Bristol had its fare share of local celebrities including street artists: Robert del Naja aka 3D, John Nation, Nick Walker and Inkie, many who have gone on to critical and commercial success (Wright, 2007). This cluster of activity has continued and is something Bristol is known for facilitating. The influence of the music scene combined with the underground attitude of the local artists was a breeding ground for creativity in street art. The importance of multiple generations involved in creative work is important for continued work and for the development of future street artists like Banksy.

Nick Walker is credited with first using stencils in Bristol and this clearly had an impact on Banksy as the media available to street artists changed in his own hometown (Wright, 2007). Younger generations (like Banksy's) are stimulated, or react to prior

generations for continuity of great ideas to exist (Simonton, 1984). The influence, admiration, and availability of role models to identify with one or more at an early age display a high correspondence of studies involving eminent individuals (Simonton, 1984). The cultural atmosphere is important for creative work to happen. Good ideas take time and part of Banksy's informal education involved discussions and exposure to the street art in his hometown. Clusters of activity have been shown to provoke creative work and the thriving art and music scene in Bristol appears to have greatly contributed toward Banksy's thinking and his artistic process. Banksy was certainly not the leader nor the innovator but was a small part of a larger cluster of activity that influenced and pushed him to refine his ideas.

Wright (2007) characterizes the city of Bristol as small, liberal with an underground quality. A mix of cultures and artists, the city boasts a close-knit but lively creative scene in music, poetry, art, and design. But the graffiti world recognizes the special place Bristol has come to claim with the wealth of top artists including Ghostboy, Kato, Paris, Sickboy, Mr. Jango, Dicy, Xenz, and FLX being prominent names. This underground scene is a major foundation for Banksy and helps us understand his youth and beginnings.

Hip hop was also part of this cultural stew in Bristol. It is a distinct type of culture that is closely tied to graffiti. Originating in New York City in the 1970s, there are four main components: MCing, DJing, breaking, and graffiti. As many street artists practiced other aspects of this culture, the overlap and practice reinforce one another. While Banksy is connected with hip hop, he is also believed to have originated from a blue-collar family. Manco (2002) claims Banksy was the son of photocopier engineer, originally trained as a butcher before becoming heavily involved in the Bristol aerosol boom.

The images of Banksy in his own published books depict him wearing a baggy sweatshirt, blue jeans, and ball cap (Banksy, 2006), clothes that a younger high school or college student might wear. The influence of hip hop and rap are apparent yet his face is always concealed. In his film Banksy wears a mask and digitally alters his voice. But whether these images are of him is also unknown. Simon Hattenstone from the *Guardian Unlimited* described him as a 28-year old male with a silver earring, silver tooth, in jeans and t-shirt. This does not sound like a media darling and whether it is true or not, the image cast is exactly what one would suspect. Or is it? Shepard Fairey, a friend of Banksy and a street artist with an international following sports a schoolboy look that would make any mother in middle-America proud. The image put forth and manipulated by Banksy could just as well be a false front, something always to consider when working with a trickster (a consistent theme with Banksy in his art and film project).

Professional influences

The city and artists of Bristol were certainly a major influence but Banksy also notes the importance of Blek le Rat (b. 1952), especially in contemporary interviews. Banksy's style draws many similarities to the French artist who is an influential street artist and who started working with stencils in the early 1980s. Often consider the grandfather of street art and originator of stencils, he was born and started his career as an artist in Paris. Blek le Rat writes:

> I had the idea to use stencils to make graffiti for one reason. I did not want to imitate the American graffiti that I had seen in NYC in 1971 during a journey I had done over there. I wanted to have my own style in the street... I began to spray some small rats in the streets of Paris because rats are the only wild living animals in cities and only rats will survive when the human race will have disappeared and died out.
>
> (Blek le Rat, 2010)

Banksy's own use of rats in his art is communicated in a much more tongue-and-cheek manner (see Figure 27). He claims that he was painting rats for a few years before someone said it was a clever anagram of art (Banksy, 2006). On a serious note he likens rats to their role in society. They are creatures that exist in the lowest levels. Hated, hunted, and persecuted yet they also hold the potential to overcome. This is comparable to the insignificant and unloved who can look to the symbol of the rat as a role model (Banksy, 2006). The rat therefore is a symbol of the low, depressed, insignificant, ignored, and disenfranchised peoples of the world. In this manner Banksy's thinking is very similar to Blek le Rat and the influence is a direct one acknowledged by the artist.

Blek le Rat's influence on Banksy is evident in the materials as well. Banksy states: "Every time I think I've painted something slightly original, I find out that Blek le Rat has done it, too," he says, "only Blek did it 20 years earlier" (Coan, 2008). Blek comments that "Banksy is a very angry man and I love that... People say he copies me, but I don't think so. I'm the old man, he's the new kid, and if I'm an inspiration to an artist that good, I love it. I feel what he is doing in London is similar to the rock movement in the Sixties" (Coan, 2008). In fact Blek believes much of his popularity is because of Banksy and the two appear to practice a friendship as Blek's popularity has grown immensely in the past decade.

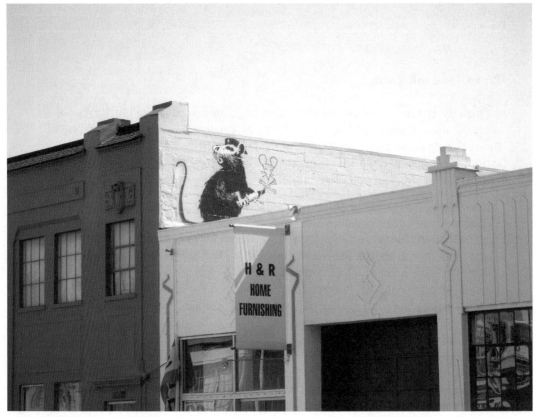

Figure 27. Banksy often uses rats in his work, 2010, Courtesy of Michael Cuffe.

Artistic media

The media of choice for artists is very important. The "I Love NY" Doctor is a stencil. It is spray paint with some use of an oil stick. Banksy uses a range of media including oil on canvas and a number of printing techniques. The specific method of stenciling is an adaptation of early graffiti art. Although it is much quicker to "put up," it does require much more preparation as the stencil must be carefully designed before hand for travel and use.

Banksy began his career as a traditional graffiti artist using spray paint in a freehand manner. It is a style and medium that requires practice, effort, and expertise to blend and contrast colors and letters successfully. Early tags by Banksy spell out his name and do not appear to have a particular message outside technical and personal ideas. The hard edges that Banksy utilizes are a result of adapting a stencil to his repertoire that eliminates the need for shading, blending, and free-hand drawing traditionally required of graffiti art. Stencils were not always considered a respectable tool in graffiti culture but that stigma has slowly dissolved.

Banksy writes that he had an epiphany when he was out tagging late one night with some friends. The 18-year old had just evaded police with some of his friends, which required him to hide under a truck. Sitting in the sludge while listening to the footsteps of police, he noticed the stenciled words on the bottom of the fuel tank. At that point, Banksy realized that he could produce tags with a stencil in half the time. A progression of his art that would provide more safety as eluding the police became more frustrating and painful. A secondary result of using stencils allowed Banksy to produce many more tags in a much shorter time, a strategy that would allow him to make quite a name for himself in a very short timeframe.

The quickness of applying the media is directly connected to the difficulties of street art. Stenciling designs is convenient, cheap, and quick to install. The artistic media falls hand in hand with where it is applied as the street artist hopes to exit the scene before they are caught. Everything from a garbage can to a public billboard is applicable for applying such images and the results are readily available to anybody. Banksy states:

> [It is] one of the more honest art forms available. There is no elitism or hype, it exhibits on the best walls a town has to offer, and nobody is put off by the price of admission. The people who run our cities don't understand graffiti because they think that nothing has the right to exist unless it makes a profit, which makes their opinion worthless.
>
> (Vanovac, 2010)

The medium for Banksy is much more than a creative concern but also part of his political message. Banksy sees himself in direct opposition to the traditional artworld that takes place in galleries and museums. Banksy's works after all have a short lifespan and are free to enjoy. Even if he does decide to sell prints, they are priced below market value. However authorities claim that graffiti costs law enforcement and city budget billions each year. Organizations like NoGraf fight for safe and clean environments. And it should come as a surprise to hear criticism from Brooker (2006) in *The Guardian* refer to Banksy as a "Renegade… a guffhead of massive proportions, yet he's often feted as a genius straddling the bleeding edge of now. Why? Because his work looks dazzlingly clever to idiots. And apparently that'll do."

Banksy's vocal criticism of mainstream artworld appears to be tied to his untraditional media. He criticizes the artists and designers alike for being thieves who simply desire to trick the public out of their money. This is a major theme in Banksy's film *Exit through the Gift Shop*. The subject of the film Thierry Guetta is characterized as a no-talent, obsessive fan of street art who instantly becomes the artworld's next big thing though self-promotion. This is scheme that works as Thierry

(aka Mr. Brainwash) continues to work in Los Angeles as a very successful street artist. Regardless of the film's legitimacy, the message is quite clear. Banksy is skeptical of artists and art institutions—a correlation with the media of choice.

Imagery

The imagery in the "I Love NY" Doctor references a small town doctor making a house call. The stethoscope he holds and his bending position infer that he is putting the equipment to use. The stethoscope, medical bag, and formal attire reference the characteristic of a doctor who has traveled to see the sick logo. The doctor's posture reflects contemplation and attention as he carefully listens to the heartbeat. Interpretations range on why a doctor is listening to the heart, but in reality this act happens during routine check-ups or when someone feels ill and requires a doctor's visit.

The heart is a symbol and represents the concept of love and has become a ubiquitous idea. The "I heart NY" logo depicted in Banksy's artwork was developed and made famous by the graphic designer Milton Glaser. The original design was used and popularized by the city of New York to promote tourism. The iconic image is reprinted on souvenirs in every part of the city and is a visual affirmation of the city. In an e-mail to the New Yorker, Banksy states "I originally set out to try and save the world, but now I'm not sure I like it enough" (Altman, 2008). Regardless, there is hope in Banksy's doctor that something is worth saving.

Location

The general public considers graffiti to be a negative influence on society. Graffiti accompanies areas without upkeep and is often thought to attract illegal behavior. Gladwell (2002) explains the significance of the broken window theory that suggests that cleaning vandalism keeps urban environments in good condition and prevents further vandalism and crime. These actions are essentially a preventative measure to controlling an epidemic where the unexpected becomes expected. The revitalization of Times Square in New York City was applied using this theory. When law enforcement started paying attention to the details, the illegal activities began to stop.

Location is an important component to Banksy's thinking. Having transformed a dangerous area of the inner city into an exhibition space in the past, the power of art and expression to transform for the positive is something Banksy is passionate about. Leake Street was known for its crime and dirty reputation. Banksy wrote in response; "I'm hoping we can transform a dark, forgotten filth pit into an oasis of beautiful art— in a dark, forgotten filth pit" (Coan, 2008). Banksy clearly holds a differing opinion of

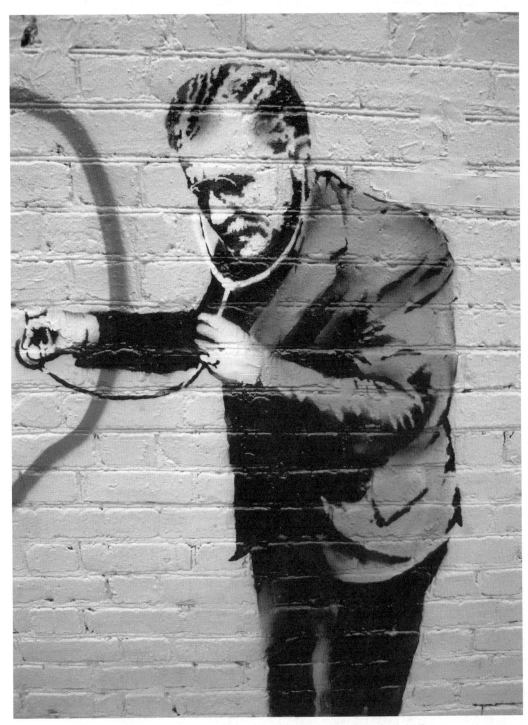

Figure 28. Detail of San Francisco Chinatown Doctor, 2010, Courtesy of Michael Cuffe.

graffiti and its location is a serious matter to him. It is a positive if done right and has the potential to bring beauty where none existed.

The "I Love NY" Doctor is depicted on a wall just a few blocks from Ground Zero in the financial district of Manhattan, the implications are not difficult to recognize. The fall of the twin towers was and still is a frustrating blow to American security and safety. The hurt and pain of that day continue to live on as family and friends of victims live with this anguish. The terrorist attacks wreaked havoc across the city and evidence of the destruction is plain to see in the changed landscape of lower Manhattan. Banksy may be known for his wry humor and sense of irony but his messages are layered with political and social issues. Images of Guantanamo Bay prisoners, military helicopters with ribbons, and references to the unhealthy eating habits of Americans are just a few examples of serious references to American politics and culture.

The after effects of 9/11 resulted in many police, firemen, and volunteers becoming quite sick years after the event. Those who worked or were exposed to the fumes in the recovery after the attack have been plagued by illness from the poor air quality. Banksy has a history of incorporating characteristics of the environment into his art. Aspects of a brick wall are visible as the maid sweeps dirt under the rug or a rat stenciled on a wall cuts away at a real missing chunk of cement on the sidewalk. Illustrations like these demonstrate the planning and thought process of the artist. They are more than quick creations but must be planned long before they are applied in the middle of the night.

It addition to the physical location, the particular characteristics of the walls that are used is also an aspect of the location. It is not the storefront or high-profile location but the side of a building. This is a forgotten corner, a spot that is ignored and passed over in the city.

> Bus stops are far more interesting and useful places to have art than in museums. Graffiti has more chance of meaning something or changing stuff than anything indoors. Graffiti has been used to start revolutions, stop wars, and generally is the voice of people who aren't listened to. Graffiti is one of those few tools you have if you have almost nothing. And even if you don't come up with a picture to cure world poverty, you can make somebody smile while they're having a piss.
>
> (Banksy, 2003, p. 1)

Banksy raises questions about the purpose of public spaces. Who owns them? Advertisers have the opportunity to place their images in public spaces for a fee. "Any advertisement in a public space that gives you no choice whether you see it or not is yours. It belongs to you. It's yours to take, re-arrange and re-use. Asking for permission is like asking to keep a rock someone just threw at your head."

Advertising spaces have grown progressively larger and larger, while the pedestrians have become more and more adept at looking the other way. Street art serves as an irritant; it begs the questions about individual expression, public perception, and, time and again, also poses the question as to how much "user interface" the passer-by is really presented with (Stahl, 2009, p. 21). The doctor is placed above the ground level and appears to be standing on a step that is part of the city landscape. A deliberate choice creates an illusion that the doctor is real and he is evaluating the poster on the wall. A sentimental and soft message compared to the blazing effect advertising has on the viewer's senses. A subject, Banksy feels quite adamant about addressing:

> The people who truly deface our neighborhoods are the companies that scrawl giant slogans across buildings and buses trying to make us feel inadequate unless we buy their stuff. They expect to be able to shout their message in your face from every available surface but you're never allowed to answer back.... The wall is the weapon of choice.
>
> (Vanovac, 2010)

However, this is not to say that Banksy's choice of location is sweet and sensitive. There is a war-like language that street artists employ. Graffiti artists often call their work a "hit," bombing," or "burner" and it emphasizes the war these artists have with authorities and the folks who maintain these public spaces (Lewisohn, 2008). New York City is known for an availability of brash advertisements that line the buildings and public spaces in all parts of the city. The war-like language of graffiti is certainly applicable in this context as Banksy has a history of critiquing the space that advertisers use to manipulate the public.

> Twisted little people go out every day and deface this great city... They just take, take, take and they don't give back. They're mean and selfish and they make the world an ugly place to be. We call them advertising agencies and town planners.
>
> (Banksy, 2002, np)

Location is clearly a key aspect and important enterprise for graffiti artists in general. The majority of Banksy's work appears in the street. Even major exhibitions of his work tend to be displayed in abandoned warehouses and unconventional locations. The importance of location is highlighted in the "I Love NY" Doctor and clearly makes references to NYC history. This is a demonstration of careful planning in the creation of the image and its placement.

Irony

Irony may be the most successful aspect of Banksy's artwork. It makes viewers laugh and highlights the absurd. Brassett (2009) addresses the importance of irony and the ability it has to question global justice. The political, social, and moral issues raised in the work on Banksy are serious and deadly. Famine is not something that one can smirk at but Banksy's absurdity functions as nonrational political intervention that provokes a new perspective on global issues (Brassett, 2009). In other words, sometimes humor is the best method for addressing a serious topic.

> Irony is how Britons deal with their collective sense of loss: loss of empire, loss of the moral high ground, loss of economic and military credibility, loss of ignorance to Empire's excesses. In this way, irony can be more than the merely playful recognition of our own certain fragilities then.... irony is one of the greatest ethical resources on offer to (perhaps from) the British: an abject collective sense of ethical limits.
>
> (Brassett, 2009, p. 221)

This irony is present when Banksy is asked about selling out, he replies:

> It's hard to know what "selling out" means—these days you can make more money producing a run of anti-McDonald's posters than you can make designing actual posters for McDonald's. I tell myself I use art to promote dissent, but maybe I am just using dissent to promote my art. I plead not guilty to selling out. But I plead it from a bigger house than I used to live in.
>
> (Ward, 2010)

This serious side is often undercut (or highlighted) by Banksy's sense of humor and buiness acumen. The "I Love NY" Doctor also has this layered relationship. The heart is treated like a real human organ and demonstrates a symbolic relationship to the heart of a city. However, the heartfelt and emotional subject matter must also be compared with the calculated timing of the movie premier to its installation. This is a sensitive and quiet moment. The doctor is caring and concerned. There are real emotions about peace and love that are difficult to ignore yet its presence does so much more than demonstarte an admiration for New York.

Conclusion

Banksy's success commercially has contributed toward the attention works like the "I Love NY" Doctor has received from audiences. However, by reflecting on this one particular piece, major enterprises for this image were explored including subject, media, imagery, location, and irony. Despite the many limitations, a strong analysis of his work is attainable. Banksy's publications are limiting because the work and commentary within them are dated. For example, the Art by Banksy in his 2006 publication are from a concentrated time period of 4 years (many which are reproduced from earlier publications).

Dated works listed in Banksy's 2006 publication

 2000 – 0
 2001 – 3
 2002 – 10
 2003 – 19
 2004 – 21
 2005 – 18
 2006 – 4

But online discussions, magazine interviews, and correspondence with the media allow for more contemporary data and insights. From these sources it was apaparent that a concentrated effort on location and its relation to the subject was deeply important. However, Banksy's use of irony often undercuts these efforts and contributes to the fuel that detractors and critics of street art require to fight his graffiti campaign.

Banksy has indeed become a celebrity and nowhere is his fame and presence felt more than in his birthplace of England. Banksy has self-published three texts that feature his work titled *Existencilism* (2002), *Banging Your Head Against a Brick Wall* (2003), and *Cut It Out* (2005). A fourth text *Wall and Piece* was published by Random House in 2006 and has since sold more than a quarter of a million copies (Collins, 2007). Street art is temporary and books, websites, and journals are a few avenues that keep these concepts alive and active. Often a work by Banksy may only last a few hours. A few are protected but the limitations of the media and exposure to the elements outside condemn street art to a relatively short life. The publications document and allow a much wider audience access to Banksy and his art.

These hard-to-find self-published books are quite small and can fit into one's front pocket. They are filled with short quips, stories, and lots of photographs of Banksy's work. In short, they demonstrate the plethora of work Banksy has accomplished and a bit of his voice as an artist. Banksy comes across as smart, funny, and hard working based upon the amount of work, the subject matter, and the wryness of his humor.

However, he is not without his faults. These early books also demonstrate anger, disrespectfulness, and a lack of education. This is apparent in his word choice, lack of research, and inability to see things from diverse perspectives (although he does appear to purposely exploit these characteristics).

A good example involves Banksy (2002) retelling of a story heard from a "man in a pub" about a king, his court painter and a vagabond. Essentially the king facilitated a contest between the vagabond and the painter for the title of greatest painter. The two men worked for a month and when it was time to reveal their paintings, the court painter's still life of fruit was so realistic that it fooled a bird that attempted to swoop down and eat the food only to slam against the canvas. The king then asked the vagabond to remove the cloth that covered his painting only to realize that the painting was the cloth. The vagaboud had the last laugh as his competition deceived nature while he fooled the king.

Banksy apparently identifies with the vagabond but the story has been retold many times. The *Naturalis Historia* is an encyclopedia published in the first century by Pliny the Elder (philosopher, naturalist, and author) during the Roman Empire. In an attempt to report Ancient knowledge, he describes the painting contest between Zeuxis and Parrhasius (Greek painters from the fifth century BC). The story proceeds with Zeuxis creating a painting that fooled birds while Parrhasius fooled a fellow artist with his mastery of realism.

Banksy may or may not be aware of this history (it is difficult to tell), but it is apparent that the triumph of the unappreciated fooling those in charge and exposing their fallacies is a consistent theme. The uneducated and simplistic surface-level critique is also warranted in these cases as Banksy's critique is deep but it is difficult to know whether he knows what he is talking about (reinventing and reintroducing history in a new package) or unknowingly sharing an old lesson as a profound insight.

The hard line, "this is how I see it mentality" is constant and Banksy is bent on demonstrating the wrongs of society by breaking the law. By protesting war, claiming the artworld is just about money, or claiming that advertising is all lies, Banksy is demonstrating that there are moral issues that society needs to address. He feels he is in the right and that his art brings attention to these issues. This is an inherent contradiction that he seems to fail to recognize as he performs illegal acts in the process of communicating his message.

The most consistent aspect of Banksy across all media is his constant critical eye. This is apparent in the "I Love NY" Doctor and in his writing. He is not above reversing criticism of himself. The back page of his text has an ironic quote from the Evening Standard that states: "Superficially his work looks deep but it's actually deeply superficial" (Banksy, 2002). The enterprises that contribute toward The "I Love NY" Doctor are real and important but they must be weighed against the realization of it simply being a movie poster.

References

Altman, A. (2008, July 21). Banksy: An Artist Unmasked. *Time*. Retrieved on August 9, 2010 from: http://www.time.com/time/arts/article/0,8599,1825271,00. html?xid=rss-arts.

Banksy (2006). *Wall and piece*. London, UK: Century.

Banksy (2005). *Cut it out*. Weapons of Mass Distraction.

Banksy. (2003). *Banging Your Head against a Brick Wall*. Weapons of Mass Distraction.

Banksy (2002). *Existencilism*. Weapons of Mass Distraction.

Blek le Rat (2010). Manifesto. Retrieved on October 20, 2010 from: http://bleklerat. free.fr/

Bowen, T. E. (1999). Graffiti art: A contemporary study of Toronto artists. *Studies in Art Education*, *41*(1), pp. 22–39.

Brassett, J. (2009). British irony, global justice: a pragmatic reading of Chris Brown, Banksy and Ricky Gervais. *Review of International Studies*, *35*, pp. 219–45.

Brooker, C. (2006, September 22). Supposing… Subversive Genius Banksy is Actually Rubbish. *The Guardian*. Retrieved August 10, 2010 from: http://www.guardian. co.uk/commentisfree/2006/sep/22/arts.visualarts.

Bull, M. (2009). Banksy Locations & Tours: A Collection of Graffiti Locations and Photographs in London, England (US Edition). Oakland, CA: PM Press.

Coan, L. (2008, June 13). Breaking the Banksy: The First Interview with the World's Most Elusive Artist. *Daily Mail*. Retrieved on October 22, 2010 from: http:// www.dailymail.co.uk.

Collins, L. (2007, May 14). Banksy was here: The invisible man of graffiti art. *The New Yorker*. Retrieved on July 1, 2011 from http://www.newyorker.com/ reporting/2007/05/14/070514fa_fact_collins

Daichendt, G. J. (2010). The Bauhaus artist-teacher: Walter Gropius's philosophy of education. *Teaching Artist Journal*, *8*(3), 157–64.

Fairey, S. (2006). Banksy: The man, the myth, the miscreant. *Swindle*, 8, 83-91.

Gablik, S. (1985). *Has Modernism Failed?* New York: Thames and Hudson.

Gablik, S. (1992). Report from New York: The graffiti question. *Art in America, 70*(9), 33–9.

Gladwell, M. (2002). *The tipping point: How little things can make a big difference.* New York: Back Bay Books.

Gruber, H. E. (1989). The evolving systems approach to creative work. In D. B. Wallace & H. E. Gruber (Eds), *Creative people at work.* Oxford, UK: Oxford University Press.

Lewisohn, C. (2008). *Street art: The graffiti revolution.* New York: Harry N. Abrams.

Manco, T. (2002). *Stencil grafitti.* London: Thames and Hudson.

Miller, N. (2010, April 13). Banksy Talks Art, Power and Exit through the Gift Shop. Wired. Retrieved on November 5, 2010 from: http://www.wired.com/underwire/2010/04/banksy-exit-through-the-gift-shop/

Schön, D. (1983). *The reflective practitioner: How professionals think in action.* New York: Basic Books.

Simonton, D. K. (1984). *Genius, creativity, and leadership: Historiometric Inquiries.* Cambridge, MA: Harvard University Press.

Stahl, J. (2009). *Street art.* Duncan, SC: H.F. Ullman.

Time's Staff (2010, April 1). The 2010 TIME 100 Poll. Retrieved on November 5, 2010 from: http://www.time.com/time/specials/packages/article/0,28804,1972075_1 972078_1972200,00.html.

Vanovac, N. (2010, July 24). Is Banksy's Film a Hoax? Do You Care? *Reportage/Online: Magazine of the Australian Centre for Independent Journalism.* Retrieved August 10, 2010 from http://www.reportageonline.com/2010/07/is-banksys-film-a-hoax-do-you-care/

Ward, O. (2010, March 1). Banksy Interview. *Time Out London.* Retrieved August 9, 2010 from: http://www.timeout.com/london/art/article/863/banksy

Wright, S. (2007). *Banksy's Bristol: Home sweet home: The unofficial guide to Banksy's early years.* San Francisco, CA: Last Gasp.

Wolfe, T. (1981). *From Bauhaus to our house.* New York: Bantam Books.